Easy Digital Photography

Scott Slaughter

Abacus

www.abacuspub.com

Copyright © 1997

Abacus
5370 52nd Street SE
Grand Rapids, MI 49512

www.abacuspub.com

Printed in the U.S.A.

ISBN 1-55755-330-0

10 9 8 7 6 5 4 3 2 1

Contents

Part 3: Image Editors 209 - 402

Chapter 10: Image Editors: The Darkroom Of Image Editing 211

Introduction: A Crease In The Photo

You may not realize it but you're probably a big user of digital technology already. For example, every time you listen to your favorite CD, whether is Beethoven or Sheryl Crow, you're using digital technology. Digital technology is becoming more important in the computer world, too. Desktop publishing and the World Wide Web demand colorful graphics and images to break up text and add interest.

You've likely snapped photos of special occasions like vacations, proms, reunions and countless other situations. You'd take the film to the photo center to be developed and wait a few hours or days for them to develop the film. Then after a while, the excitement wore off and the photos were relegated to a box in the closet.

You're probably just as "snap happy" today. However, now you can use your photos in a completely different way than you could before.

The basic technology of photography has not changed much in the last 150 years. Today's digital cameras use the same basic technology as your 35-mm film camera. There is, however, one important difference: Digital cameras create images instantly. You can then manipulate ("tweak"), print and even e-mail the images. Don't panic... the price of many consumer level digital cameras is less than $300 now.

Even if you're not interested in digital cameras or are unimpressed with their low resolution, you can still use your PC to explore the world of digital technology. For example, use a color scanner to transfer your conventional prints onto your computer.

Then after your images are saved on your hard drive, it's very easy to turn your PC into a digital darkroom. Even a beginner's beginner can use image editors like MGI PhotoSuite, Arcsoft PhotoStudio, Picture It! or LivePix to remove red eye, change backgrounds, adjust colors and contrasts, add special effects and otherwise "tweak" images (see Chapters 10-14).

Then when you're finished tweaking the image, put it into a report, letter, newsletter or even the Internet. You can start a family newsletter and keep grandparents up-to-date on your kids. Put a picture of your missing pet in a flyer so would-be rescuers have more information. Many image editors also let you put your pictures on calendars, mugs, magnets or screen savers. Then you can print out the image using inexpensive, near photo quality inkjet printers.

Don't have a scanner or digital camera. You can still be part of the new digital darkroom. You can also have your 35-mm film processed onto a floppy disk or Photo CD. Seattle FilmWorks, a mail-order film processor, will place digitized film onto a floppy diskette. You can even download your photos from their Web site. PictureVision offers a similar service at their PhotoNet site. (See Appendix A)

You don't even have to use film to start your digital darkroom. A completely filmless approach is to capture, or *grab*, video images directly from a camcorder, VCR or television. These are called video capture devices. They're pocket-sized devices that connect a camcorder, VCR or television to your PC. You simply click a button to capture the image from the video. See Appendix A for more information.

What's in this book

We've divided this book into four parts. The first part talks about digital cameras and their technology. This includes tips on using digital cameras, the manufacturers of digital cameras and who uses digital cameras. The second part deals with scanners. We'll talk about tips on using scanners, manufacturers of scanners, other uses for scanners, such as scanning 3-D objects, etc.. The third part talks about image editors. These are software programs that let you tweak an image. We've even included one on the companion CD-ROM that you can use. The fourth part is the Appendix.

We're interested in knowing what you think of digital cameras and today's digital technology. Let us know how you use your digital camera, scanner and image editor. Send your ideas and comments to scott@abacuspub.com.

Part 1

Digital Cameras

The First Frame: Introducing Digital Cameras

Chapter 1

The First Frame: Introducing Digital Cameras

"Development" Of Digital Cameras

The reasons for the fast growth of digital cameras

How Do These Things Work

CCD (charge-coupled device)

Transferring images from your camera to your PC

Who Uses Digital Cameras?

Advantages And Disadvantages

Disadvantages using a digital camera

Advantages of digital cameras

For the last 150 years photography involved silver-nitrate-based film, the corner drug store and waiting hours or even days for the film to be developed. The basic technology of photography has not changed much during that time. The fast speed, assorted lenses and other capabilities of today's 35-mm camera would impress the famous Civil War photographer Matthew Brady, but he would still understand how the camera works.

It would be a different story, however, if Brady were to get his hands on one of today's color digital cameras. It's doubtful he would even recognize it as a camera because it's unlikely he ever considered using a camera that did not use film. Color digital cameras, also called *filmless cameras*, create instant images that can be manipulated, printed and electronically mailed.

An "unretouched" photo snapped with the Chinon ES3000 digital camera

"Development" Of Digital Cameras

The idea for digital cameras literally came from outer space. The digital imaging technology grew from research involving satellites for military and scientific research applications. Although digital cameras sound like a new technology, practical electronic photography began back in 1982 with the Sony Mavica.

Sony shook the photographic world when it introduced Mavica. The Mavica, short for *magnetic video camera*, was revolutionary for one main reason: it didn't use film. Mavica may have shaken the photographic world but it shocked manufacturers. They realized they had two choices: start research on their own electronic photography products or face declining sales.

Although it was a still camera, the Mavica was more like a Sony television camera. The pictures it produced were technically television pictures. However, Mavica produced single frames of video instead of 25 (in Europe) or 30 (in Japan and the US) frames per second. In other words, the Mavica produced video pictures. These pictures, taken as individual frames, were "still" pictures. Instead of film, Mavica recorded still video images on two-inch floppy disks (resembling today's miniature computer disks).

However, the Mavica used analog recordings, not digital. Therefore, before the signals could be used in a computer, they had to be converted from analog to digital. This was done with a digitizing card.

Mavica cameras were available only in the US and Japan. Sony never produced a still video camera for the European market. Instead, Canon introduced the Ion RC-251 still video camera through specialty stores. Using a digitizing card in the Mac, users were able to get digital images from the Ion RC-251 camera.

Today's digital cameras started with the legendary QuickTake camera from Apple Computer (co-developed with Kodak). The first QuickTake camera cost around $700 and was the size of a small pair of binoculars. This fixed-lens camera included an internal 1-Meg flash memory. This was enough to store 8 to 32 images, depending on the resolution (maximum 640 x 480). Users connected the QuickTake to the Mac or PC through the serial port.

Many companies have since released digital cameras. These companies include well-known camera makers such as Minolta and Kodak as well as companies from the computer world such as Ricoh, Chinon and Casio. Most of these cameras were improvements over the QuickTake. For example, they exceeded the image capacity and internal storage limitations of the QuickTake. They also added higher resolution color CCD imagers, JPEG for fast compression, more flash memory and faster serial communications.

The reasons for the fast growth of digital cameras

There is no single reason for the explosive growth of digital cameras in particular and digital imaging in general. We can list at least five reasons related to the sudden increase in popularity of digital cameras:

Faster and more powerful PCs

A fast processor, such as the Pentium-class processor, is virtually required when working with the images captured by a digital camera. Working with these images is very math intensive. Processors before the Pentium, even the 486, weren't fast enough to handle the necessary calculations. Earlier processors simply required too much time to handle these images.

Larger capacity hard drives

Digital images can also require large amounts of hard-drive space. Some of the images that you'll snap with a digital camera will be larger than 1 Meg each. Keeping a number of these shots obviously requires a relatively large hard drive and these weren't available until recently.

Now that 1.2 Gigabyte (and larger) hard drives are available, we have plenty of room to store dozens of images.

Image editors

Perhaps the most important breakthrough wasn't the advent of more powerful hardware, but more powerful software. Software, especially image editors, are required to manipulate or edit photographic images. In 1991, the year recognized by graphic artists as the start of the "image revolution," this was realized. That year Adobe Systems released the first version of Photoshop. Other image editing software have come and gone and dozens of image editors are now available, but Photoshop remains the industry standard several years after its introduction.

Lower prices, more competition

Although digital cameras are still more expensive than 35-mm cameras, the cost of a digital camera continues to fall as competition from different manufacturers increases. The suggested retail price for most home digital cameras range from $500 to $1,000 and the "street price" is even lower.

Although even the street price is not cheap for many PC users, it's about half of what comparable cameras cost a very short time ago. Then the least expensive digital camera was the Kodak Quicktake 150 (about $750). Furthermore, the prices are likely to continue dropping as competition increases and more companies release new models. Many companies, such as Eastman Kodak (from its Digital Science division), Chinon, Sony, Casio, Apple and others are creating a new market for digital cameras with prices below $1000. See Chapter 3 for a description of these cameras. Most likely, these prices will have come still further down by the time you read this.

Of course, you can always go "top end" with studio digital cameras that currently cost between $15,000 and $30,000.

*The Kodak 410 is an example of professional digital camera
(suggested retail price is about $7000)*

Hey, they're fun to use

Using a digital camera can be just plain fun. These cameras are great for viewing full-color, full-screen pictures on your monitor. They make enhancing your home page on the World Wide Web a breeze. Perhaps their most interesting feature currently is their new technology; it's fun to have something new.

How Do These Things Work

Digital cameras are very similar to traditional cameras. Both have a lens, shutter and diaphragm. However, that's where the similarities end. As you've guessed, digital cameras use a completely different technology to develop pictures.

As their name suggests, digital cameras do not use film but instead use built-in memory chips to store the pictures you snap. Traditional cameras focus their images on film coated with light-sensitive silver halide crystals. After you take the film to the lab, it's dipped in chemicals to develop and permanently fix the recorded image.

However, you do not take the pictures stored in a digital camera to the corner drugstore for processing. Instead, you download (or transfer) the pictures from the camera to your PC.

CCD (charge-coupled device)

As novel as digital cameras may seem, they use a familiar bit of magic to capture images. Instead of film, digital cameras focus their images on small photosensitive semiconductor chips called *charge-coupled devices*, or simply, CCD. (Scanners, fax machines and camcorders also use CCDs.) The CCD acts as the "film" in a digital camera by turning the image it captures into pixels (picture elements). To "develop" these pictures, you transfer them to your PC. Then you can use image editing software to manipulate (or *tweak*) the image.

Many people consider digital cameras to be an alternative to film cameras because they operate and look like film cameras. However, digital cameras are image capture devices and therefore more closely related to scanners. A digital camera converts a real-world image into digital form, as does a scanner. The difference is that a digital camera lets you capture virtually any image you can see with your eye but a scanner captures objects only. See Chapters 6 through 9 for information on scanners.

CCDs contain hundreds of thousands (sometimes millions, depending on the camera) of resistors that act as sampling points. The resolution, and therefore image quality, improves as the number of CCD cells increases. In other words, the more CCD cells, the higher the resolution and, therefore, image quality.

When you press the shutter button on a digital camera, light is reflected from your subject to the CCDs. This in turn creates electrical impulses that are translated immediately into the zeros and ones of digital information that your PC understands. The information is then saved to memory. Available light is more important to a digital camera than to a film camera, as more electricity is generated as more light hits the CCD cells. When low light or no light is present, very little current is generated (or maybe even no current), making for "muddier" pictures.

A digital camera depends a great deal on light,
when low light or no light is present, the pictures can appear muddy

Color is produced as the image passes through red, green and blue filters. The light then falls on the CCDs pixels. These pixels are sensitive to either red, blue or green color. Then an analog-to-digital converter (ADC) chip converts the intensity of electrical charges into zeroes and ones. Digital cameras use built-in ADC circuitry to instantly convert the charges when the image is captured. The digital data is then compressed and saved to the camera's memory. The amount of time required for all this differs (depending on the

camera), but is typically about five seconds. Some color digital cameras require a much longer time to produce a picture. Additional time is required for the camera to recharge its built-in flash (if it has one). Then you're ready to shoot the next picture.

When your film camera runs out of film, you simply insert a new roll of film and continue shooting. Many digital cameras save the images you take to built-in memory. So, you're much more limited in how many pictures you can take with a digital camera. The maximum varies with the manufacturer. The Chinon camera, for example, can record only five images in high quality mode while the Casio can store 96 images. One option is to use 1 Meg to 16 Meg PC memory cards to increase the number of images. However, this is an expensive option.

> Cameras that can store images on PC cards can have a big advantage when transferring images. For example, Chinon has announced plans for an image-card reader that attaches to your PC through a parallel or SCSI port. To transfer the images, simply remove the card from the camera and insert it in the reader. This system can transfer images up to eight times faster than a serial connection.

Transferring images from your camera to your PC

When you've reached the maximum number of images (or whenever you're ready to view the images), you must transfer the images to your PC. This is also called *offloading* or *downloading*.

Digital images are transferred from the camera to your PC through a serial cable and special software provided by the manufacturer. The time required to transfer images depends on your camera, the transfer rate of your PC through the serial port (bps) and the file format that is used. Sending a 24-bit color image through a serial connection can be slow, typically taking between 10 and 90 seconds per image.

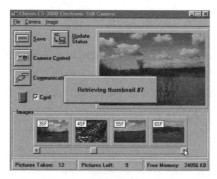

An example of transferring (also called downloading
and offloading) *images from a digital camera to a PC*

Once in your computer, use the image editors from Chapter 10 to retouch, crop, edit and store the images. Many digital camera manufacturers include image editing applications, called applets. These applets let you do some minor editing or enhancing to the images (e.g., cropping, rotating and tweaking).

Who Uses Digital Cameras?

You don't have to look very far to see digital cameras being used. You'll find many wide-open opportunities for digital cameras. These include desktop publishing, Web pages, auction catalogs, entertainment venues and environmental issues.

The following is part of growing list of examples of how and where digital cameras are used today:

Internet World Wide Web publishing

Visual graphics have become a necessity for eye-catching web pages. So, digital cameras have become invaluable for designers providing artwork and page layout for businesses wanting an Internet home page.

By using a digital camera, when you're in a hurry to update your page, you don't have to race to the local photofinisher for developing and printing. Instead, simply transfer the images directly from your camera to your PC (takes from 10 to 90 seconds per image). You then can edit and post the new images within minutes.

Resolution is perfect for Web pages

Most digital cameras are capable of producing a resolution of 640 x 480 pixels. This is more than you'll likely need for Web pages. You may even need to crop or resample pictures down to smaller sizes.

Electronic publishing

Many book and magazine publishers use digital cameras to add images into their publications quickly. This eliminates the need to use photographs and slides because the media is electronic.

Souvenirs

Digital cameras are great for taking photographs with your favorite "cartoon" characters and quickly incorporating them into T-shirts and mugs for memorable personalized souvenirs.

Real-estate and insurance agents

Real-estate and insurance agents were among the first to see the potential of digital cameras. They use digital cameras to include pictures in reports and publications. Real estate agents can "show" a property almost immediately by posting photographs of properties for sale or rent to hundreds of potential customers on the Internet. They can also send the information to associates in a remote office. Insurance agents can use a digital camera and the Internet to transmit images of property damage to speed claims processing.

The United States Navy

The United States Navy is faced with the increasingly serious and difficult problem of disposing photochemical waste. So it decided to do

most of its photography digitally. Digital photography doesn't need chemicals to develop images. Other branches of the military are also changing over to digital cameras.

Lower advertising costs

Stores can lower advertising costs by switching to digital cameras. Because the images are sent directly to the printer, the retailer doesn't pay for developing, scanning and other costs.

Government agencies

Law enforcement agencies, photo ID centers and photojournalists use digital photography more frequently today. For example, New York's Department of Motor Vehicles uses a digital photography system for every driver's favorite photograph: their driver's license picture.

Digital photography classes

Schools and colleges offer digital photography classes along with traditional photography classes. This lets students create a digital portfolio of their work over the semester or term that can be stored on CD-ROM or other media. This portfolio may be used as an evaluation tool for college entry or employment.

Local newspaper

Your local newspaper, like many major newspapers around the country, probably uses digitized photographs. Photojournalists can send digital images along with their stories by electronic mail. Photojournalists no longer have to wait for the lab to develop the film or run to get the processed film to the editor.

Publicity

Major photography magazines, such as Shutterbug and Popular Photography, feature increasing articles on digital photography.

Personal use

Perhaps you've wanted to add photos to your newsletters, flyers or even in a database. Your previous options were to buy prescanned photographic images on a CD-ROM or to buy a scanner and scan images into your PC. The images then had to be edited and saved on a hard drive before they could be placed in the document. Either option was time-consuming and expensive.

Today, you'll find a digital camera to be a valuable tool. Images taken with a digital camera can be almost immediately inserted into sales presentations or printed in brochures, newsletters and catalogs. The advantage with a digital camera is that you're knocking out at least one, and in many cases, two steps.

Great way to learn photography

Camera buffs have complained forever about wasting dollars to process poor shots that they took. Now, digital cameras eliminate that potential costly problem. A digital camera is great for learning and experimenting with photography. For example, digital cameras can store dozens of images and because you can overwrite the images, you can shoot all the pictures you want. Then you can delete the less-interesting photos and transfer the "keepers" to your PC.

Security

Businesses can easily and quickly increase their security systems by using digital photographs when issuing personal ID badges. These photo IDs can be quickly checked against an image database in a PC.

Advantages And Disadvantages

We've talked about how great digital cameras are, who uses them and why, but like all new technologies, digital cameras have certain advantages and disadvantages. This section talks about both. Let's start with the disadvantages.

Disadvantages using a digital camera

Before you gather your family, friends, pets or models for a photo shoot, it's important for you to understand what digital cameras are not. Most important, they are not replacements for film cameras.

Downtime

Digital cameras can take as long as 1.5 seconds from the time you press the shutter until they capture the picture. Therefore, your subjects will have to remain motionless a little longer than usual. This is called the *cycle time*.

Also, another four to nine seconds is required for the camera to save the image to its memory. This *recycle time* depends on how new the batteries are and whether you're using a flash. So, since you cannot take your next image until the previous one is saved, you cannot take sequential action shots, such as those in a sports event.

Printout quality

When you print the image you snapped with your digital camera, you'll probably notice the images typically look coarse and washed-out. The printout may appear this way even on high-end color laser and thermal printers. The printout quality of an image taken with a digital camera is simply no match for the richly saturated, continuous-tone prints produced by even a $10 disposable 35-mm camera, much less a $300 SLR model.

While prices are falling, digital cameras are still more expensive than film cameras

Although this remains true, the gap is narrowing rapidly. The cameras we talk about in Chapter Three are well under $1,000 (and street prices are likely to be well under the manufacturers suggested retail price). Some high-end models are available for over $2,000. Although that's not cheap, it's about half the price comparable cameras were selling for only a short time ago. As the field of companies selling digital cameras grows and competition increases, the prices will continue to drop.

Image quality, while good, is not as good as that of photos taken with a film camera

A $10 disposable camera produces better image quality than a digital camera that costs $1,000. Also, as we mentioned above, digital cameras can't match the resolution or color accuracy of film. The simple reason digital cameras cannot produce clear photos with accurate color is their limited storage capacity.

A digital camera must store slightly over 1 megabyte of data to snap a photo with a 640 x 480-pixel resolution and 24-bit color. It would be prohibitively expensive to load up a camera with *nonvolatile memory*, which holds information even after you turn off the camera.

To overcome this problem, manufacturers use *compression* to cram several megabytes' worth of information into a camera's limited memory. Unfortunately, compression degrades the quality of the image (see Chapter 2 for information on compression).

These cameras typically give you very few lens and aperture options.

Digital cameras have few lens options or shutter controls. In other words, few entry level digital cameras allow you to manually set f-stops or shutter speeds to adjust for changing light conditions.

Furthermore, because many digital cameras have fixed focal length lenses, interchangeable lenses aren't available for these cameras. Also,

most cameras don't allow for close-up images. Therefore, hard-core photographers may feel limited in what they can do with a digital camera.

A color output device is usually needed to get the images from computer to paper

Unless you're using your images for Web development or transferring them over the Internet or e-mail, the images live in your hard drive until you print them. Because you won't want to use a monochrome printer, you'll need to buy a color printer. Unfortunately, quality color printers aren't cheap (ranging from low-end color-inkjet printers ($300) to dye-sublimation, thermal-wax-transfer and color laser printers (costing several thousands of dollars)).

Viewfinder system

Many digital cameras feature simple optical viewfinders that have no *automatic parallax correction*. Automatic parallax correction allows you to make adjustments for accurately framing close-up and macro shots. Without this ability, what you see in the viewfinder may not necessarily be what you are capturing in the camera. This is especially true at close range.

If you run out of digital "film," you can be out of luck

Keep in mind that although you don't need film in a digital camera, you don't get to snap an unlimited number of pictures. You can receive a "memory full" error after you snap only a few pictures. For example, the Epson Photo PC stores just 16 high-resolution images in its standard configuration. Once you've taken those 16 pictures, you must transfer the images to your PC to clear the memory for more pictures. Sixteen pictures may get you through an afternoon party but it's probably not enough for a two-week vacation.

The number of pictures you can take with a digital camera depends on the amount of memory in the camera and the resolution you use for your

pictures. Most cameras give you the option of adding extra memory—at extra cost, of course.

You have to be near a computer with a serial cable to transfer the photos

This is a disadvantage related to the one above. If your digital camera runs out of memory, you must transfer or delete those images before snapping more. So, you must take time to go to your PC and transfer the images.

Advantages of digital cameras

So why use, let alone buy, a digital camera with those disadvantages? Let's talk about the advantages of using digital cameras. Most of these advantages overcome these disadvantages.

No film or processing costs, so you can cut photo costs dramatically

The only real cost associated with digital technology is the initial cost of the camera itself. You don't need to worry about film costs, processing costs, etc.

Speed-all the pictures can be "developed" in seconds or minutes

A digital camera provides a fast way to capture images directly to your PC. Instead of waiting hours or days to have your film processed and printed, simply snap a picture and immediately transfer the image to your laptop or desktop PC. The image can then be quickly and easily sent to your Web home page or to friends through the Internet. Professional photographers, real estate agents, students, insurance agents, graphic artists, teachers and home PC users are using digital cameras to capture images that can be displayed immediately on their computers.

Reshoot any image several times for the best shot

You can reshoot almost immediately if you don't like the appearance of an image. So you can shoot several images of the same subject, select the best and toss the rest.

20

Use image editing software for endless retouching options (delete, rotate, crop, and enhance digital images quickly and easily)

You can save images in several file formats and insert them into documents creating impressive presentations, reports and art. Advanced image editing software lets you cut and paste elements from different photos and manipulate almost every aspect of an image. Remember drawing horns and a beard on your elementary principal's portrait? With image editing software, the horns and beard can look like they grew naturally from his head and he was photographed with them already present.

Use a modem to send pictures around the globe in minutes

Using a modem and your telephone, you can instantly send your images anywhere in the world, including to the Internet.

Digital images can last a lifetime

Many of the color pictures you have from the 40's, 50's and 60's are probably beginning to fade. As long as you have a computer, digital images can last forever and cannot "fade."

Security

A digital camera is perfect when you need to create a photographic database of personnel, parts or property.

Digital cameras are "green"

The environmental benefit is not always clearly associated with digital photography. But film manufacturing and processing are chemically intensive and still pollute the environment. However, because you don't have to worry about film processing, the environment benefits from reduced use (and disposal) of toxic chemicals. Furthermore, digital cameras use "borrowed" technology from equipment already in production.

Manufacturers are agreeing upon some standards

Many of the newer cameras use the same type of removable flash-memory PC card for storing images. This makes it easier and less expensive to add memory (and therefore picture capacity) to your camera.

Fun

Furthermore, a digital camera can be just plain fun if you want to experiment with photography.

Other advantages

Other advantages include more dynamic range "detail" than photographic film, no grain like film, no messy Polaroids and consistency in image quality that can't be matched by film and processing. Furthermore, you'll eventually need to scan your film anyway so why not save a step (and a generation) and money?

Selecting A Digital Camera

Chapter 2

Selecting A Digital Camera

Parts Of A Digital Camera

Lens

Viewfinder

Preview screen

Flash

Exposure

Other Features To Consider

Maximum resolution

Number of images stored

Lens/exposure options

Bundled software

Color balance and contrast

Delays after snapping the picture

Image quality: 24-bit color

Connecting to your PC

File formats

Other important features

The growing interest in and popularity of digital cameras is easy to see. If you're considering joining the ranks of digital photographers, however, you should consider many things. First is selecting the right camera.

Although selecting the right digital camera is basically very easy, you'll still need to make important decisions before you buy. Price is of course an important consideration but price alone should not determine which camera you select. While you may be disappointed by the number of digital cameras available today in the under $1,000 price range, you can expect to see many more digital cameras on the market in 1997 as the technology matures. This chapter discusses the information you'll need to select the digital camera that's right for you.

Parts Of A Digital Camera

Before you can make an intelligent decision about selecting, buying and especially using a digital camera, you should understand the parts of the camera. If you're familiar with a 35-mm camera, you'll find that many of its parts have the same or similar function as their counterparts on a digital camera.

Lens

The lens on a digital camera, like the lens on a 35-mm camera, is an important consideration when buying a camera. Digital cameras can include a wide array of lenses. A zoom lens provides the most versatility; use it to take photos ranging from wide-angle pans to telephoto shots. Also, an autofocus lens normally delivers better shots than a fixed-focus lens.

The lens on the Kodak DC-40 digital camera

The following table explains the types of lenses you can use with a digital camera:

Lens	Explanation
Fixed-focus lens	Least expensive, adequate in bright light.
Fixed-focus, dual-position (wide-angle and telephoto)	Adds a second angle of view to the fixed focus lens.
Focusing, single-focal-length lens	Focusing helps greatly, especially in low light.
Focusing, dual-position (wide-angle and telephoto)	Combines the advantages of the types listed above.
Focusing, interchangeable front elements for wide-angle and telephoto	Although less convenient than a dual-position lens, the interchangeable elements in the Polaroid camera perform better optically.
Focusing zoom lens	The most flexible lens type, though not necessarily the best optically.

Lens attachments for up close and personal photos

Some digital cameras can accept optical attachments. You can identify these cameras by the threads they have on the front of the lens. A wide-angle attachment can shorten the focal length by 30 to 40 percent. The resulting wider view is especially important if you cannot move back

Not all digital cameras can use different types of lenses. Check with the manufacturer. Also, since many camera lenses have built-in macro features, you may not need to worry about an attachment.

from the subject. The threads also accept close-up lenses. However, you'll find it's very difficult to frame and focus a close-up picture using a digital camera unless it has a live preview feature.

Viewfinder

Most digital cameras use a simple optical viewfinder without automatic *parallax correction*. Parallax correction is the adjustments the camera makes to accurately frame close-up and macro shots. If your camera doesn't have parallax correction, use your image editor to crop the image if necessary.

Remember when using a digital camera that no viewfinder will frame an image precisely. What you see in the viewfinder isn't necessarily what you're capturing in the camera. The captured image will only be about 80 percent (by area) of what is visible in the viewfinder. Also, the optical viewfinder on most digital cameras usually doesn't frame accurately for close-up photographs. One exception is the Apple QuickTake, which includes a close-up attachment with a prism to adjust the viewfinder image.

Preview screen

A few digital cameras, notably from Casio, use a small active matrix LCD panel instead of an optical viewfinder. This preview screen provides precise framing, but the LCD image is slightly slower (about two-thirds of a second) than the "action."

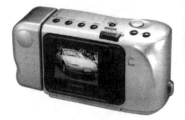

Casio digital cameras use a small active matrix LCD panel instead of an optical viewfinder

Since this makes shots of rapidly moving subjects very difficult, don't plan on taking too many pictures of your daughter's record setting 100 meter dash. Another problem is that the live previewing is usually at a very low resolution. You also have to be careful because LCD displays can "disappear" in direct sunlight.

Some digital cameras are also equipped with an optical viewfinder that you can use in this case. For example, you can use an optical viewfinder or an optional LCD monitor with the Fujix and Ricoh digital cameras. This optional LCD monitor provides better resolution and far less lag than the Casio cameras. However, it's also a fairly expensive option.

You can control the brightness of the LDC screen on most digital cameras that use these screens. For example, the Apple and Sony cameras feature a small rotary thumbwheel to control the brightness. You can change the LCD settings on some cameras, notably from Olympus, only when the camera is connected to your PC.

Previewing images

An important advantage of a preview screen is that it can display captured images, allowing you to scroll through all the shots stored in the camera. The ability to preview your photos gives you the opportunity to reshoot a picture if necessary. You can also delete shots you don't need to make space for new pictures. Without a display screen you must transfer all the images to your PC to see the images.

Cameras from Fujix, Ricoh and Casio can output the image in standard NTSC video format for viewing on a TV screen, so these cameras are like self-contained picture playback devices, even without a computer. Cameras from Epson and Polaroid allow you to preview images when you connect the camera to your PC. However, you're limited in both delay and resolution. Furthermore, the Polaroid's preview is in black/white.

The important advantage for cameras with a preview feature is that they work effectively for carefully set up close-up photography with a tripod and other work that benefits from precise framing. For example, using this feature you'll know for sure if a vertical line's really vertical.

The flash unit on a digital camera is usually located close to the camera lens. This can produce the "red eye" effect in your pictures. Red eye is the result of the flash reflecting off the back of the eye. We we know of only one camera (the Fujix) that currently has a red-eye reduction feature. It uses several quick flashes before putting out a stronger flash for the actual picture.

To reduce the effect of red eye, move in for a close-up picture, use a wide-angle lens setting or have the subject look away from the camera. You may need to use an image editor to reduce the effect of red eye. See the chapters on image editors (10-14) for more information.

Flash

Most digital cameras include a built-in flash for extra light. The notable exceptions are the cameras from Casio. However, the flash on digital cameras is not designed to produce or replace quality lighting. We mentioned in Chapter 1 that digital cameras depend on good lighting more than a 35-mm camera does. Many studio

The flash unit on the Kodak DC-40 digital camera

photographs are taken by flash, but usually with one flash unit connected to the camera triggering multiple slave flash heads. Although this is a complex technique, it will work with the digital cameras we talk about in this book.

Exposure

Most digital cameras that we discuss have automatic exposure. The exposure setting is critical because CCD sensors have less exposure latitude than color film. However, many digital cameras offer no exposure adjustments at all.

A few cameras can compensate for backlight (by lightening subjects seen in shade against a strong backlight). The two Kodak cameras offer five exposure steps, a major advantage for the careful photographer. The camera from Fujix goes further with 10 exposure steps plus four f-stop settings so you can also adjust the depth of field.

Once you've become experienced with your digital camera, you can hold its exposure settings by pressing down slightly on the shutter button. This will, with practice, help you gain some exposure control. Unfortunately, no digital camera currently indicates its exposure setting.

The CCD sensitivity typically corresponds to an ASA film speed in the 80 to 125 range. Only the Fujix has a sensitivity switch; just as with film, the higher the sensitivity, the noisier the image. Digital image noise is very similar to film grain.

Other Features To Consider

Now that you understand the basic elements of digital cameras, it's time to go a little deeper. This section talks about several key points to consider when shopping for a digital camera.

Maximum resolution

The resolution of the image refers to the number of pixels an image contains. In simple terms, resolution is the maximum size you can display an image onscreen without enlarging it, which drastically reduces the quality. The maximum resolution of an image that most digital cameras can typically capture is 640 x 480. Many digital cameras can also capture images at a lower resolution (320 x 240). This doubles the number of shots a camera can hold in the same amount of memory, but at a lower image quality.

Some of the more expensive digital cameras, for example the Ricoh RDC-1, can capture images at 756 x 504 resolution.

Although you can store twice as many lower resolution images, "tweaking" these images using an image editor requires more work. It' much easier to work with a high-resolution image in an image editor (see Chapters 10-14). Then you can zoom in to work on fine details of the image without losing visual details in a multitude of pixels.

Use the image editor, if necessary, to resample a large image down to a smaller size for smaller storage. Keep in mind, however, that going the other way is difficult--when not impossible.

Difference in resolutions of 320 x 240 (top) and 640 x 480 (bottom)

Number of images stored

Just as with a hard drive, having more memory available for a digital camera means you have more room to store images. Some cameras, such as the Kodak DC20, have a set amount of memory for storing images (96 total images). Other cameras, such as the Chinon ES-3000, let you use a PCMCIA memory card to add memory. (PCMCIA memory cards are also called "PC cards" or

simply "memory cards.") This memory card, often used in notebook computers, is the size of a credit card. If you're using PC cards, you can pop in a new card just like you would with film in a conventional camera and continue snapping more pictures.

An example of a memory expansion card...this one is used with the Chinon ES-3000 camera

Look for a camera that can handle the number of images you expect to snap between transfers to your PC. If you won't be far from your PC or laptop when you've snapped the last picture, a camera that can store only five to 16 pictures will do the job nicely. If distance, time, location, etc., will cause delays in transferring the images to your PC, consider a camera with lots of storage space or which uses replaceable PC memory cards.

Compression scheme

We said in Chapter 1 that a disadvantage of digital cameras is they have only a specific amount of RAM. So, fewer high-resolution images can be stored than lower resolution images. To store these higher resolution images, a digital camera uses *compression schemes* to pack high-quality images into less space. Why is compression necessary? A 24-bit image snapped with a 640 by 480 resolution requires nearly 1 Meg of memory. In other words, a digital camera uses a compression scheme to reduce the size of the images so more images can fit in its fixed memory.

> Whichever digital camera you buy, you'll soon begin gathering several megabytes of graphics on your hard drive. So, we recommend considering buying a Zip drive or similar removable storage device. If you start to go crazy with digital photography, you may need the extra storage a removable storage device provides.

Problems using compression schemes

Compression schemes, however, lead to certain problems. The compression techniques used by some digital cameras may, as a side effect, degrade the quality of the images. In this case, the compression is called *lossy*, meaning that the expansion process cannot restore the full original image. So, remember, you'll get the best image quality by using the least amount of compression.

Several digital cameras allow you to choose the level of compression. Unless you must conserve memory for image storage or are intentionally shooting in a low resolution mode, snap pictures at the highest quality setting. You can always use an image editor later to compress images. So consider cameras that let you decide when and how much to compress the pictures as they're snapped.

The total number of images stored depends on the camera. It ranges from about 10 up to 28 for high-resolution pictures, or from 40 to over 100 for low resolution images.

Lens/exposure options

Fixed-focus cameras with a single field of view are acceptable for grab shots (e.g., "Look what Susie's doing! Quick, grab the camera!"). However, if you want the most flexibility in subject matter and the best quality across a variety of shooting conditions, look for the following in a digital camera:

➤ Adjustable focus or an optional macro attachment

➤ Wide range of shutter, speed and aperture combinations (even if they're set automatically)

➤ A zoom lens (if possible)

We said "if possible" with a zoom lens, because it isn't absolutely necessary but is a nice feature. If your camera doesn't have zoom capabilities, try taking a few steps back or moving in closer to your subject.

Bundled software

All digital cameras include software to control how images are transferred from the camera to your PC. This typically involves only transferring the image and providing some simple functions, like deleting images from the camera. The primary task of the software that is included with most digital cameras is to transfer the images from the camera and cards or to let you control the camera from the software.

You'll probably find that a camera will be more useful to you if it includes additional software. The basic image editor included with most cameras (sometimes called an *image-editing applet*) is important but should not be a determining factor in selecting a camera. It usually provides basic functions (crop, rotate and tweak images). A few image-editing applets even eliminate the "red eye" effect.

Many reasonably priced commercial programs, such as those we talk about in Chapters 10-14, are better than the image editor bundled with the digital camera.

Another important software feature is the ability to view thumbnail images before downloading the full-size files. This will save you a lot of time by allowing you to extract the best shots from a group.

Viewing thumbnail images is important before taking time to download the full-size images

Color balance and contrast

Most digital cameras try to perform automatic color balance for different kinds of lighting--daylight/flash, tungsten light or fluorescent light. But you'll probably need to use an image editor to achieve the desired color balance.

Using software to make modest changes in the color balance can usually produce acceptable flesh tones; bright colors, however, usually cannot be corrected without distorting color values in other parts of the image.

The image contrast is more challenging than color balance. Images from a camera producing excessive or harsh contrast often can't be made usable even with powerful image editors, like Adobe Photoshop. These cameras work fine with low-contrast subjects, but that's a very severe limitation.

Delays after snapping the picture

Most digital cameras have a small but noticeable delay between pressing the shutter and taking the picture. This is the *cycle time*. Keep this in mind when snapping your pictures, especially if you're snapping several consecutive shots. This is especially true if you're experienced with fast 35-mm film cameras.

Also, most digital cameras require time to actually store the picture after you press the shutter button. This is the *recycle time*. This can last as long as 8 seconds, during which you cannot take another picture.

Image quality: 24-bit color

The number of colors the camera can capture is important. Do not consider any digital camera that captures less than 24-bit color (also called "true color" or "16.7 million colors"). The term *24-bit color* refers to the number of bits per pixel of information. The digital cameras that we talk about are all 24-bit cameras—don't consider anything less.

Connecting to your PC

To get the pictures into your computer, you simply transfer the images from the camera to your PC. This process is called *downloading* or *transferring*. Most digital cameras include two serial cables (one for a PC and one for a Mac) to move the images to your computer. The cameras also include the software for controlling the downloading process. Once the cable is connected, transferring the images to your PC is as easy as clicking on a button. This command automatically sends and saves the images to your hard drive.

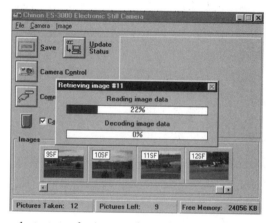

Getting ready to transfer images from the Chinon ES-3000 to a PC

Soon after you've snapped a picture with your digital camera, you can use the image in any paint, word processor, desktop publishing or image editor program (see Chapters 10-14 for more information). The images you transfer from a digital camera are stored on your hard drive like any other graphics file.

Time to transfer images

The time needed to transfer pictures depends on the camera. The Ricoh RDA-1 can require up to 2 minutes to transfer a single high-quality image. The Kodak DC50 can transfer four pictures in about a minute. The time depends on the type of file stored and where or whether the decompression step is done.

File formats

An important part of the software bundled with the camera is its file export capabilities. Make certain it can save your images in the file format you need. If you plan to capture images for multimedia presentations, for example, your requirements may be different from those for printed materials or Web display.

See the Appendix for more information.

Other important features

Compatibility

Compatibility probably should not be a concern. All the cameras support (or will soon support) both Windows and Mac systems. However, some manufacturers ship separate versions of their cameras—in other words, a version that works only with a PC and a version that works only with a Mac. Make certain you get the version that works with your computer. Fortunately, most manufacturers include both Mac and Windows support in the same camera.

Power source

Batteries power digital cameras. Make certain to look for a camera that can go into "sleep mode." This saves battery power if the camera is unused for even a few seconds.

F-stops and shutter speeds

If you've used a 35-mm camera, you know the importance of f-stops and shutter speed ranges. They dictate how a camera will perform in low-light and fast-action situations. However, the CCD sensors used in digital cameras vary so much between cameras that the ranges of f-stops and shutter speeds provide few clues to the overall image quality you can expect.

Deleting images: the "oops" factor

To delete an image stored in a digital camera, you simply press a button. This will give you additional room for more images. A digital camera should also let you delete the most recent capture so you don't waste valuable memory on a botched shot. Most cameras also let you delete several nonsequential shots, but a few cameras force you to delete all the images that are stored.

Warranty and support

> All the cameras have a safety device that prevents you from accidentally deleting images stored in the camera's memory. With a little experience, you'll appreciate this feature as much as we do.

A digital camera should have at least a one-year warranty. Toll-free support should also be included. Other pluses to look for include faxback services and online forums to answer your questions.

Zooming In On Digital Cameras

Chapter 3

Zooming In On Digital Cameras

Preliminary information before we start

Important terms

Examples Of Digital Cameras

Agfa ePhoto 307

Apple Quick Take 150

Canon PowerShot 600

Casio QV-10A

Casio QV-11

Casio QV-100

Casio QV-120

Casio QV-300

Chinon ES-3000

Dycam 10-C

Dycam Model 4

Epson Photo PC

Kodak DC20

Kodak DC40

Kodak DC50

Kodak 120

Olympus D-200L

Olympus D-300L

Polaroid PDC-2000

Sony DSC-F1

Whatever you've heard or read about digital cameras probably mentioned incredibly expensive experimental products or simple glorified toys. However, as you'll see in this chapter, real, affordable digital cameras are available now. These cameras are made by companies from both the photography and computer industries. Familiar companies like Kodak, Casio, Chinon, Sony, Fuji, Olympus and many others now manufacture digital cameras.

You can select from several digital cameras that are now available (or coming this year). So, you should be able to find a digital camera, whatever your budget may be.

We're not intending this chapter to be a complete summary of all digital cameras that are available. We cannot even mention all the details and features of each camera that we do discuss. This is only a sampling of the digital cameras that are available. However, we hope to whet your appetite for more information. If we succeed, you'll find the manufacturer's Web site and other information listed in the large table near the end of the chapter.

Also, this list is only meant as a guide; we're not necessarily recommending one camera over another. Finally, we're not intending this to be a critical review, but a source of information. Prices, models, features and other information may change, so please contact the manufacturer for specific information.

Preliminary information before we start

Before we talk about specific digital cameras, we need to mention some general information about these cameras.

Some cameras are "related"

Some of the cameras that we'll talk about are "related." For example:

➤ Kodak helped design the Logitech and Apple cameras.

➤ Dycam uses its name on the Chinon ES-3000.

➤ Chinon made the camera bodies for Kodak, Apple, Dycam and Logitech.

Since so many cameras are "related," they also share many features and similar output. All these cameras snap pictures with 24-bit colors so you have a palette of over 16 million colors available. However, the maximum resolution (which determines clarity of detail) varies between the cameras.

Don't panic—they're easy-to-use

The cameras we'll talk about in this chapter are all ready to use immediately. Although most users probably have Windows 95 as their operating system, don't panic if you're using Windows 3.x. Each camera will work well with either Windows version. You'll find that installing the bundled software (software that is included with the camera) is quite simple. Read your users guide if necessary for detailed instructions.

You'll find that a digital camera is as easy to use as a film camera. Digital cameras look, feel and act like conventional point-and-shoot cameras. A digital camera, like a film camera, has a lens, shutter and viewfinder. It also provides an automatic light sensor to adjust shutter speed and aperture for perfect exposures. Only a few digital cameras do not have a built-in electronic flash.

We mentioned in Chapter 2 that an important difference between digital cameras and film cameras is the time digital cameras require to work. A digital camera requires a few seconds to capture, convert, compress and save an image as digital data. Keep this in mind when you're using any of these cameras.

The first step in using a digital camera is simply sliding open the lens cover. This turns on the camera. Then you just point (and perhaps adjust the flash setting if necessary) and shoot. See Chapter 5 for a hands-on example on using the Chinon ES-3000 camera.

A few digital cameras come with autofocus lenses or macro lenses. Some cameras let you use third-party lenses. A fixed-focus lens, however, is more common. (See *lens* below for more information.)

Also, most digital cameras include viewing software and a cable for transferring images to your PC. Other features might include self-timers and PC cards to store additional images. Most of these features are controlled by icons on the camera's rear-panel LCD. Simply press a command button to start a feature or to make an adjustment.

Important terms

One thing that digital cameras and film cameras share is the same terminology. If you're familiar with using a 35-mm camera, you'll understand the terminology used in the "digital world." However, since some of these terms may be new, we'll explain them here. We've already talked about bit-depth, resolution and compression. These terms are specific to digital cameras. Other terms, like f/stop, aperture and macro lens, are used in both the digital-camera and film-camera worlds.

f/stop

The f/stop refers to a specific lens opening. This opening controls the amount of light that is allowed to enter through the lens and into the camera. The f/stop is basically a math formula:

The "f" represents "focal" length of the lens
The "/" means divided by
The number represents the stop currently used.

For example, if you were using a camera with a 50-mm lens set at f/1.4, the diameter of the lens would be 35.7 mm. In this example, "50" represents the focal length of the lens, divided by 1.4 (the stop) to get the answer of 35.7 for the diameter of the lens opening.

Aperture

This is the small round hole in front of the camera lens. Its primary function is to control the amount of light that enters the camera. Most film cameras and some digital cameras use an aperture that is variable. The degree of variation is expressed by the f/stop.

Keep in mind that apertures are simply fractions (1/2.8 or 1/5.6 or 1/16, e.g.). Then it should be easier to understand why an f/16 lens opening is smaller than an f/2.8 opening.

Lens

A digital camera can use many types of lenses (depending on the camera). As we mentioned, a *fixed-focus lens* is the most common type of lens. To stay in focus with this type of lens, you must be between two to four feet from the subject. Some digital cameras can use an *autofocus lens* that let you snap pictures from about 20 inches to 20 yards from the subject. A *macro lens* is usually an add-on lens that lets you get close-up shots—really close-up shots, as within a few inches up to two feet.

Shutter speeds

The shutter speed refers the length of time that the light passing through the aperture remains on the film (or CCD). For example, setting the shutter speed at 500 means that the light passing through the aperture remains on the film (or CCD) for exactly 1/500th of a second.

Examples Of Digital Cameras

In this section we'll talk about several specific cameras. Again, this is only a sampling of the digital cameras that are available. Models, features and especially prices may change, so please contact the manufacturer for specific information (see the table on pages 70-71).

One tip before you start shopping for a camera: Check out as many models as you can before buying. As you might expect, you'll find different features and prices among today's digital cameras. The cameras also differ in sharpness, skin tones and color quality.

Agfa ePhoto 307

One word comes to mind when describing the ePhoto 307 from Agfa and that is "simplicity." The ePhoto 307t looks and feels like a 35-mm point-and-shoot camera but more importantly it almost works like one. Its high resolution is well suited for Web page production and similar work.

The ePhoto 307 is box-shaped with its control panels on top. It measures 3.2 x 5.5 x 1.9 inches and weighs just 9.9 ounces. It includes a self-timer and built-in flashes with red-eye reduction.

Storage capacities and resolution

You can snap 72 standard resolution images (320 x 240) and 36 high resolution images (640 x 480) with the ePhoto 307. It does not have optional expandable memory modules but includes 2 Meg of internal flash memory.

Lens

The camera uses a 43-mm lens that produces a slightly wide-angle view similar to that of most 35-mm point-and-shoot cameras (the lens is equivalent to a 35-mm camera). The autofocus begins at 2 feet so it's not truly ideal for real close-up work. Shutter speed and focus are set automatically. Focus-free lens from 2 feet to infinity (0.6m to infinity)

Other information

The ePhoto doesn't have a few options that other digital cameras we'll talk about in chapter do have (for example, macro lens attachment, an LCD preview window and removable memory). However, if this is your first digital camera, the low cost and ease of use should make the ePhoto a favorite.

The ePhoto includes Agfa's custom PhotoWise software. It lets you not only install the camera quickly, but you can control all camera functions while connected to your PC. The software automatically detects a camera attached to the serial port, then constantly monitors its battery condition and memory status. Images are transferred to the PC, then duplicated as thumbnails compiled in an album. This allows you to view the thumbnails and then delete one or more of the originals. PhotoWise is as intuitive to use as the camera and offers basic cropping and editing tools. Agfa also includes Adobe PhotoDeluxe for more demanding image-editing tasks.

An LED panel displays the number of frames available, battery status, flash mode, resolution, and whether the 10-second timer is set.

Apple QuickTake 150

The QuickTake 150 replaces the legendary QuickTake 100 color digital camera. The 150 looks and works similar to the 100, but it can store more pictures and includes a macro lens for close-up photography. It's small enough to fit firmly in your hand and weighs just one pound.

46

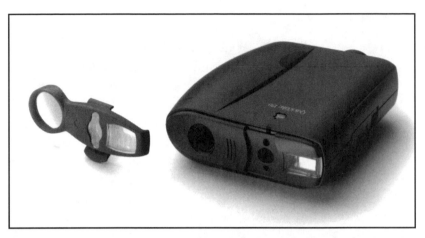

QuickTake 150 from Apple replaces the legendary QuickTake 100 color digital camera

Storage capacities and resolution

The QuickTake 150 can take and store up to 16 high-quality images, 32 standard pictures or a combination of the two in its 1 Meg of memory. You can switch anytime between the two resolution levels. The difference between high quality and standard depends on compression. See Chapter 2 for more information on compression used by digital cameras.

Both high-quality and standard resolution snap 24-bit color images. Since both settings capture at a 640 x 480 resolution, the QuickTake matches the most common monitor resolution.

Lens

The lens on the QuickTake 150 is equivalent to a 50-mm lens on a 35-mm film camera. It offers apertures ranging from f/2.8 to f/16 and shutter speeds from 1/30 to 1/175 of a second. The fixed 50-mm-equivalent lens focuses from four feet to infinity.

A parallax-correction lens is included that snaps over the front of the camera for shots to be taken within 10 to 14 inches of the subject. (*Parallax* is the difference in perspective between the viewfinder and the lens itself.)

47

Other information

The QuickTake 150 is a good example of easy-to-use digital cameras. An LCD control panel displays the number of pictures taken (and remaining), the current compression setting, flash setting, battery level and the 10-second timer. Four buttons are at the corners of the LCD. Most users will find this to be much easier than a two-button system used by other cameras. You'll use these four buttons to select a specific feature and another button to change the status of that feature. The icon next to each button indicates its function (flash, self-timer, delete all photos and switch resolutions). The erase button does what it's supposed to do, but unfortunately you cannot select which images to erase; it's all or nothing.

Those looking to snap pictures quickly will appreciate the Apple QuickTake 150's short cycle time of 7 seconds. Also, the recycle time of 4 seconds between shots is faster than many cameras.

You may have a problem if you're wearing glasses because the viewfinder is covered by a rubber cup.

Three lithium AA batteries are included with the camera and provide enough power for about 200 images (half taken using the flash). A total of 200 photos is a relatively low number (an optional battery booster pack holds eight more batteries). Consider the optional AC adapter if you plan on taking a lot of pictures. These options add a several-thousand-shot capacity.

The QuickTake transfers images to the PC faster than most digital cameras. All the images can be downloaded in a single batch to save time. The software includes basic tools such as cropping, resizing, rotating, color-depth switching, brightness and contrast. You'll probably need to use one of the image editors we talk about in Chapters 10-14 for more advanced work.

A nice accessory to the package is that the QuickTake 150 even includes a black carrying case.

Canon PowerShot 600

The PowerShot 600 is arguably the premier camera for the consumer market. Although it's one of the more expensive digital cameras we'll talk about, it has many impressive features. The reason its price is higher is not just its features and higher resolution (832 x 608), but also because it can record sound clips (see below).

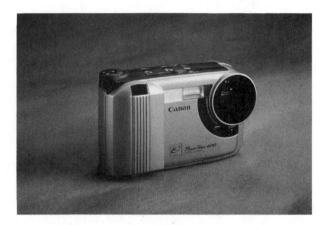

Storage capacities and resolution

You can snap only six images in the high-resolution mode. However, since the resolution is 832 x 608, the pictures should be excellent. Even the lower resolution of 640 x 480 matches the highest resolution of many other cameras. The lower resolution lets you snap 12 pictures.

The PowerShot 600 has 1 Meg of internal memory and can use PC cards to store more pictures. A 4-Meg card is about $229 and a hard-drive card is about $380. These are indeed steep prices for PC cards. However, the PowerShot 600 uses the new higher capacity Type III PC cards. Although these cards are only the size of a thick credit card, each can store up to 900 high-resolution images. Use a 500 Meg Type III hard drive and you can store literally *thousands* of pictures.

Lens

All photographers will appreciate the PowerShot 600's powerful CCD sensor, 7.5-mm autofocus lens with macrofocusing (from 4 to 16 inches) and variable shutter speeds. In other words, you can use the PowerShot 600 to snap a perfect picture of this page. This is an impressive accomplishment for a consumer-level digital camera.

Other information

We mentioned the PowerShot 600 can also record sound clips. The advantage of these sound clips is that you can immediately record comments about each photo you snap. Other digital cameras simply time stamp and date stamp the pictures you snap.

The battery is expensive (about $35) but is rechargeable. If you can afford this camera, the price for the battery should not be a problem.

The PowerShot 600 is intended primarily for business users, such as real estate agents. It's also used by graphic designers and publishing professionals who require high-quality color. The bundled software for editing includes Ulead's PhotoImpact and ImagePals.

Casio QV-10A

Just as we were going to press, Casio announced they were replacing the legendary QV-10A with the QV-11. Nevertheless we did want to talk a little about the QV-11 since it was such an important camera. You still may be able to buy at retail and discount stores. It was one of the smaller digital cameras in both size and weight. It easily fits in your pocket and weighs only 6.7 ounces (without batteries). The camera attaches to any computer serial port and is easy to install.

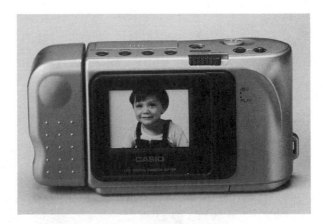

The Casio QV-10A

Casio QV-11

The new Casio QV-11 has a 1.8 inch TFT Active Matrix, low-glare color liquid crystal monitor that doubles as a viewfinder. It lets you view images immediately. You can scroll through all the images that you have stored and selectively delete any image.

Storage capacities and resolution

The camera holds up to 96 images in 2 Meg flash memory. The camera offers only one resolution setting (480 x 240 dpi).

Lens

The lens is a rotatable fixed focal length lens with macro mode and exposure control.

Other information

The QV-11 includes Adobe PhotoDeluxe and other software. The camera definitely will not weigh you down. It weighs a mere 6.7 ounces and is 5.12" x 2.6" x 1.57" in size. The package includes, camera, case, wrist strap and cleaning cloth, four AA batteries and a video cable to connect the camera to a video device, with NTSC video in (TV, VCR, etc.).

51

Casio QV-100

The QV-100 has many of the same features as the QV-10A but is a higher resolution version.

The QV-100 from Casio shares many features with the QV-10A but offers higher resolution

Storage capacities and resolution

Like the other Casio cameras, the QV-100 has two resolutions: fine (640 x 480) and normal (320 x 249). You can store up to 64 fine resolution images or 192 normal resolution images on the QV-100's built-in memory.

Lens

The lens on the QV-100 is equivalent to a 40.5-mm lens on a 35-mm film camera. It offers apertures of f/2.8 and f/16 and shutter speeds from 1/8 to 1/4,000 of a second. The fixed lens focuses from 11cm to infinity. The lens can rotate plus/minus 90 degrees so you can snap pictures from unusual angles.

Other information

A nice feature about the QV-100 is that you can scroll images (forward/reverse) on your monitor. This makes your work a lot easier when it comes time to find the one image you want. You can also copy images from another QV-10A or computer.

The QV-100 includes some nice accessories, too. These include Adobe PhotoDeluxe image editor, hand strap, soft case, video cable, test batteries (4x ΛΛ size batteries), cleaning cloth and more

Casio QV-120

The new Casio QV-120 has a 1.8 inch low-glare color liquid crystal monitor that doubles as a viewfinder. It lets you view images immediately and scroll through all the images that you have stored and selectively delete any image.

Storage capacities and resolution

The QV-120 has both "Fine" and "Normal" resolution modes. You can snap 96 images in normal resolution (320 x 240) or 32 images in fine resolution (640 x 480). The QV-120 features 2 Meg flash memory.

Lens

The lens is a rotatable fixed focal length lens with macro mode and exposure control.

Other information

The QV-120 includes Adobe PhotoDeluxe and other software. The camera definitely will not weigh you down. It weighs a mere 6.7 ounces and is 5.12" x 2.6" x 1.57" in size. The package includes, camera, case, wrist strap and cleaning cloth, four AA batteries and a video cable to connect the camera to a video device, with NTSC video in (TV, VCR, etc.).

Casio QV-300

The QV-300 is Casio's top of the line digital camera. Use its large 2.5 inch LCD screen to view your pictures immediately after you snap them. You can delete unwanted images with a simple touch of a button. Display one, four or nine shots at a time in the camera or on a TV. You can even save images on your computer or to videotape.

The QV-300 is Casio's top of the line digital camera

Storage capacities and resolution

The QV-300 can snap and save an impressive 192 images in Standard Resolution (320 x 240) or 64 images in Fine Resolution (640x480). All images are in 24-bit color. You can snap pictures at either resolution.

Lens

The QV-300 uses a two position focal point lens (47mm for wide angle or 106mm for telephoto) with macro position.

The lens can rotate plus/minus 90 degrees. This lets you snap pictures from unusual angles.

Other information

The QV-300 includes a built-in TFT liquid crystal anti-glare display to give you clear images even outside. This lets you snap pictures without looking through a viewfinder. You can also view your images right after they're shot.

The QV-300 also features built-in 4 Meg flash memory and resolution reduction. This lets you free some memory by reducing any images that are stored in Fine Resolution to Standard Resolution.

The QV-300 also includes some nice accessories. These include Adobe PhotoDeluxe image editor, hand strap, soft case, video cable, test batteries (4x AA size batteries), cleaning cloth and more.

Chinon ES-3000

We've mentioned that you'll notice similarities between this camera, the Dycam 10-C and the Kodak DC50 camera. Chinon makes most of the parts for all these cameras.

Storage capacities and resolution

The biggest difference among the three cameras is that the best resolution of the ES-3000 is only 640 x 480. The ES-3000 includes three resolution settings for capturing images (standard, fine and superfine). However, the fine and superfine settings capture images at the same resolution (640 x 480). The difference between the two is that less compression is applied to superfine images. Nevertheless, it's very difficult to notice any difference in image quality between the two modes. You can snap 40 images at a resolution of 320 x 240 in standard mode, 10 fine mode images and 5 images in superfine mode (640 x 480).

The ES-3000 also has a PC card slot that lets you snap and store more images on a memory card. The card lets you store your pictures on Chinon's own removable memory cards. Chinon offers cards in sizes from 2 Meg to 16 Meg. Unfortunately, these cards are proprietary, so you cannot use other PC cards or use these cards in another camera.

Lens

The Chinon ES-3000 uses a 7-mm to 21-mm zoom lens (equivalent to 35-mm to 114-mm on a 35-mm camera). The lens features an f/2.6 to f/16 aperture. The shutter speed for the camera ranges from 1/16th to 1/500th of a second. Furthermore, the ES-3000 has spot focus, focus lock, macro mode (useful for close, detailed work) and many other focus modes.

Other information

See Chapter 5 for more information on the Chinon ES-3000, which we'll use for a hands-on demonstration of operating a digital camera.

Dycam 10-C

Dycam is an old, familiar name in the digital camera world. One of the first consumer-level digital cameras was made by Dycam. We've mentioned that the Dycam 10-C is a "relative" of the Chinon ES-3000. The 10-C has some advantages over the ES-3000, including better image management software and a lens ring for using different filters and adapters.

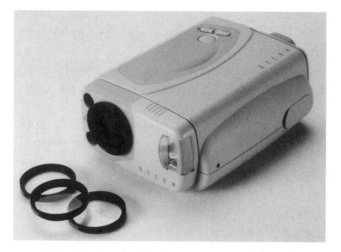

Storage capacities and resolution

Like the ES-3000, the 10-C captures images in standard, fine and superfine resolutions. You can switch between the resolutions with each shot. The camera's 1 Meg of memory can hold forty standard (320 x 240) photos, ten fine (640 x 480) or five superfine (640 x 480, with less compression).

Lens

Dycam offers both wide-angle and macro (close-up) lenses. The 10-C has three focus modes and three flash settings to improve picture quality. The multi-autofocus mode is excellent even if you're shooting several subjects or subjects that are off-center. The spot and macro focus are ideal for close-ups. The close-up lens lets you take pictures as close as 5 inches from your subject.

Other information

The 10-C stores pictures in a proprietary format, so you must transfer the images from the camera to your computer. Then you'll need to convert the images to a more popular format so they can be used with other applications. The images download at the rate of about one and one-third pictures per minute.

The only real concern for many users is the image storage capacity of the 10-C. It can store only five images in its highest quality. However, optional memory storage cards in 2, 4, 8 and 16 Meg capacities are available.

Dycam Model 4

The Model 4 is small enough to put in a large pocket yet strong enough to withstand an accidental drop.

Storage capacities and resolution

The Model 4 captures 24-bit color images in two resolutions (496 x 365 and 248 x 182). Note the resolution levels of the Model 4 are much less than most other digital cameras. You can snap and store 8 to 24 full-sized pictures or 16 to 48 half-sized pictures. The number depends on the image compression you've selected.

The Model 4XL (for about $200 more) quadruples the amount of DRAM. This, in turn, increases the number of images that you can store. However, you must use your PC to change any camera settings (including, unfortunately, the resolution and compression). Also, all images stored in the camera must be deleted before these settings can be changed.

57

Lens

The Model 4's fast shutter speed of 1/2000th of a second is good for freezing motion. Cameras from Apple, Kodak and Logitech often blur fast or moving action. The Model 4 uses a focal length lens equivalent to a 70-mm lens on a 35-mm film camera. So, the resulting images look as if they were snapped with a telephoto image, creating smaller and more tightly cropped pictures.

Other information

The Dycam Model 4 doesn't use an LCD control panel. So, you cannot switch off the flash, see how many shots you've taken or know how much power remains in the battery. Keeping track of the number of shots taken may not always be a problem, but the lack of an indicator is an inconvenience. This is especially true if a long time passes between snapping pictures.

An unusual piece of equipment is the adapter that you must connect to the camera before transferring images or recharging the battery. The Dycam camera uses a volatile 1 Meg of DRAM memory to store the pictures. When the 100-hour charge of the built-in NiCad battery is exhausted, your images are lost—so you better find an electrical outlet within three hours to transfer your images.

Transferring images from the Model 4 to your PC is easy. The Dycam Viewer software included with the camera has a batch download feature that lets you transfer the entire camera's contents onto your hard drive. You can preview small thumbnails of the images before rotating, flipping or resizing them. You also have control over other elements such as sharpness and brightness.

The time required to transfer the images using the least amount of compression is about 90 seconds, which is longer than many cameras. This is in part because the software performs color processing when transferring pictures.

Although its colors are very accurate, the Model 4 stores fewer pictures and takes images at a lower resolution. Also, you'll probably need a good image editor; the images produced usually need more tweaking than those produced by many other cameras.

You may want to consider the Model 4 for low volume, portable photography.

Epson Photo PC

This camera looks and feels like a 35-mm film camera. It's also larger than many digital cameras. However, because the Photo PC has a rubber non-stop grip, it's easy to hold and carry. It's the first consumer-level digital camera with a street price under $500.

Storage capacities and resolution

You can snap 16 high-resolution images (640 x 480) or 32 low-resolution images (320 x 240) with the Photo PC. An optional expandable PhotoSpan memory module ($149 for 2 Meg or $249 for 4 Meg) is available for storing more images. The 2 Meg memory module holds 48 high-resolution or 96 standard images and the 4 Meg memory module increases capacity to 96 high-resolution or 160 standard resolution photos.

Lens

The PhotoPC's autofocus lens lets you focus on subjects as close as 2 feet, though its best range is from a few feet away. It accepts any 37-mm video camcorder lens or filter. Epson includes an order form if you want to order accessories from Tiffen, one of the BIG names in film, video and digital camera accessories. These accessories will let you do macro shots, wide-angle shots and much more.

Other information

The Photo PC also features two flash modes for ranges up to 10 feet. The LCD display shows how many pictures you've snapped and how many pictures remain. It also shows the image quality resolution, flash setting and battery level.

Epson includes its EasyPhoto software for previewing pictures, transferring images and for basic editing tasks. A TWAIN driver is also included, which lets you capture images directly into an image editor (see Chapter 10-14).

59

The Epson PhotoPC may not impress everyone with its image quality. Nevertheless, it offers reliable performance at an affordable price.

Kodak DC20

One of the smallest and most affordable digital cameras available is the Kodak DC20 ("DC," of course, refers to "**D**igital **C**amera"). The pocket-sized DC20 camera combines a film camera's ease of use with a digital camera's advantages.

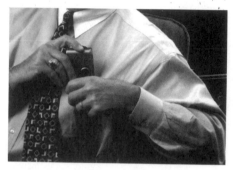

The DC20 definitely is a pocket-sized digital camera

Storage capacities and resolution

The DC20 captures images in two resolution modes. You can snap 8 pictures in high resolution (493 x 373) or 16 pictures in standard resolution (320 x 240). The memory is not upgradable.

Lens

The DC20 uses a fixed-focus lens, so it won't have much versatility. However, keep in mind this is a lower priced ($329) camera.

Other information

The CCD chip's sensitivity, built-in light sensor and automatic white balance feature accurately adjust your picture for most lighting situations. The DC20 cannot tell you how many pictures you have left before its memory is full. This probably won't be much of problem since you have only eight pictures in high-resolution mode anyway. A red warning light does appear, however, when you have three shots remaining.

Consider Kodak's DC20 if you want to try digital photography without spending a fortune. You may just find that you'll have fun in the process.

Kodak DC40

The DC 40 is Kodak's "mid-level" camera. Not only is this hand-held camera versatile and easy to use, but it's affordable for most PC users.

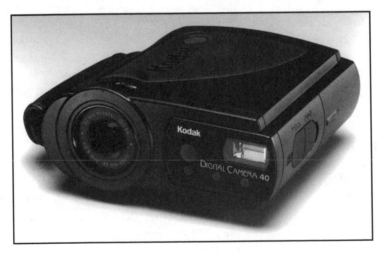

The DC 40 is versatile, easy to use and affordable for most PC users

It's one of the more unconventional looking cameras. The DC40 looks and feels more like binoculars instead of the wide and boxy appearance of the DC50 or the 35-mm camera-like look of the Olympus D200L.

Storage capacities and resolution

Its 4-Meg internal memory is large enough to store 48 high-resolution images (756 x 504) or 99 standard images.

The DC40 can use additional memory cards that you insert into the camera to increase its memory. This increases the number and size (resolution) of the pictures you take.

Lens

The DC40 uses a fixed-focus, non-zoom lens. This lets you capture subjects or objects at distances of four or more feet. Third-party telephoto and wide-angle lenses (i.e., from Tiffen) enhance the built-in 42-mm equivalent lens.

Kodak is now bundling PhotoEnhancer (from PictureWorks) with their cameras. PhotoEnhancer features advanced image editing and correcting tools that are very useful.

Other information

The DC40 combines plug-and-play with point-and-shoot. The controls are easy to use. The camera's four AA lithium batteries are good for about 500 pictures (depending on how often you use the flash and how many images you transfer to a PC). It supports a 5-second cycle time between shots when fresh.

The exposure level on the DC40 gives you some control over how much light enters the camera. This is very useful in tricky lighting situations. The exposure, flash, self-timer and delete controls are at the back of the camera. Use the LCD screen to check their levels.

The DC40 is a good compromise between the DC20 and DC50 Kodak cameras. It's also a much better camera than the similarly priced Apple QuickTake 150.

Kodak DC50

The top of the three Kodak digital cameras is the DC50. It offers great versatility in both taking and using pictures for computer display and output. Because it's fully automatic, taking pictures is very easy.

The DC50 Zoom Camera resembles Chinon's ES-3000 and Dycam's 10-C, but its image quality is much better.

Its 3x zoom lens, close-up mode and built-in flash will let you take virtually any type of your favorite pictures.

Storage capacities and resolution

The DC50 can capture only seven pictures in high resolution, but the good news is that the resolution is 756 x 504 pixels. You can increase the number of high-resolution shots by using a standard Type I or Type II PC card. These cards let you take 24, 48 or 80 pictures in high resolution.

You can also snap 11 standard or 22 low resolution images (and many more with a PC card).

Lens

Not only does the DC50 use an autofocus 3x power zoom lens (from wide angle to telephoto), but you have several other options as well. These include center focus, off-camera focus (for a sharp view of both the main subject/ object and the background) and a macro capability that can get you within 15 inches of the subject.

Other information

The problem with flash units on many digital cameras is that they're located close to the lens, which can result in harsh shadows in your pictures. However, the flash unit on the DC50 is a little different. When you turn on the camera and open the lens, the flash unit moves an inch away from the lens. Although an inch may not seem like much, it nevertheless will give your pictures better coverage and fewer harsh shadows.

Many experts consider the DC50 to be the best digital camera in its class. It's a good choice for home businesses (or what's now being called "SOHO:" Small Office/Home Office) or anyone who needs high-quality images.

Kodak 120

The DC120 features a sleek, lightweight design. The sturdy hand strap makes it easy to carry the camera wherever you go. An on-board, 1.6 inch color display lets you preview 1, 4, or 9 pictures. So you know right away whether you've captured just the right shot, and you can delete the shots you don't want. A separate LCD panel shows you the number of pictures taken, battery status, and much more.

The Kodak 120 features a sleek, lightweight design

Storage capacity and resolution

The resolution for this powerful camera is a very high and impressive 1280 x 960 (or 1.2 million pixels per image). This high quality is achieved through a new CCD image sensor that provides outstanding image quality. You can switch between the four image-quality levels (Uncompressed, Best, Better, Good) at any time.

The DC120 has 2 Meg of internal memory. This is enough for 20 pictures. You can extend storage by using the optional Kodak Digital Science Picture Card. Each removable storage card holds either 2 (21 pictures) or 10 Meg (105 pictures). When a card is filled, remove it, insert another, and keep on shooting.

Lens

The 3x zoom lens is equivalent to 38-114mm on a 35mm camera. It combines telephoto and macro (close-up) capability. Infrared sensors provide auto focusing from 19 inches to infinity. In close-up mode (manual focus) you can move in for detail from 8 inches to 19 inches. The DSC-120 includes a built-in flash unit that is automatically works whenever it's needed (up to 14 feet). An optional flash sync cable is also available that allows connection to an external flash.

Other information

The package includes everything you need to start snapping your pictures: camera, exclusive software, cables, and batteries.

Use the software included with the DCS-120 to transfer all pictures from your camera or Kodak Digital Science Picture Card to your PC. Then you can tweak your images and import them directly into many popular applications

You can upload your DC120 pictures to the Kodak Picture Network (once you become a member) and share them with others over the Internet (limited availability).

Another great thing about owning a DC120 Digital Camera is that you're entitled to download Kodak Digital Science Picture Postcard Software for free!

Olympus D-200L

The D-200L looks, feels and operates like a conventional Olympus point-and-shoot camera. Olympus wanted to make it as user friendly as possible. So it has the same basic feel as a typical 35-mm autofocus camera. This is a big advantage if you're coming from 35-mm camera with no experience using a digital camera.

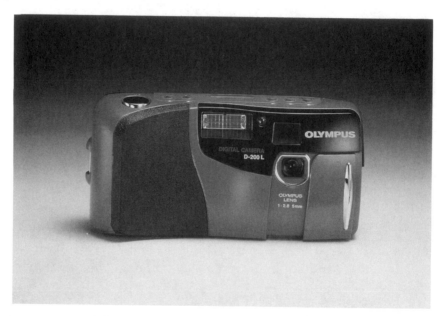

Storage capacities and resolution

The Olympus D-200L captures 20 high resolution images or 80 standard-quality images (either 640 x 480).

Lens

The lens is an f/2.8 wide-angle macro lens that will be focus-free from 2.5 feet to infinity. It's equivalent to a 36-mm focal length lens. The automatic flash includes "Red-Eye" reducing flash to reduce the dreaded red-eye

Other information

You can erase one image or all images at one time. The built-in automatic flash offers several shooting modes (including red-eye reduction).

The viewfinder on the D-200L "doubles" as a viewer so you can see up to nine images simultaneously. This lets you review several full-color images at one time. This is a big advantage if you're new to digital photography; you'll know immediately if the image was focused and composed correctly.

The D-200L uses 4 AA Alkaline, NiCad or Lithium batteries. Battery life depends on how often you use the flash and if you use the LCD display to view or review. Olympus recommends using lithium AA batteries. You should be able to snap over 400 images (depending on how often you use the flash) on a set of batteries. An optional AC adapter is available.

The D-200L is bundled with PhotoDeluxe from Adobe. It has won many awards, including Product of the Year 1996 and "Hot Pick" by *InfoWorld* and Best Buy Award in March 1997 from *PC World*.

Olympus D-300L

This is the first consumer level digital camera with almost 800,000 pixel images in 24-bit color. The D-300L is similar to the D-200L in size (2.8 x 5.7 x 1.8 inches and weighing just under 12 ounces without batteries).

Storage capacities and resolution

A big difference from the D-200L is the D-300L has 6 Meg of memory built-in. This is enough room for either 30 high-resolution (1024 x 768) or 120 standard resolution images (512 x 384) in 24-bit color.

Lens

Another difference is the D-300L has autofocus capabilities. It uses an Olympus f2.8 lens, autofocus and automatic flash. The automatic flash has four modes and autofocus. The macro mode lets you take pictures as close as 7.9 inches from your subject. The 36-mm focal length lens is similar to conventional 35-mm cameras.

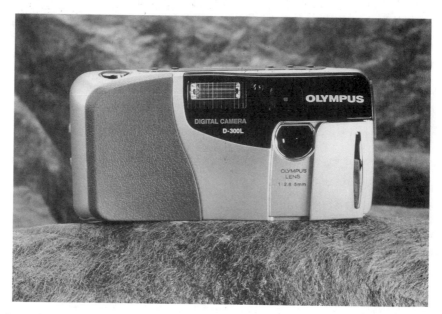

Other information

The D-300L uses an LCD screen as both a viewfinder and image viewer for quick preview and review of photos. The LCD also displays various functions and status.

The LCD panel will function as a live viewfinder while the lens is uncovered. When the lens is covered, the LCD will become an image viewer, displaying nine thumbnails at a time. You can then view images and erase them individually or all at once.

The D-300L has already won many awards (including *Imaging* magazine's editors Choice Award and *Byte* magazine's User's Choice Award).

68

Polaroid PDC-2000

Well, we won't end the chapter without talking about one higher priced digital camera. The PDC-2000 is that camera and Polaroid's first digital camera. It's also the first professional-quality digital camera that's as easy to use as a fully automatic hand-held camera.

Storage capacities and resolution

The PDC-2000 has the highest resolution of the cameras we talk about in this chapter. An image can be either high resolution (800 x 600) or super high resolution (1,600 x 1,200). The file size is also correspondingly large—about 5.6 Meg for one super-high-resolution image.

Polaroid has three models available for the PDC-2000, differentiated by the number of images each stores. The PDC-2000/40 stores 40 images on the camera's internal hard drive. The PDC-2000/60 stores 60 images in memory. However, neither of the built-in storage options is removable. The only way to transfer images from the camera is to connect it to your PC. The PDC-2000/T is tethered to your PC for direct camera-to-computer image storage.

Lens

The PDC-2000 is a range finder-type autofocus, autoexposure point-and-shoot digital camera. It features a fixed 11-mm f/2.8 glass lens. This is the same as a 38-mm focal length on a 35-mm camera. A 60-mm-equivalent lens is available as an optional accessory. The focus range is 10 inches to infinity.

Other information

Four rechargeable AA NiCad (nickel-cadmium) batteries supply the power for the PDC-2000. The batteries should last for about 150 pictures on one charge.

OK, the PDC-2000 costs more than other cameras in this chapter; it's also a breakthrough in image quality for its price. It delivers images that rival cameras costing over three times as much. The images may require only minor adjustments for contrast and color balance. If you want the quality of a higher priced camera but without the cost, consider the PDC-2000.

Sony DSC-FI

The DSC-F1 digital camera is about the size of a Sony Walkman. The DSC-F1 is the first digital camera with an internal infrared connection that allows you to wirelessly transfer images to a PC or printer with IrDA capability.

A Quick Look At Some Of Today's Popular Digital Cameras			
Manufacturer	web site	Max Resolution	Storage capacity
Agfa ePhoto 307	www.agfa.com	640 x 480	36/72
Apple Quick Take 150	www.apple.com	640 x 480	16/32
Canon PowerShot 600	www.powershot.com	832 x 608	6/12
CASIO QV100	www.casio.com	640 x 480	64/192
CASIO QV300	www.casio.com	640 x 480	64/192
Chinon ES-3000	www.chinon.com	640X480	5/10/40
Dycam 10-C	www.dycam.com	640x480	5/10/40
Dycam Model 4	www.dycam.com	496 x 365	8/24 or 16/48
Epson Photo PC	www.epson.com	640 x 480	16/32
Kodak DC20	www.kodak.com	493 x 373	8/16
Kodak DC 40	www.kodak.com	756 x 504	48
Kodak DC 50	www.kodak.com	756 x 504	5/40
Kodak DC-120	www.kodak.com	1280 x 960	2/7/12/20
Olympus D-200L	www.olympus.com	640 x 480	20/80
Olympus D-300L	www.olympus.com	1024 x 768	30/120
Polaroid PDC-2000	www.polariod.com	1600x1200	0 (tethered)
Ricoh RDC-1	www.ricoh.com	768 x 576	246/492
Sony DSC-FI	www.sony.com	640 x 480	108

This table is as accurate to our best knowledge but please check the manufacturers web site for more information. Prices, features and even models can change without notice. Also check their websites for other cameras that they may manufacture.

Storage capacities and resolution

A nice feature on this camera is that pictures are stored as JPEG format, so you probably won't need to convert the images to a file your PC can understand. (Other digital cameras use their own proprietary formats.)

The DSC-1 has three modes from which you can select. However, all images are 640 x 480 regardless of the resolution mode you select. The number of images you can store in the camera's unusually large built-in 4-Meg memory depends on which level of compression you use.

Focus/range	Lens (35-mm equiv)	Internal memory	Typical prices
24 inches to infinity	43-mm/fixed	2 Meg	299.00
48 inches to infinity	50-mm/fixed	I Meg	599.00
16 inches to infinity	50-mm	I Meg	949.00
I I cm to infinity	40.5-mm	4 Meg	600.00
11 cm to infinity	47-mm to 106-mm	4 Meg	650.00
20 inches to infinity	35-mm to 114mm 3x power zoom/automatic	I Meg	999.00
19 inches to infiinity	38-mm to 114mm 3x power zoom/automatic	I Meg	795.00
48 inches to infinity	70-mm/fixed	I Meg	795.00
24 Inches to Infinity	43-mm/fixed	I Meg	399.00
48 inches to infinity	42-mm/fixed	I Meg	329.00
48 inches to infinity	42-mm/fixed	I Meg	699.00
19 inches to infinity	38-mm to 114mm 3x power zoom/automatic	I meg	999.00
28 inches to infinity	38-mm to 114-mm	2 Meg	985.00
29.5 inches to infinity	36-mm/fixed	2 Meg	599.00
29.5 inches to infinity	36-mm/automatic	6 Meg	899.00
10 inches to infinity	38-mm	n/a (tethered)	2995.00
I cm to infinity	4.5-mm to 45-mm	mini-cassette	1599.00
20 inches to infinity	35-mm	4 Meg	850.00

Use fine mode to store 30 images or standard mode to store 58 images. If you're not too concerned about image quality and want to snap more pictures instead, use the snapshot mode, under which 108 images can be stored.

Lens

The lens (and the flash) on the DSC-F1 is different than that on most digital cameras because it can rotate 180 degrees. In other words, you can point the lens straight, up or in back of the camera to snap your picture. A macro mode is available so you can capture images as close as three inches away. In manual exposure mode, you can adjust the aperture plus or minus two stops. You can also set the shutter speed from 1/8 to 1/1000 of a second.

Other information

Among other features, the Sony camera includes an infrared transmitter so you can transfer images to your PC without using a cable. A cable can be used, however, if your PC cannot use the infrared transmitter.

You can also transfer images back to the camera from a PC. This lets the camera be used as a portable presentation device. For example, a sales representative can take the camera out of his/her coat pocket, plug it into a TV and display full-screen images, charts and presentation documents from the camera.

Although the DSC-F1 is primarily for business and graphics users, it can be used for many applications, including corporate presentations, multimedia production and Web development.

Get Creative: Digital Photography Tips

Chapter 4

Get Creative: Digital Photography Tips

Select the right tools

When to shoot

Check the batteries

Use a fast PC

Get close

Hold the camera steady

Predict and be prepared

Go crazy

Flash hints

Remember, there's no film developing

Try a new angle or vantage point

Take a variety of pictures

One of the things that makes a vacation worthwhile is bragging to your friends and coworkers about it. You will, of course, need pictures to back up some of your wilder claims. However, you'll need to know how to take the best possible pictures using your digital camera; otherwise, the images may not be what you expect.

There's really no secret to using a digital camera successfully. Most of the basic tips you'll find about how to use a 35-mm camera also apply to using a digital camera. In this chapter we'll give you specific suggestions on how to use your digital camera. Keep in mind that we could fill an entire book with photography tips and tricks. If you want more basic tips, check with your local library or bookstore for a book on basic photography.

Most of the basic tips you'll find about how to use a 35-mm camera also apply to using a digital camera

The first tip we'll give you is learn to work within the limitations of your digital camera. If you cannot learn to do that then many of your images may not turn out good and you may lose that one perfect picture for which you've been waiting.

> We did not use Adobe Photoshop or other image editor to tweak any of the photos that you see in this Chapter. These are the original "unretouched" images snapped with the Chinon ES-3000 camera.

Select the right tools

Start by choosing the appropriate combination of tools for the job. You may be able to rent a digital camera from a computer retailer or a photography shop if you're not sure where to start or if a digital camera is even the right tool. Kinko's copy centers are another possible source if you're interested in renting a digital camera. If the rental price is affordable, maybe rent more than one type of digital camera. Then you can experiment with different cameras and quickly gain valuable experience, not only for the particular equipment that interests you, but also for digital imaging in general.

When to shoot

You may not realize it but there are better times during the day to snap pictures. Lighting is not equal at all times of the day (remember, digital cameras depend a lot on light). Too much sunlight, such as at noon or early afternoon, will produce glare and dark shadows on your images.

The best times to take outdoor pictures is usually early in the morning (two or three hours after sunrise) or late in the day (two or three hours before sunset). The light is softer, warmer and more favorable for both people and landscapes at those times.

The light is more favorable early in the morning or late in the day

Check the batteries

Check the batteries in your digital camera at least once every 6 months (see the owners manual for more specific information). You don't want to miss that once-in-a-lifetime picture because of low battery power.

If you're not using a PC equipped with a 486 or faster processor, you may want to consider using conventional photography and a scanner instead. See Chapters 6-9 for information on scanners.

Use a fast PC

We've mentioned many times how big the files can be in digital imaging. A large-capacity hard drive is only part of your hardware considerations. You'll also need a fast PC to process the images. The minimum is a PC with a 486 processor, but we recommend at least a Pentium-class processor.

Get close

Get as close as possible to your subject; this is especially true for frame portraits. Disable the flash (if lighting permits) to avoid pale-face. Try to shoot in daylight, especially in late afternoon, but avoid direct sunlight.

If you're working with artificial light, keep the background slightly darker than the subject's face. However, don't keep it so dark that the automatic-exposure setting in the camera tries to compensate for it. Otherwise, your subject's face will wash out.

Keep in mind that while you can use an image editor later to adjust lighting and color, it's better to start with the best shot you can get.

Get as close as possible to your subject
when using a digital camera

What you see in the viewfinder is likely to be what's in the picture. Check around the border area of the viewfinder. Get closer (or use the zoom lens if you're camera has one) if your subject doesn't fill the frame. Sometimes the camera may be too far from you. If so, you cannot see the borders of the viewfinder; move the camera closer to your eye.

78

Hold the camera steady

An easy way to eliminate blurry pictures is to keep a firm grip on the camera. Also, your digital camera won't immediately click the shutter when you push the button. A lag time, called the *cycle time*, is needed for digital cameras to calculate lighting and focus requirements. So hold the camera very steady as you snap a picture. We recommend using a tripod if one is available. The small digital camera may look a little funny sitting on top of a tripod, but it's an effective technique. Also, if you're taking pictures of people, tell your subjects to hold their poses and stay still until the flash goes off or the camera is ready for the next shot.

Keep a firm grip on the camera to eliminate blurry pictures like this

Hold the camera firmly with your right hand. When you're ready to snap the picture, use your right forefinger to press the shutter release button. Steady the camera further by using your left hand to grip the lower-left corner of the camera.

Predict and be prepared

If you're looking for candid, action or other "unexpected" shots, make certain you can anticipate the action. The best photographers can guess or even predict what action will occur next.

79

*Anticipate the action if you're looking for candid,
action or other "unexpected" shots*

Also, you'll find out that you may have only one chance to capture the ideal picture. Be ready; click the shutter as soon as you see something happen. Then get ready as fast as you can because you never know when another good picture will present itself.

Go crazy

Although we mentioned at the top of the chapter that basic 35-mm photography tips also apply to digital cameras, try not to consider your digital camera as just another 35-mm camera. The next time you have a party, put your digital camera out on the table. (Make certain you trust everyone at the party—you don't want someone walking off with your camera.) Tell your partying guests to take all the pictures they want, candid or otherwise. You'll probably be surprised at the different types of pictures when you transfer the images to your PC.

Have fun using your digital camera...
experiment with the camera, subjects and the images you've snapped

Don't just *try* to have fun—*do* have fun! If you're having fun while using your digital camera, the quality of your pictures will show it. Don't be afraid to experiment with the camera or the images you've snapped. Use image editors creatively, too (see Chapters 10-14 for information on image editors). Learn the tricks and quirks of taking images snapped with your digital camera and tweaking them with an image editor.

If possible, use one of the image editors we talk about in Chapters 10-14. You'll be able to combine parts of different images, change colors and draw in objects or text. You'll probably discover the only limitation will be your imagination.

Flash hints

Too many users believe that nighttime or indoors is the only time to use the flash on a camera. However, using a flash during daylight can help eliminate some of the problems caused by backlighting and dark shadows. Always remember (again) that proper lighting is important when snapping pictures with a digital camera.

It's also very important to remember that the built-in flash has no "carrying power." In other words, the flash is only designed for close-in illumination of the subject and is not generally effective past 9 or 10 feet. This is true for all cameras, both film and digital. For example, you've probably seen flashbulbs popping off from all over the stadium at the Super Bowl or other events. However, trying to use a flash unit to light a football field from dozens of feet away is simply wasting a flash and maybe losing the picture. Using a flash from that distance will not affect the picture because the flash has no carrying power beyond a few feet.

Check your users manual for more information on the carrying power of the flash unit. The owners manual may also include suggestions on when to use the flash unit.

Remember, there's no film developing

You don't have to worry about film developing costs with digital cameras so why are you hesitating to snap pictures? We recommend that you go wild and snap pictures as if your life were in the balance. As you take more pictures, you'll become more familiar with your camera and will become a better photographer.

Also, by snapping more pictures, you'll increase your chances of getting better pictures. Human emotions can be elusive to capture with a camera so keep taking pictures of your children, coworkers and friends. You'll discover the best way to capture one of these types of pictures is to shoot quickly and often. Perhaps many images won't turn out too well, but maybe you'll get that one picture you'll always treasure.

Try a new angle or vantage point

Consider a different angle or viewpoint when shooting a subject; the first angle or viewpoint from which you're shooting may not be the best. A picture may look a lot better if you simply snap it from a different angle a few feet away. Walk around the subject or, if possible, look up or down at the subject. In other words, experiment with many visual possibilities. Find a stronger foreground or a less cluttered background, different colors and lines, better light on the subject or an unusual angle.

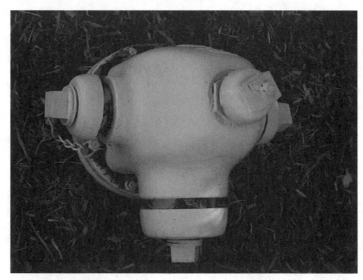

Always consider a different angle or viewpoint when shooting

Take a variety of pictures

Don't simply take all nature pictures or all people pictures. Add some variety to your digital photo album. Then people will be more interested in looking through the album. If you're taking some posed pictures, stop for awhile and take some candid shots as well. This technique is especially effective at birthday parties, reunions, etc. Turn the camera vertical instead of the normal horizontal and snap some pictures. Combine close-up shots with panoramic views. You'll discover the best way to capture moments is to include several views.

Add some variety to your digital photo album

Having Fun With A Camera & Your PC

Chapter 5

Having Fun With A Camera & Your PC

In this chapter we'll show you how easy it is to use one of today's popular digital cameras. We're using the Chinon ES-3000 here and the information is specifically for the ES-3000. However, most of what we discuss is typical for many other digital cameras, too.

In the first part of this chapter we'll talk about using the Chinon itself. This includes how to hold the camera, which buttons to push and more. The second part of this chapter talks about transferring the images from the camera to your PC.

Unfortunately we can't explain all aspects of using the ES-3000 (or any other digital camera) in one small chapter. So we will leave out topics that are very specific to the Chinon (for example, the LCD Indicator Panel). We will, however, show you how to transfer pictures from the camera to your PC. Transferring images is done about the same way with any digital camera. We'll also give some tips on using the camera.

We did not use Adobe Photoshop or other image editor to tweak any of the photos that you see in this Chapter. These are the original "unretouched" images snapped with the Chinon ES-3000 camera.

What's in the box

Like most digital cameras, the ES-3000 is all set to be used right from the box. In other words, you can use it immediately because everything you need is in the package, which includes:

➤ ES-3000 digital camera

➤ Four AA batteries

➤ Connecting cable to plug into your PC's port 1

➤ Software to transfer the images that you've taken

Chinon also includes a TWAIN driver that lets you send images directly into an image editor or other program.

Optional items you should consider for any digital camera include an AC adapter and additional memory card(s). The AC adapter may pay for itself by saving you a small fortune in battery costs, especially when transferring images from the camera to your PC.

Using The ES-3000

The following tips on using the ES-3000 are intentionally very general. We could go into great detail on which is the best angle for a specific shot or which level of zoom to use. However, that really would require an entire book on just digital photography. So our main advice in using this or any other digital camera is to experiment. You'll need to experiment with different lighting and graphic resolution settings to get the "feel" of the camera. Remember, this is an advantage of using a digital camera. You don't need to worry about film and development costs when experimenting with different settings and lighting situations.

After using the camera for a while, we found the best "people" shots were with a subject 2 to 6 feet away and in normal lighting. Normal light in this case is outdoors on a sunny day or in an office with good lighting.

Zoom settings

The Chinon uses three zoom settings. These levels are set by pressing the appropriate button on top of the camera, near the shutter button. This makes it easy for you to zoom in or out and snap your picture. Press the T-button to zoom in (think of telephoto) or the W-button to zoom out (think of wide-angle). You can see the zoom levels change in the viewfinder just as you would using a typical 35-mm film camera.

Holding the camera

You can hold the ES-3000 vertically or horizontally when snapping your pictures. One note of caution when holding the camera vertically: Your photos will appear sideways after you transfer the image to your PC.

However, you can always use your favorite image editor and rotate the image to a normal orientation. Hold the camera with two hands, one on each side of the camera. Slide your right hand under the wrist strap on the right side of the camera, making sure your fingers do not cover any part of the flash unit or camera lens.

If you don't have access to a tripod, try tucking your elbows into your sides. This may help give enough support and minimize camera shake.

Make certain to hold the camera steady when snapping your photos. It needs some time to determine the lighting and focus requirements. If you cannot hold the camera steady, use a tripod. The Chinon ES-3000 has a mounting socket on its bottom for mounting it to a tripod. (It may look a little curious having a small digital camera attached to a tripod, but it works.)

If you're trying to snap a "people" picture, tell them to remain still even after you push the button. They should not move until the flash goes off or you tell them they can move.

Snapping the picture

When you're ready to snap your picture, look through the viewfinder and note the small round object. This is the AF Target mark; make certain it's centered on your subject. Move close to your subject if you're taking a portrait shot. Now try your first shot without the flash. Avoid direct sun if you're shooting in daylight. Late afternoon offers great opportunities for outdoor shots. The warm tones of late afternoon light are especially good. If you're working with artificial light, keep the background slightly darker than the subject's face, but don't make it too dark or the automatic-exposure setting in the camera may compensate for it. Although you can use an image editor to tweak the image, it's always better to start with the best shot you can get.

Press the Shutter halfway down to automatically adjust the focus. When focusing is complete, the green AF LED light to the right of the viewfinder eyepiece will shine.

Gently press the shutter all the way down to take a picture, then gently release it. Once you release the shutter, hold the camera still until the AF LED begins to flash. This means the Chinon is processing the image.

The Picture counter on the LCD indicator panel will also flash. When it stops flashing, the new number shows how many pictures are left in memory.

Transferring images to your PC

OK, so you've snapped so many pictures that your ES-3000 cannot store one more image. It's now time to transfer the images from the camera to your PC (the terms *transfer* and *download* are interchangeable in this context). We've mentioned many times that the images produced by a digital camera can require a lot of hard drive space. So before transferring the images from the camera to your PC, make certain you have enough room on your hard drive.

To transfer the images from the camera to your PC, you'll need to use the Image Acquisition Utility (IAU). This utility, included with the Chinon ES-3000, is on the installation diskettes. Once the IAU is installed and you've connected the camera to your computer, you can start the IAU.

When you start the IAU, *thumbnail images* are copied and transferred from the ES-3000 to your PC. Thumbnail images are simply low-resolution versions of your pictures. Since they're smaller in file size and resolution, thumbnails transfer to your PC faster than the actual image. They also let you preview the pictures. Then you can decide which images to transfer to your PC and which to dump, which can save you time and hard drive space.

The following are the steps involved in transferring images from the camera to your PC:

Move the protective slide cover to turn on the camera. Take a look at the LCD Indicator Panel. You should see a rotating pattern appear there. This indicates that the camera and the PC are properly connected.

How you start the IAU depends on how you installed it. One way is to double-click the IAU icon. The second way is to select the **Start/Programs/Chinon ES-3000/Chinon ES-3000 Electronic Still Camera** command. If you've connected the camera and your PC properly, you should soon see the following screen:

You should soon see this screen if everything is connected properly

If a problem develops or if you didn't connect the camera properly with your PC, an error message will appear on your screen. This is an example of a common error message:

This error message probably means the camera
isn't switched on or it's not connected properly to your PC

If you see this error message, double-check the connections between the camera and the PC. Make certain the camera is turned on and the AC adapter is plugged in correctly.

After you see the "Connecting to camera" message, you'll see the following screen appear briefly:

If everything is connected right, you should soon see the thumbnail images being loaded (retrieved).

The software is downloading (or retrieving) the thumbnails

However, you don't always need to display the thumbnails. Press and hold the (Shift) key as the IAU is loading. This will stop the transfer of the thumbnails and will display the IAU Main Panel.

Thumbnail images that were successfully transferred appear in the Images area of the Main Panel (near the bottom).

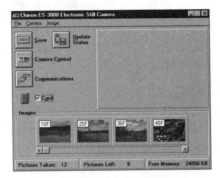

The IAU Main Panel and loaded thumbnails

If you need to view or transfer more images, use the scroll bar located near the bottom of the window. Click the arrow on either side to scroll through additional thumbnail images.

93

*Click the arrow on either side to scroll
through additional thumbnail images.*

The Main Panel shows other important information, too. For example, at the bottom it shows the number of pictures taken (12 in this example) and pictures left (9). It also shows the available space remaining on your hard drive (24056K in this example). This information will change as you use your camera or hard drive, so it's important to keep track of this information.

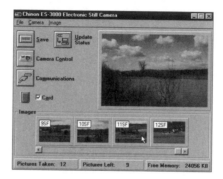

Besides the thumbnails, you've probably also noticed the different icons on the left side of the Main Panel. These five icons let you:

➤ Save
Save images to your PC's hard drive

➤ Camera Control
Control the camera from your PC

➤ Communications
Set the port through which your PC will communicate with the camera

➤ Card
Access images on a flash memory card or SRAM memory card.

94

➤ Update Status
 Click this button to see information about the camera and its current
 settings.

Viewing pictures

The Main Panel shows only the first four thumbnails of the images you've
taken. This is true regardless of the number of pictures you've snapped
(unless, of course, you've taken less than four pictures). Use the scroll bar as
we mentioned above to move through the images if you've snapped more
than four pictures. The mouse pointer in the following illustration is on the
right arrow to scroll in that direction and the IAU is retrieving thumbnail #7.

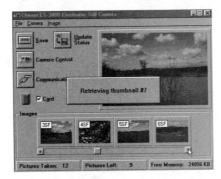

Click the right arrow to scroll in that direction and view more thumbnails

To see the "real" image you must load a thumbnail into the Viewing Area. To
do this, move the mouse pointer to the thumbnail you want to view. In the
example below, we're selecting thumbnail 11SF.

Selecting a specific thumbnail to view
(#11 in this case)

Click the left mouse button one time while the mouse pointer is on the desired thumbnail. This will open the Retrieving Image dialog box. The program will need a few seconds to read and decode the thumbnail into the Viewing Area. You can watch the progress of the reading and decoding in the Retrieving Image dialog box.

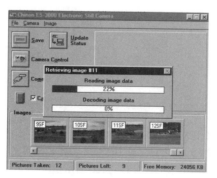

Reading and decoding image data for image #11

In a few seconds the Retrieving Image dialog box will disappear and you'll see the image in the Viewing Area.

96

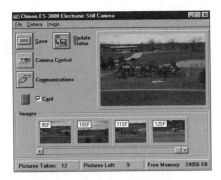

Image #11 now appears in the Viewing Area

Double-click anywhere inside the Viewing Area if you want to see it as a full-screen image.

*Double-click anywhere inside the Viewing Area
to see a full-screen version of the image*

Click the close box in the upper-right corner to return to the Main Panel.

Finding information on an image

You can find important information about any image that appears as a thumbnail. Move the mouse pointer to the thumbnail of which you'd like more information and click the right mouse button to open the Picture Information dialog box.

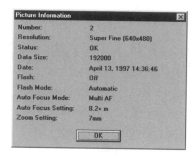

*The Picture Information window shows important
information about the images*

You can get a lot of useful information from this dialog box, including date, zoom setting, resolution, file size and more.

The 24-bit color images from the Chinon give you excellent images to import into your documents. We've included several on the companion CD-ROM. You'll find the image editor that came with the Chinon ES-3000 is good for some basic work. This is true with most digital cameras and their bundled image editors. Therefore, we recommend using another image editor to "tweak" the images instead. See Chapters 10-14 for more information on image editors.

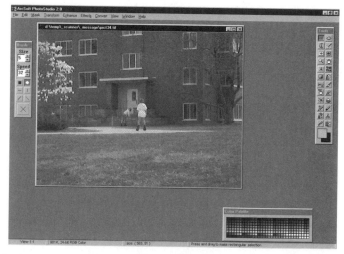

An image snapped with the Chinon and loaded into PhotoStudio

Saving images

We've shown you how to open an image or images. However, the images are still in the memory of the ES-3000. So, even at this point if you were to press the camera's Erase button, all the images would be lost. You must transfer the images from the camera to the PC so you can save them on the hard drive. Then you'll be ready to snap some more pictures.

The ES-3000 offers two ways to transfer images to a hard drive.

Save icon

The Main Panel lets you transfer images to your PC's hard drive using the Save icon. The first step is to open an image. As we did above, click on the thumbnail image you want to open. The IAU will read and decode the image and load it into the Viewing Area. For example, we've loaded picture 2SF in the following illustration:

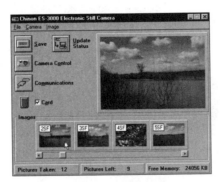

1. Click the Save icon on the Main Panel

2. This opens the Save Image Dialog box. Select a subdirectory or folder where you want to store the image. In our example, we're using the Chinon subdirectory on the C: drive (\ES-3000).

*Selecting the Chinon subdirectory on the
C: drive (\ES-3000) for the destination directory*

3. The next step is to type in a name for the image. Use the familiar
 Windows naming conventions here. We're calling our picture "Pond"
 in this example.

Using "POND" as the filename for our image

4. Now we must select a format type. The ES-3000
 uses the DCT file format to store pictures in its
 internal memory. You can also store pictures on
 your hard drive in DCT format. The advantage

 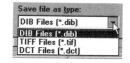

 of this is speed. You may save some time using this format since no
 decoding time is needed to perform file format translation.

 The default format type is DIB (Device Independent Bitmap), a
 standard Windows graphics format. The third file type is probably
 more familiar to you. TIFF is one of the most popular formats and one
 that you can use with many applications.

 We're using TIFF in our example. It may take a little longer, but the
 file probably will have to be converted later anyway. However, if you
 don't have an AC adapter you may want to select the fastest file
 extension (DCT in this case). This will help save your battery power.

You'll probably need to use a conversion program to convert the file to another format, but that's better than having the batteries running low on power just as you want to snap a picture.

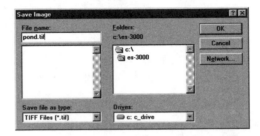

Selecting "TIF Files (.tif) as the file format for our image*

5. Click the OK button to save the picture to your hard drive.

Now you can load the image into an image editor for more tweaking!

Save Menu Commands

The second way of storing images is to use the pull-down menus to save pictures to your computer's hard drive. The **File** menu lets you save a selected image or all the images stored in the camera or on a memory card.

Selecting the **Save Selected Image** command lets you save the image in the Viewing Area to your hard drive. This command opens the same Save Image dialog box that we talked about above.

Select the **Save All Images** command if you want to save all the images stored in the camera's memory or on a memory card inserted in your camera. They'll be saved as a group on your hard drive. Selecting this command opens the Save All Images dialog box.

*The Save All Images dialog box lets you
save all the images at one time*

As with the Save Image dialog box, simply select a subdirectory or folder and
the image format and type in a name for the group of pictures. Then click the
Save button. This saves the pictures on your hard drive in a numbered
sequence under the group name that you entered.

Summary

We hope this short chapter has given you some idea of what it's like
using a digital camera. Once the images have been transferred to your
hard drive you can use an image editor and tweak them as necessary. See
Chapters 10-14 for more information on image editors.

The companion CD-ROM includes several "unretouched" examples of photos
that were taken with the ES-3000. We've included these on the companion
CD-ROM so you'll have a better idea of what photos from a good digital
camera will look like.

Part 2

Scanners

The Second Frame: Introducing Scanners

Chapter 6

The Second Frame: Introducing Scanners

Scanner Basics: Hey How Do They Work

Important Scanner Terms

Bit-depth

Single pass or three pass

Resolution

TWAIN-compliant

OCR software

Scanner Types

Hand-held scanner

Photo scanner

Flatbed scanner

Sheet-fed scanners

M aybe you've had one or more of the following happen to you:

➤ Your children spent time creating a special drawing or other artwork only to have it accidentally lost, damaged or misplaced.

➤ You realized that your vacation pictures were interesting for a while but are now stored, forgotten, in boxes in the closet.

➤ You've discovered that important legal papers and other documents were misplaced or lost.

➤ Insurance agents are asking for proof of ownership for a valuable collection that was lost in a fire or through theft.

Maybe you've wondered if it were possible to have copies of these mementos and important documents in case the originals were lost or destroyed. It is possible-if you have a scanner. What can you do with a scanner? Use a scanner to turn artwork, important documents, photographs and countless other items into digital files. Then you can store the files safely on your hard drive, floppy diskettes or other storage device until you need them.

You can still proudly show off your children's drawings on the refrigerator door as you've always done. However, by using a scanner, you can show off the same artwork on the Internet. Instead of simply putting vacation pictures in forgotten boxes, showcase your vacation photos in electronic greeting

cards, homemade calendars or create a magazine cover. Use a scanner to scan your birth certificate, mortgage, insurance papers, etc. Then you won't have to search frantically for the important documents. Instead, call up the scanned image on your PC.

Scanners have recently become a popular way to import or load images into a PC. Don't panic...buying a scanner isn't likely to put a crimp in your budget. Several color scanners are available for under $500. Furthermore, as with computers, scanner prices continue to tumble while features continue to become more powerful. See Chapter 8 for information on specific scanners and their features and prices.

Scanner Basics: Hey How Do They Work

Before we talk more about scanners, we need to talk about how a scanner works. Although many types of scanners are available, we're usually talking about *flatbed scanners* in this section. Flatbed scanners are the most versatile and probably most widely used type of scanner. See the "Scanner Types" section for information on the specific types of scanners, including the flatbed scanner.

We don't want to become involved with the "mechanics" of how a scanner works. Instead, we'll give some general information. You're probably more interested in knowing that a scanner *will work* than in *how* it does work. Therefore, a simple way to describe how a scanner works is to say it converts light into digits (1s and 0s) that your PC understands. This simple description applies to all types of scanners. A scanner really isn't much different from a photocopier. However, instead of printing a copy to a sheet of paper, the scanner stores the "copy" of the image you scanned. You can then save the image as a file on your hard drive.

To scan an object, scanners use several thousand CCDs (charge coupled devices) as their "eyes.". These tiny components convert the amount of light received into electrical impulses. The strength of those impulses depends on the intensity of light that strikes them. They send that information to your PC. Since your PC can only understand whole numbers (integers), the impulses are translated from analog to digital. The pictures are then stored as groups of integers.

To capture a whole image, the scanner divides the image into a grid and uses a row of eyes (called the scanhead) to record how much light is reflected in each location. When the computer has the necessary data, a file representing the image in digital form is created.

Each of the cells in the grid is called a *picture element*, or *pixel*. Each pixel contains either one color or one shade of gray. The entire picture is completed only when the pixels are all combined. Scanners differ primarily in two ways:

1. How many pixels they can measure (called *resolution*).

2. How the actual scanning process occurs.

For more information, see the "Important Scanner Terminology" section.

The color (and its intensity) in each pixel is determined in one or more bits of data. The number of bits refers to the number of colors each pixel can contain. The most common are one-bit, 8-bit and 24-bit. A 1-bit scanner is the most basic type of scanner because it only records black and white. Each bit is able to express two values (either "on" or "off").

Most color scanners today are at least 24-bit because they collect 8 bits of information about each of the three primary scanning colors (red, blue and green). See "Bit-depth" in the "Important Scanner Terminology" section for more information.

Scanners, like digital cameras, depend on a quality light source

As we mentioned, scanners capture image data by reading light that's been reflected off, or passed through, the item being scanned. Therefore, the quality of the light source can determine the quality of the resulting scan. The first desktop scanners used fluorescent bulbs as light sources. However, these lights emitted consistent white light for only a short time. Also, they released enough heat to affect other parts of the scanner. Most quality scanners now use a "cold-cathode" bulb. These bulbs produce whiter and more consistent light but produce less heat compared to the fluorescent bulbs.

Optics

A scanner uses prisms, lenses and other optical parts to direct light from the bulb to the CCDs. These optical parts can vary in quality. A high-quality scanner uses high-quality glass optics that are color-corrected and coated for minimum diffusion. However, some lower priced scanners use plastic components to keep costs down.

Flatbed scanners use several methods of reading light values with CCDs. In the next section ("Important Scanner Terminology") we'll mention how the first generation of scanners used the three-pass method. In this method, one CCD read each of the primary scanning colors (red, blue and green) separately. Most of today's flatbed scanners, however, use a single pass method with either a beam splitter or coated CCDs.

The ADC (Analog-to-Digital Converter) is an important part of any scanner. It's responsible for changing, i.e., converting, the analog signals from the CCDs into digital data that your PC can understand.

The location of the ADC inside the scanner can be important. Electrical interference and other "noise" can affect the work of the ADC. So, the ADC on higher quality scanners processes data farther from the main circuitry of the scanner. Although this helps prevent interference, it also increases the manufacturing cost of the scanner. This is why many lower cost scanners use ADCs that are built into, or integrated with, the scanners' primary circuit board.

When a beam splitter is used, light passes through a prism and separates into the three primary scanning colors. Each color is read by a different CCD. This is generally considered the best way to process reflected light. However, to hold down costs, many manufacturers use three CCDs.

Because a film coats each of these CCDs, it reads only one of the primary scanning colors from an unsplit beam. This second method, although technically inaccurate, normally produces results that are very similar to those of a scanner with a beam splitter.

Color scanning usually requires three separate scanning passes: one each for red, green, and blue. Rather than exposing the entire image at once, the diodes sweep across the source image (like the light sensors on a photocopying machine).

The number of distinct readings, taken vertically and horizontally, determines the resolution of the scanned image. The possible number of values that could be represented is the dynamic range of the image.

The image is converted to a specific file format after it's been scanned. Many formats are available that you can use, but a few formats are better than others.

Once your image is saved on your hard drive, you can load it into an image editor or any application that can load a graphics file.

Important Scanner Terms

Before we talk about selecting and using a scanner, we need to talk about the terms and words you're likely to hear concerning scanners. For example, you'll often hear the following terms (among others):

➤ Bit depth

➤ 24-bit color

➤ Single-pass flatbed models

➤ Optical resolutions

➤ 300 x 600 dpi

➤ TWAIN compliant

We'll explain these and other terms in this section.

Bit-depth

When a scanner converts an image into digital form, it looks at the image pixel by pixel and records what it sees. However, different scanners record different amounts of information about each pixel. The amount of information a scanner records is measured by its *bit-depth*.

The most basic type of scanner is called a 1-bit scanner because it only records black and white. Each bit can express two values because 0 and 1 (on and off) are the only two possible combinations of numbers. However, to see the different levels of black and white, a scanner must be at least 4-bit (maximum of 16 tones). These scanners use 16 combinations of four bits:

0000 0001 0010 0011 0100 0101 0110 0111 1000 1001 1010 1011 1100 1101 1110 1111

An 8-bit scanner can show up to 256 tones. A 16-bit scanner can show up to 65,536 tones. When you have 24 bit color, a total of 16,777,216 colors is available.

Why are all these numbers so important? Keep in mind that a scanner with a higher bit depth can record information about a given pixel more accurately. This, in turn, results in a higher quality scan. Most color scanners today are at least 24-bit. They're called 24-bit scanners because they collect 8 bits of

information about each of the three primary scanning colors (red, blue and green). A 24-bit scanner can theoretically capture 16.7 million colors. However, the number is often much smaller. Because this is near-photographic quality, these scanners are also called *true color* scanners.

The following are examples of the same image of different bit-depths. You should be able to see a change in image quality as the bit-depth changes in the following photos. Notice, too, how large the file size becomes.

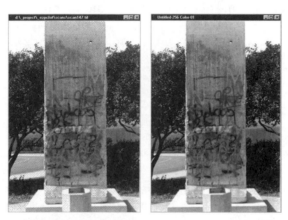

On the left is a 24-bit version of the image (11,365K)
and on the right is a 8-bit version (256 color) version of the image (3789K)

On the left is a 4-bit color version of the image (1899K)
and on the right is a 1-bit version of the image (483K)

You'll probably see 30-bit or even 36-bit scanners becoming more popular in 1997. These scanners can capture billions of colors (at least in theory). The major problem right now with a 30-bit or higher scanner is that most software is designed to work only with a 24-bit scan. However, this won't be a long-term problem if the 30-bit or higher scanners become more popular. Software companies will release versions of their software to work with 30-bit and 36-bit scanners.

Nevertheless, some of today's image editors can work with scans from 30-bit and 36-bit scanners. These editors use the huge amounts of extra data to correct for noise in the scanning process and other problems that affect the quality of the scan. In other words, 30-bit or 36-bit scanners tend to produce better color images even in an image editor designed for a 24-bit images.

> Some monitors can display only 8-bit images (256 colors) instead of 24-bit images (16.7 million colors). This is especially true for older monitors. If scanned images look patchy, distorted or otherwise "bad," and no amount of work with an image editor will improve them, don't immediately blame either the scanner, the image or even your scanning abilities. The monitor is may be the source of this problem.

Single pass or three pass

The first generation of consumer level scanners required three passes of the scanhead (the lighted bar that holds the scanning circuitry) to scan an image. In other words, a three pass scanner works like this:

1. The first pass captures red light

2. The second pass captures blue light

3. The third pass captures green light

The scanner then combined the colors into the finished scan.

The problem with these scanners was obviously their slow speed. Since these scanners had to scan the same image three times, scanning time was tripled. Even if the extra time wasn't a concern, a problem combining three separate scans occasionally resulted in *registration problems*. This was when one scan, say the green scan, was not aligned with the other two scans. Single pass scanners suffered other image quality problems as well.

Besides being 24-bit, most color flatbed scanners today are *single pass* scanners. These scanners read the red, blue and green light in one scan, hence the name single pass. Single pass scanners are not only faster than three pass scanners, but they eliminate most registration problems because only one scanning pass is required.

Three-pass scanners are now considered "old technology." So be careful: When a scanner is available in a discount catalog for an unbelievably low price, check to see if it's a three-pass scanner.

Resolution

The most important term you'll need to understand concerning a scanner is its *resolution*. We can describe resolution simply as a measurement of how many pixels a scanner can read in a specific image. An easy way of understanding and measuring scanner resolution is to use a grid. If a board has eight squares along each side, the resolution of that grid is 8 x 8 because there are 8 squares along each side:

Now, imagine if grid has 24 squares along each side, its resolution would be 24 x 24 (see following illustration).

Although the size of the grid is the same, notice how the resolution changes from the 8 x 8 example to 24 x 24 example. This is how the quality of a scanned image increases as you increase the resolution of the scanner. Remember at the beginning of this chapter we mentioned that one of the differences between scanners is the number of pixels they can measure. A 24 x 24 resolution is obviously better than an 8 x 8 resolution. More pixels are measured (each square in the box equals one pixel) in the same amount of area. For the same reason, a 600 dpi scanner will normally produce better scans than a 300 dpi scanner

A scanner uses two types of resolution (*optical* resolution and *interpolated* resolution). We'll talk about the optical resolution first because it is much more important.

Optical resolution

The most important resolution measurement for a scanner is its *optical resolution*. Typical optical resolutions are measured in dots per inch (dpi). You'll see scanners with resolutions of "300 x 300 dpi" or "300 x 600 dpi" or "400 x 400 dpi" and other numbers.

It's safe to assume that a scanner can capture more detail if it has a higher dpi. In other words, say a scanner samples a grid of 300 x 300 pixels for every square inch of the image. It sends a total of 90,000 readings per square inch back to the computer (300 x 300 =90,000). A higher resolution produces more readings while a lower resolution produces fewer readings. Higher resolution scanners normally cost more but produce much better scans compared to lower resolution scanners.

Optical resolution is often indicated using two numbers. The first number describes how many sensors are on the bar that collects the data for the scan. The second number refers to the number of dots the bar can scan as it moves from the top to the bottom of the page. Higher numbers indicate the bar is moving slower.

For example, say we're looking at a flatbed scanner with a 300 x 300 resolution. This scanner uses a scanning head with 300 sensors per inch so it can sample 300 dots per inch (dpi) in one direction. To scan in the opposite direction, it stops 300 times per inch as it moves the scanhead along the page. This lets it scan 300 dpi in the other direction as well.

The scanhead on some scanners will stop more frequently as it moves down the page. These scanners have resolutions of 300 x 600 dpi or 600x1200 dpi. Don't be fooled; always remember the smallest number is the important number. You won't get more detail by scanning more frequently in only one direction. In other words, a scanner is still a 600 dpi scanner regardless of whether it's called a "600 x 600" or "600 x 1200."

Interpolated (or enhanced) resolution

Most scanners use software to try to improve upon the optical resolution. This new measurement is called the *interpolated resolution* or *enhanced resolution.*. Some manufacturers will say their scanners have interpolated resolutions of 2,400 x 2,400 dpi or better (see sidebar note below).

As with the second number describing optical resolution, don't be fooled by interpolated resolution. It's supposed to sharpen your scan by telling the scanner to, for example, turn a 300 x 300 dpi scan into a 600 x 600 dpi scan. It does this by collecting data from two adjacent pixels. The pixels are then averaged and a new pixel is created to fit between those two pixels.

However, instead of improving the quality of the scan, interpolation more often degrades the quality. At the very best, interpolation won't greatly improve the overall quality of the image. The one thing of which you can be certain concerning interpolation is that it will increase the file size of the scanned image. For example, say you wanted to scan to the following photo:

To scan this photo in color at 600 dpi would require over 17.7 Meg of hard drive space. That's a lot of space for one image. However, since you're probably using a 300 or 600 dpi printer, you wouldn't need a higher resolution scan, anyway. (To reduce the file size, you could either scan in gray scale or use an image editor to remove the colors. This would lower the file size dramatically.) The same file scanned at 1200 dpi required almost 71 Meg, which is much too large for a single image. The image scanned at 2400 interpolated resolution required a whopping 276 Meg. At this size the image would become unmanageable for most image editors. Even more shocking is the file size if we scanned it at 4800 dpi. At a file size of over 1100 Meg, it wouldn't even fit on a CD-ROM.

Manufacturers and dealers like to use high numbers when they're talking about resolution: "Up to 4800 by 4800 dpi interpolated!" Don't be fooled...remember the optical resolution is the most important concerning the resolution level of a scanner. It more accurately indicates the level of detail the scanner really captures. As we mentioned, interpolation may smooth jaggies in line art but isn't likely to improve the detail of other images or color images.

So, don't pay too much attention to claims of interpolated resolution. Interpolation doesn't really add to the value of the scanner. Even if interpolation were to improve the scanned image, keep in mind that most ink jet or laser printers have either a 300 dpi or 600 dpi resolution. Therefore, these printers cannot use the interpolated information anyway. It's probably overkill to use a 300 dpi laser printer to print a 9600 dpi interpolated scan.

The only exception to use interpolation might be if you plan to scan line art at very high resolutions. For example, a higher interpolated resolution can be good idea when you're enlarging small originals. Using the higher resolution in this case produces an image with far more detail than a 300-dpi scan.

TWAIN-compliant

TWAIN is an acronym for Technology Without An Interesting Name. It allows applications to send their scanning instructions in a standard format that any compatible driver software can understand.

OK, that sounds nice but why is this important? The advantage of this is that you can scan images directly into an image editor or other application such as a word processor. You had to perform at least two steps before TWAIN became widely available:

1. You had to save the image you just scanned using software provided by the scanner manufacturer.

2. Reload the file in the image editor.

TWAIN eliminates the first step because the scanned image is sent immediately to the image editor. Most applications even use the same menu command for scanning (the "Acquire..." command in the "File" menu). This makes scanning from different applications even easier.

*Use the Acquire... command to load a TWAIN image
directly into an image editor or
other application (PhotoStudio in this case)*

OCR software

Scanners consider all the images they scan as graphics files. This is fine so long as the image is a picture, photograph or other type of graphic. You simply use an image editor to work with the graphics file. However, instead of manipulating a photo of your favorite aunt, you want to manipulate the letter you received from her. In other words, can the text itself be manipulated similar to how graphics files are changed?

The answer is, yes. To turn the text into files that you can edit in your word processor or database, you'll need to use *optical character recognition* software. This type of software, usually simply called *OCR*, allows you to scan a document with alphanumeric characters (letters, numbers or both). It then converts the text in the scanned image into a file that you can edit using your favorite word processor. It's as if you typed the information in yourself.

Just what can you edit with OCR software? You can, for example, use a scanner to scan transcripts, magazine clippings, memos, etc. Then make quick and easy changes in the image using a word processor such as Word. For example, you can enlarge or reduce the type, substitute fonts, change the size and even rewrite the text.

Scanner Types

Several types and styles of scanners are available from which you can select. Some scanners have very specialized functions or are used in service bureaus and professional applications. These include slide scanners and drum scanners. As the name suggests, slide scanners are used to scan 35-mm slides. A drum scanner is used for very high resolution and professional printing. These scanners are usually too large and too expensive for home or even small business use.

So, the scanners designed primarily for the consumer market include:

➤ Hand-held

➤ Flatbed

➤ Photo scanners

➤ Sheet-fed scanners

The following pages talks more about these scanners in detail.

Hand-held scanner

The least expensive type of scanners are *hand-held scanners* (sometimes simply called *handhelds*). The best way to describe the appearance of a hand-held scanner is to compare it to an oversized computer mouse. Most hand-held scanners have a scanning width of about four inches. They're ideal for copying small images such as signatures, logos, business cards and small photographs. You simply roll the hand-held scanner over an image.

The main advantage of hand-held scanners is they take up a lot less room on your desk or table. Also, hand-held scanners are easy to install. All you need to do is simply plug it into the parallel port of a PC. Since they don't need a SCSI card like flatbed scanners, hand-held scanners are very portable. One hand-held scanner can be shared easily between several computers or workstations. They're also popular with notebooks or laptops.

Hand-held scanners were inexpensive alternatives when the price of flatbed and sheet-fed scanners were well over a thousand dollars. However, now that flatbed and sheet-fed scanners have come down in price, the appeal of hand-held scanners has fallen.

Although the prices of hand-held scanners have also fallen recently (many are less then $100), they still have the same disadvantages. Most users have problems dragging the scanner in a straight line because hand-held scanners require a very steady hand and a very smooth surface. That's a major disadvantage; few users can drag the scanner smoothly across a page. (To overcome these problems, many hand-held scanners now have alignment templates to help guide you when scanning.)

Scanning larger-sized photos can be a difficult task. Hand scanners can scan only a 4-inch-wide photo or part of a document in a single pass. You can, however, use special "stitching" software when scanning larger-sized photos. This software combines several scans to create a larger image. Hand-held scanners are slower than flatbeds and photo scanners. Also, the weaker light sources of hand-held scanners make them less accurate than a flatbed scanner.

A comparison between an image scanned with
a hand scanner (top) and a flatbed scanner (bottom)

Nonetheless, hand-held scanners remain popular and are capable of quick and easy, low-cost scans. The one tip we can give you if you use a hand scanner is to roll them slowly and steadily. It's not too hard to do, but don't be in a rush.

Also, make certain a hand-held scanner includes stitching software if you're looking to buy one. Some combinations of hand-held scanners and software will warn you if you're moving the scanner too fast. Moving the scanner too fast can result in part of the page or image being skipped.

We recommend using a hand-held scanner only in the following cases:

➤ Your budget is very tight

➤ You need to do a quick one-time job of scanning a few images

➤ You don't have access to a flatbed scanner.

Photo scanner

A *photo scanner* is a small, relatively inexpensive motorized scanner that scans photographs, business cards and other similar sized images. Their specialty, as the name suggests, is to capture photos. However, this is also limits the size of the image they can scan. They are, nevertheless, easy to use and certainly don't need as much desk space as a flatbed scanner.

> Although you can find hand-held scanners with resolutions up to 400 dpi, most users have problems getting accurate scans at resolutions above 200 dpi. A higher resolution means your hand must drag the scanner much slower and steadier across the image.

The Kodak PhotoDoc is an example of a photo scanner

Flatbed scanner

The most popular desktop scanners today are *flatbed scanners*. Flatbed scanners, as the name suggests, have a flat glass surface (called the *bed* or sometimes the *platen*) on which you place the object you want to scan. The bed also doubles as the *scanning area*.

124

Flatbed scanners are used to scan flat originals of various sizes, such as photographs or prints. (Chapter 9 even talks about how to scan small three-dimensional objects like coins, keys, food, clothing, etc.).

A flatbed scanner is perfect if you want to scan pages from a book without removing or damaging the pages.

An example of a flatbed scanner

Keep one thought in mind if you're considering a scanner: Color rules. If there's even a tiny chance you'll want to scan color images at some point, get a color scanner.

A flatbed scanner resembles a photocopier in both how it looks and operates. In other words, you place the object you want to scan on the bed and close the cover. The scanning head or light bar moves below your object and scans it.

You can even use an optional automatic document feeder to scan several pages at once. Also, most flatbed scanners can use a transparency adapter so you can scan slides, x-rays and other transparent originals. However, these are very special add-ons and cost about as much as the scanner itself.

Although flatbed scanners are more expensive than hand-held scanners, they're more versatile and include more features. In other words, you can scan a far wider range of objects with a flatbed scanner. For example, use a flatbed scanner to scan anything from paper to full color artwork to 3-D objects such as coins and keys. Furthermore, they're usually bundled with "value-added" software and image editors.

As with digital cameras, fierce competition is forcing the retail prices of flatbed scanners to fall. The magic price for entry-level scanners is from $400 to $800 (see Chapter 8 for more information on specific flatbed scanners).

Sheet-fed scanners

Sheet-fed scanners, also called *personal sheet-fed scanners*, have recently become more popular. They're somewhat similar to a fax machine because the page being scanned is moved past the scanhead. (A flatbed scanner is similar to a photocopier; the scanhead is moved below the object to be scanned.)

The Tamarack Personal Document Scanner is an example of a sheet-fed scanner

A sheet fed scanner produces more reliable scans than a hand-held scanner. It's also less expensive and usually smaller than a flatbed scanner. Sheet-fed scanners are typically used for scanning black and white documents.

The disadvantage of using a sheet-fed scanner is that you can scan only a single sheet of paper. (Some sheet-fed scanners can use automatic document feeders to avoid this problem.) This is why sheet fed scanners are usually used for small amounts of scanning. This also presents a problem if you want to scan a page from a book or magazine. To scan a page from a book or magazine with a sheet-fed scanner, you must tear out the page.

The quality of the scans produced by sheet-fed scanners usually cannot match those produced by flatbed scanners. Distortions can be a problem. This is because a sheet-fed scanner moves the paper as it's being scanned. Nevertheless, a sheet-fed scanner is a good choice for handling paperwork without giving up much desk space.

Selecting A Scanner

Chapter 7

Selecting A Scanner

Perhaps you've been thinking about buying a scanner. Maybe a friend just bought one and is telling you how great it is. Or maybe you're tired of using the scanner in the office and think it's now time to buy a scanner for yourself.

However, you should not simply run out and buy the first scanner you see. Like most of your computer hardware peripherals, you need to make a few but important decisions first. Chapter 6 introduced you to scanners. This chapter will tell you what to look for when selecting a scanner.

Before Selecting A Scanner

Before you go scanner-shopping you should consider some details, which we'll talk about in this section. By understanding and evaluating this information you'll be able to see why one scanner might be better than another for what you need.

How will you use the scanner?

First, consider the reason(s) you're buying a scanner; determine how you'll be using your scanner and for what purpose(s). Then look for a scanner that will most closely satisfy those needs. Don't pay now for extra quality or features that you may not need for awhile. For example, consider the following general guidelines:

Do you plan to scan just clipart, line art or black and white images?

You may not want to buy an expensive color scanner when you're only planning to scan black and white images. A black and white or grayscale scanner will work fine in this case. However, *color rules,* so be absolutely certain that all you'll *ever* want to do is to scan black and white images. You're really limiting yourself by buying a black and white or grayscale scanner. You may discover very quickly that you'll need the versatility of a color scanner (besides, a color scanner can scan black and white images, too). But if black and white is all you'll need, a monochrome (one color) scanner can be the best choice.

Do you plan to scan color images, art, graphics, photographs, etc.?

If you're even *thinking* about scanning color graphics and images, you must get a color scanner. Even if your current plans are only to scan monochrome (black and white) images, you'll soon want to scan color images. Besides, a color scanner can also scan black and white images if necessary.

Do you plan to scan only photographs?

This is an example where a photo scanner may be a good choice. Or if your budget is limited, then a hand-held scanner might be the better choice. Remember that you're limited in the size of the photo that can be scanned when using either of these scanner types.

One exception is when you use a notebook computer. In this case, a hand-held scanner is easier to carry than a flatbed scanner. Unfortunately, they're not as accurate as a flatbed scanner or a photo scanner.

Some scanners use lenses to increase the resolution available in one area of the scanning bed. This is done by concentrating the light reflected off the image. Although this is very useful for scanning slides and other items, it may be misleading if the high-resolution area is only a small part of the overall scanning area. Be wary of scanners offering dual resolutions; the highest resolution will probably only be available for small images.

Are resolution, speed, color and professional quality important?

Resolution, speed, color and quality are arguably the most important considerations when selecting a scanner. If any or all apply to your needs, you should probably consider a flatbed scanner. A flatbed scanner offers the best combination of speed, color, resolution and quality of the four scanners we talk about. (See the "Scanner Types" in Chapter 6 for information on each type of scanner.)

Another reason to consider a flatbed scanner is the maximum physical size image a particular scanner can scan. If you'll be scanning objects of different sizes and shapes, a flatbed is the only way to go. For example, most hand-held scanners and photo scanners are limited to images of a certain width (usually about four inches).

Also, flatbed scanners have different scanning sizes. Some flatbed scanners can scan only a letter-size (8.5" x 11") page, but other flatbeds can handle a full legal-size (8.5"x 14") scan. When selecting a scanner, consider how important it is to you to have a larger scanning bed. You may never use the added size, but the added price may be worth it. You may discover a future project requires the larger scanning area.

Final notes on resolution

If you'll be using a laser printer or color printer to output your scanned images, a 400-dpi or 600-dpi scanner is probably the right choice. In a few instances, however, a 300-dpi scanner will work just as well.

If you plan on displaying your scanned images only on the Internet, a 300-dpi scanner will provide acceptable resolution.

The suggestions above are intentionally very general. Your specific requirements and budget may be quite different. However, a flatbed scanner is probably the best choice for most users.

Scanning speed

How important is the speed of a scanner? Manufacturers, reviewers and dealers have argued the importance of scanner speed for a long time. The importance of a scanner's speed probably depends more on how often you plan to use the scanner. A slow scanner probably won't be a problem if you use it only a few times a day. On the other hand, a fast scanner is more important if you're using it constantly. A fast flatbed scanner should scan an image at a rate of about 166K per second. This takes about 11 seconds to scan a 400-dpi page of text. Most scanners operate with transfer rates of less than 133K per second.

Many things determine the speed at which a scanner operates. These include whether it's the preview scan or the final scan, the resolution at which the image is scanned and the time required for the scanning software to save an image. Interpolation increases the time required to complete a scan (another reason to avoid interpolation; see Chapter 6).

Scanner speed is often argued over because no standard is available to evaluate the time needed for a scanner to scan an image. So, an accurate way to compare scanning speed is difficult. When you're shopping for a scanner, you may see a speed expressed in milliseconds per line (or "ms/ln"). Manufacturers usually use this number to specify the raw speed of their scanners' motors. However, that speed rarely compares with real-world performance.

Since no reliable comparison standard is available, the best way to evaluate a scanner's speed is to create your own comparison standard. Try a few sample scans at different dealers. Use the same types of images you're most likely to scan after buying a scanner. If you cannot "test drive" a scanner this way, look for comparisons in magazine. These reviews usually test each scanner by scanning the same image under the same conditions, resulting in a fairly accurate comparison.

> Our basic recommendation is not to weigh the speed of the scanner too heavily; other features are more important. These include optical resolution, single pass versus three-pass and the other features we talk about in this chapter.

Color balance and correction

Other items you need to consider are *color balance* and *color correction*. They refer to the changing of the pixel colors in an image—adjusting brightness, contrast, mid-level grays, hue and saturation to get the best possible results.

Color balance and correction are especially important if you'll be using the scanner for graphics. Although the image editors we talk about in Chapters 10-14 can correct many color problems, it's better to start with colors that are scanned accurately.

Many scanners can perform their own color corrections. If so, you may be able to access a greater number of colors. Expanding part of the range of a 24-bit image, for example, to bring out shadow details, will compress other parts of the image. The result is, in this example, lost details in the midrange and highlight values. A 30-bit scanner can use your instructions to select and use the best, full 24 bits of data available. This can provide a far smoother tonal continuity and greater detail retention to a corrected image.

The bundled scanning software

A scanner is similar to many peripherals you're already using because it, too, includes utilities and bundled software. These programs are designed to help control the scanner and to make it easier to use.

Utilities

Utilities are usually designed for just one task, but often offer several features that can enhance the capabilities of a specific scanner. Utilities also let you define the specific part of an image you wish to scan or emphasize. Some utilities can even turn a combination of scanner and printer into a photocopier (even a color photocopier). This is done by redirecting the data from the scanner directly to the printer for output. Then you can print the image immediately without saving the scan as a file. A scanner and a fax modem combination can replace a traditional fax machine by using a fax utility. This utility redirects the scanned data straight to the fax modem driver software.

Software used by the scanner

The most useful scanning software lets you resize, zoom and edit previews quickly and easily. You should also be able to control the brightness as well as the shadows and highlights (called white point, midpoint and black point) of the image.

Make certain the software used by the scanner can save your image in a standard format, such as TIFF, GIF or EPS. If not, you'll definitely need to buy and use an image editor so you can convert the scanned image files to a more standard format.

Bundled image editor

Most scanner manufacturers bundle an image editor with their scanners. A good image editor is almost required if you're scanning graphics or photographs (see Chapters 10-14). Unfortunately, the quality and features of the image editors bundled with a scanner vary widely. Some scanners include the "full" version of an image editor. Other scanners may include low-priced, limited versions of popular image editors. The limited versions are usually called "LE," "Lite" or something similar.

LE versions won't have most of the important advanced features, but they're usually good enough to get you started. Then, as you become more experienced, you'll probably need a more powerful image editor. Since you'll want to upgrade eventually, consider buying a full version of the image

editor when you buy a scanner. You might get a good package price for the scanner and the image editor. Keep in mind too that an upgrade offer might be included with the LE version bundled with the scanner. This upgrade offer may let you buy the full version of the software at a special price.

Drivers

Every scanner, regardless of its features and type, depends on the computer to which it's connected for instructions on what and how to scan. These signals are supplied by driver software that runs on your computer and translates your instructions into commands the scanner understands.

Color calibration

Any one who has used a scanner has at least once become frustrated because a scanned image looked different on screen than it did when printed. Then, a fact adding to the frustration was that both looked a lot different from the original. The solution to this problem is *color calibration* (or *color matching*) software. By installing a color calibration system on your PC, an orange in an original image will appear just as orange on screen and on a printout.

Since a book specifically about color is required to talk fully about color matching software, we'll only mention it briefly here. One example of a popular color calibration system is the Kodak Color Management System (CMS). It uses its own color definitions with unique profiles for each scanner, monitor and printer in your computer system to translate and standardize colors. This system is used in many image editors and other software. CMS has become the favorite of graphic artists and others who depend on closely matched colors.

Another reason we don't need to talk much about color calibration systems is that you probably won't need to worry about it. These systems are important only for scanning high-quality images (transparencies, professional-quality prints, etc.) that must meet strict quality standards. In most cases, you're probably more interested in a fast, satisfactory color than a 100% accurate color.

Dynamic range

Another important criteria for evaluating a scanner is its *dynamic range*. Dynamic range is somewhat similar to bit-depth; it measures how wide a range of tones the scanner can scan. Dynamic range is measured on a scale from 0.0 (perfect white) to 4.0 (perfect black). The single number given for a particular scanner tells how much of that range the unit can distinguish.

The dynamic range for most color flatbed scanners is about 2.4. This means that the typical flatbed scanner can distinguish between perfect white (0.0) and a deep mid-range grey (2.4). High-end color flatbed scanners are usually capable of a dynamic range between 2.8 and 3.2. These scanners are designed for more professional work. Drum scanners probably provide the ultimate in dynamic range; they typically feature a dynamic range between 3.0 and 3.8.

Keep in mind that a high dynamic range doesn't guarantee a good scan. Many other factors influence the scan quality. However, the dynamic range is an indication that the scanner manufacturer is striving to please educated buyers by producing a higher-quality product. All other things being equal, go with the scanner that offers a higher dynamic range.

Other buying tips

One general rule applies when shopping for computer hardware and peripherals: The more you know, the smarter you'll buy. So we'll give you a few more quick tips:

Fast previews

The software that comes with a scanner should give you a quick, low-resolution preview of how your scan will look. Fast previews are very important because they'll save you time. Testing corrections on the preview image is faster than working with a final scan. Some scanner software lets you apply filters and tonal corrections at this point to reduce the amount of work you'll need to do with an image editor.

Read the specifications

Make certain you understand the important features about the scanner in which you're interested. Also, know beforehand what's important for you (see the first part of this chapter for some examples).

One idea is to create a table or list of specifications and features for which you're searching. List the specifications from most important to least important horizontally across the page. Then list the scanners that you're interested in vertically on the left side of the page. Put an "X" in the area where the products have a particular feature or the value of the feature (dynamic range, for instance). This will let you quickly see which scanners are most likely to meet your needs and price.

Future plans

Plan for future needs. However, be careful that you don't overestimate and buy something that's too sophisticated or too expensive for your current needs. Remember, scanner prices are likely to continue falling, so don't spend extra today for something you won't need or use until much later.

Start with the leading scanner manufacturers

The leading scanner manufacturers earned their reputations for top-quality merchandise at fair prices. See Chapter 8 for more information on their scanners. Compare your needs with their specifications. Then use the information to compare against other scanners from other manufacturers (see the list idea above).

Use the Internet

Many on-line resources are available to you that provide information about scanners. Most manufacturers have a Web site. You'll find a wealth of information by searching their Web sites. Also, search in magazines, many of which have articles on scanners, especially comparison charts, new models, etc.

Check prices and support

You've probably noticed that the prices for virtually everything in the PC market today are highly competitive. So, check online (CompuServe, AOL, the Internet, BBSes). Also, check ads for mail-order companies and then go to retail stores to check their prices. Look in your local newspapers for prices. You'll be surprised how much you can save by doing some good price shopping.

Don't forget to check the vendors' service and support policies. Go to Internet newsgroups or the vendors' forums on AOL or CompuServe. Computer users are seldom shy to complain about a vendor who doesn't provide good service or competitive prices.

Read the warranty carefully. Check the length of the warranty and its return policy. Can you return the product for a refund? If so, what about restocking fees if a product is returned. Who pays for shipping if you need to return a scanner you bought from a mail order company? Recognize all the little "gotchas" before you buy. Read the fine print on everything and make certain to get warranty and return policy details in writing.

There is a best time to buy

Believe it or not, we know of a best time to buy a scanner (or any computer or peripheral for that matter). Although sale prices and your payday may influence when you buy a scanner, try to buy on a Monday. Otherwise, buy early in the morning. If you're ordering from a mail order company, try to take delivery early in the week. Then if you need help, you can get support faster. Keep in mind that not all manufacturers or dealers have weekend, evening or 24-hour support.

32-bit driver support

Does the scanner have 32-bit driver support. Most scanner manufacturers offer 32-bit, Windows 95-compatible drivers for their scanners. Although you may not need it now, don't forget about the future.

Suitable SCSI

Plan on using a scanner with your current SCSI card? Make certain the scanner in which you're interested supports your SCSI card. If you or the dealer are uncertain, check with the manufacturer before buying. Also, many scanners include a bundled SCSI card. If you're planning to use your current SCSI card, see whether the dealer will sell the scanner at a reduced price without the SCSI card. You won't need the SCSI card, so why buy it?

> If you plan to use your current SCSI card and Windows 3.1x, you'll need the advanced SCSI programming interface (ASPI) drivers. If you plan to use Windows 95 and your current SCSI card, ask the dealer or manufacturer if 32-bit drivers are available.

Automatic document feeder (ADF)

You may also want to expand your scanner's capabilities with an automatic document feeder for OCR work, or a transparency adapter (each costs between $400 and $700).

Networks

Some scanners can be made accessible to multiple users over a network. Make certain the scanner is accessible over a network if that's what you need.

Hardware requirements

The hardware requirements for a scanner aren't the same as for image editors and most other software. So, you should base hardware requirements on the most demanding part of your work. This is likely to be an image editor or other graphics-intensive work. A 386 PC with 8 Meg of RAM can successfully operate a scanner. However, you'll find this system to be agonizingly slow when using an image editor.

OCR software included

A scanner can, of course, capture an image of the text on a page. However, you cannot edit the text because your PC considers it to be a graphics file and not a text file. By using Optical Character Recognition (OCR) software, your PC can read the image as a text file. You can then use a word processor to edit the text.

Choosing an OCR package

Planning to do OCR scanning? We recommend testing scanners and OCR packages using a sample of documents before buying. You're looking for accuracy greater than 90%. If the accuracy is less than 90%, you're probably better off having the text keyed-in (it might be a good idea first to see if the text is already available in digital form).

Two currently popular OCR applications are OmniPage, from Caere, and TextBridge, from Xerox. Both are very accurate and work in several languages. They can recognize not only the text on a page, but the format (bold, italic, etc.) in which the text was originally printed. Other OCR software may be easier to use or less expensive, but probably in exchange for less accuracy.

> Although several OCR packages are available, make certain the package in which you're interested is compatible with the scanner in which you're also interested.

Keep in mind that even the best OCR package available today can achieve little better than 99% accuracy. So even with the best OCR software, you'll still have to correct one out of every 100 characters.

Note On File Sizes And File Formats

File size can be a common problem regardless of which scanner or scanner type you're using. The photo of your girlfriend may fit neatly in the picture frame on your desk. The same photo, however, can take well over 3 Meg of hard drive space after it's been scanned. Multiply that by scanning all the prints from a 36-exposure roll of film and you'll need up to 100 Meg of hard drive space—and that's just one roll of film.

The file size depends on several factors, including image type and resolution. Color images are typically larger than grayscale or black-and-white images. Also, scanning in higher resolutions normally increases the file size.

So, as you can see, scanning images can require a lot of hard drive space. Fortunately, we know a few tricks you can try to keep these file sizes smaller.

Understand the relationship between resolution and file size

We've mentioned several times that scanning at higher resolutions increases the size of the file. So, use a resolution appropriate to your needs. If you plan to print a photo on your 360-dpi ink-jet printer, don't scan the photo at 600 or 800 dpi. The 360-dpi printer cannot produce all the detail of an image scanned at 600 dpi.

Use disk compression

Even bitmap files can require a lot of hard drive space. Therefore, many image editors give you the option of compressing files when you save them. A rate of 50 percent is typical when compressing image files. In other words, you'll save twice as many files in the same amount of space. Some scanners, such as the Storm EasyPhoto Reader, can compress images as you scan them.

Otherwise, get a commercial product, like WinZip, to compress your data files (see www.winzip.com for more information).

Delete unused image files

You probably don't show off every photo you ever snapped. So, why keep every scanned image on your hard drive? You should delete files that you no longer need. If you want to keep files even though they're no longer needed, transfer them a floppy diskette or a backup device like the inexpensive Zip drive, from Iomega.

Bit-depth, scan mode & file size

We talked about *bit depth* in Chapter 6. Although it's an important consideration in buying a scanner, it's also important when using a scanner. Bit-depth drastically affects file size. See Chapter 6 for examples of the same image in different bit-depths and notice the different file sizes for the same image.

Some Final Buying Tips & Suggestions

Even if you've narrowed your choices to a few scanners, you still may not know which one to buy. To conclude this chapter we'll provide you with some final tips on buying and selecting a scanner.

Hand-held scanners

We've said it before but we'll repeat it here. Consider a hand-held scanner only if you're on a limited budget or need a quick scan job done. If you do use a hand-held scanner make certain the software includes stitching features. Then you scan a larger photo or document and combine multiple passes or strips.

Color rules

Remember one of our notes: *Color rules*. Color scanners now rival monochrome and gray scale scanners in price. You should consider the versatility of a color flatbed scanner not just for your scanning jobs today but also for scanning jobs in the future.

Three pass scanners

Also, avoid buying a three pass scanner. You'll find the speed and higher quality scans produced by single-pass scanners to be much better.

Expensive options

Consider adding an automatic-document-feeder and transparency-module options only if you'll need high-volume scanning or specialized-media capabilities. These can be very expensive options, especially if you'll only get limited use out of them.

Interpolated resolution

Consider only the optical resolution of a scanner. Don't be fooled or tricked by advertisements mentioning interpolated resolution. For most everyday or typical scanning jobs, an optical resolution of 300 or 600 dpi is usually enough.

144

DPI and resolution

Match the resolution of your intended output to that of your scanner. In other words, scanning a photo at 600 dpi will only produce large files that take up valuable hard drive space and take your time if you plan to put the image on a Web site or use a 300-dpi inkjet printer.

30-bit and 36-bit scanners

Although 30-bit and 36-bit scanners are likely to become popular this year, first consider a 24-bit color, or true color, scanner if you'll only be sa. Consider a 30-bit or 36-bit scanner if you're outputting to graphics shops' high-color devices, or scanning slides or transparencies.

Bundled software

Virtually all scanners include software. Check and double-check bundled software. Make certain you understand what is meant by "LE" and "lite" and "limited", etc. In other words, how do these versions differ from the full versions. Also, a TWAIN driver is a must for Windows.

Getting updated drivers

Make sure a scanner vendor affords easy access—free downloads via the Web, for instance—to updated drivers. A two-year warranty and toll-free tech support are points in any vendor's favor

Easy installation

Make certain you understand what is involved in installing the scanner. Hand-held scanners usually simply plug directly in the parallel port. However, most flatbed scanners are SCSI-based and require some amount of installation.

Warranty and technical-support

Finally, check the warranty and technical-support offered by the manufacturer. Many manufacturers, for example, Canon, Epson, HP and Umax offer their customers toll-free phone support. Other manufacturers,

145

however, do not have toll free phone support. Fortunately, once you're past the initial installation, you should rarely require tech support.

Most scanners include a one year warranty. A few manufacturers, notably Canon, Epson and Mustek, provide two-year warranties. Also, make certain the vendor provides an easy way for you to get updated software drivers. The easiest way to get updated drivers and other information is to check the manufacturers website on the Internet.

The next chapter talks about specific scanners and their features.

Scanning The Manufacturers

Chapter 8

Scanning The Manufacturers

Some Examples Of Today's Popular Scanners

Agfa scanners

Canon scanners

Epson scanners

Hewlett Packard scanners

Info Peripherals

Microtek

Mustek

Nikon

Pacific Image Electronics

Plustek

Sharp scanners

Tamarack Technologies Inc. scanners

UMAX Technologies

Like most areas of personal computing, the scanner business is becoming more competitive. A scanner that was considered expensive even just a few months ago now has trouble competing with today's more inexpensive models that are easier to use, feature improved color accuracy and are bundled with great software.

We know of at least three reasons the market for scanners is growing:

1. The growing interest in digital imaging work for both small businesses and home users. An impressive 1.3 million scanners were sold in the US and Canada in 1995. However, most industry experts expect that number to swell to nearly 5 million units per year by 1999.

2. Today's scanners are much easier to use. A single mouse click is all that's needed to control many of today's scanners.

3. More manufacturers and more scanners entering the marketplace increase competition which helps make these scanners increasingly more affordable for everyone.

Some Examples Of Today's Popular Scanners

We'll talk about many of today's most popular manufacturers and their scanners in this section. Keep in mind that this is only a sampling of available scanners. We're including the information to give you an idea of the scanners that are available and their capabilities. We're not necessarily recommending only these scanners or only these manufacturers. Refer to the table near the end of the chapter for a quick comparison of all the scanners we mention.

Since you're probably looking for a color flatbed scanner, we'll only be talking about flatbed scanners in this section. Also, some of the software bundles may change, too, so check the manufacturers' web sites or your favorite dealers for the most current information.

Agfa scanners

StudioScan IIsi

The StudioScan IIsi, from Agfa, is a very affordable and extremely simple to operate scanner. It's also arguably one of the more attractive scanners you can buy. Installing the scanner is very easy and is ideal if this is your first scanner. You probably won't have to worry about anything "techie" when using the Plug-and-Play software, which means you won't need to worry about nasty software addresses or jumpers.

The Agfa StudioScan IIsi is a 30-bit color scanner, offering an optical resolution of 400 x 800 dpi and interpolated resolution of 2400 x 2400 dpi. It's also one of the fastest scanners for scanning speed. The Agfa also boasts a very large scanning area.

It's bundled with an image editor (Adobe Photoshop LE) and OCR software (Caere OmniPage Direct). Several Agfa programs are also included in the bundle, including the feature-filled FotoLook driver. This driver allows sharpening, descreening, shadow detail enhancement, color cast removal and automatic density control. Many users and experts agree this is the best

150

driver available with any home or small office scanner. Its features alone may make most post-scan tweaking unnecessary. FotoLook also features real-time previewing. It uses a helpful wizard to guide you through every step of the scanning process.

StudioScan IIsi is very affordable and extremely simple to operate. It's ideal for adding sharp, colorful images to newsletters, flyers, technical documents and Web pages.

Canon scanners

IX-4015

Although the Canon IX-4015 uses a small scanbed (8.5 x 11.7 inches) and isn't a powerful scanner, it's probably good enough for typical or everyday scans. It offers an optical resolution of 400 x 800 dpi. As long as you won't be scanning transparencies (it doesn't have a transparency option) or oversized pictures, this scanner is a good alternative to other budget-priced scanners.

Canon IX-4025

The IX-4025 is a 27-bit color scanner. It offers an optical resolution of 300 x 600 dpi and an interpolated resolution of 1200 x 1200 dpi. It also uses a smaller size scan bed (8.5" x 11.7"). It's bundled with OFOTO 2.0, OmniPage Direct 2.0, a TWAIN Driver and a copier utility (so you can make color copies right at your desk).

Epson scanners

ES-1000C

The ES-1000C is a 30-bit scanner with an optical resolution of 400 x 800 dpi and an interpolated resolution of 1600 x 1600 dpi. The ES-1000C uses an 8.5 x 11.67 inch scanning bed. It's bundled with Adobe Photoshop 3.0 LE, Xerox Textbridge OCR and more.

The EZ-1000C scanner includes SCSI and bi-directional ports for dual connections. This means you can connect it to a Macintosh and PC at the same time without switching cables. It uses a built-in calibration through EPSON Scan to calibrate the monitor, scanner and printer to produce sharp and crisp images.

Because it's a 30-bit scanner, the ES-1000C can distinguish over a billion colors. Besides brilliant colors in the mid-tones, your images include more detail in the highlight and shadow areas. The high resolutions assure that your images are perfect.

ES-1200C

The ES-1200C is also a 30-bit color scanner. It offers optical resolutions of 600 x 600 dpi and interpolated resolution of 2400 x 2400 dpi. It can scan documents up to 8.5"x11.67" in size.

The ES-1200C has won several awards for value and excellence. It's either bundled with Adobe Photoshop 3.0 and Kai's PowerTools or you can buy only the scanner with the necessary driver software.

The included TWAIN software features automatic exposure (that will set the optimal brightness and contrast levels for each scan) and extensive adjustments to almost every part of the scanning process. For a slight boost in image quality, but longer scan times, you can do a triple pass scan.

Like the ES-1000C, the ES-1200C also has dual connections, so a Mac and PC can use the same scanner. A nice touch with the Epson ES-1200C is that it includes a parallel interface. This interface will limit the possible IRQ and other conflicts you might face. You'll also find that the ES-1200 is very easy to install and that it will begin working immediately.

Expression 636

An example of a "pricey" scanner is the Epson Expression 636 scanner. It's a great combination of high-quality scanning and fast speed. The Expression 636 scanner is a 36-bit color scanner with an optical resolution of 600 x 600 dpi and interpolated resolution of 4800 x 4800 dpi. Because it's a 36-bit scanner, the Expression 636 recognizes more than 68 billion colors. It also scans in 12-bit gray scale.

The Text Enhancement Technology (TET) of the Expression 636 can ignore the color background when scanning documents. The result is much cleaner scanned text when you're working with OCR software.

Epson has four models of the Expression 636. Each model is targeted for a different market and each has a different price. All four models, however, share the same features. The differences are in the software that is bundled with each scanner.

Hewlett Packard scanners

Hewlett-Packard (HP) makes some great color scanners in the $500 to $1,000 price range. They're described below from the top of the range to the bottom. Check out HP's Web page (http://www.hp.com/) for more information on HP's scanner line.

ScanJet 4c

The ScanJet 4c is a 30-bit (1 billion colors) flatbed scanner offering an optical resolution of 600 x 600 dpi and an interpolated resolution of 2400 x 2400 dpi. It uses an 8.5 x 14-inch scanning bed.

Scans can be sent to the screen or routed directly to a printer, fax machine or other peripheral using an intuitive pull-down menu. An automatic exposure button adjusts the contrast and brightness with a single click. The bundled DeskScan II software offers realtime previewing so you won't have to rescan a document to see how a change would look.

In a way, the ScanJet is almost too easy to use. Configuring the product for a high-quality scan requires you to open a new dialog box and then manually type in the horizontal and vertical resolutions you need, which can be confusing for new users. Fortunately you can save the setups for future use.

The ScanJet 4c was the easiest scanner to use among those reviewed and consistently produced high-quality scans.

The HP ScanJet 4c scanner is similar to the HP ScanJet 3c except that the former comes with a new software program called Visioneer PaperPort. When used with the HP DeskScan II scanning application, PaperPort allows managing, annotating and linking of scanned images to multiple applications.

Bundled with powerful image-editing software (Corel Photo-Paint), award-winning Visioneer PaperPort software for automatic linking to e-mail and e-fax applications and integrated optical character recognition software (OCR) that makes it easy to scan documents directly into a word processor and avoid retyping, the ScanJet 4c is packed for performance.

It scans up to 50 pages at a time with the optional automatic document feeder and scans transparent media, such as 35 mm slides, with the optional transparency adapter.

ScanJet 3c

The ScanJet 3c has been getting plenty of good reviews in recent months and, pitted here against its brethren, the 3c certainly holds its own. The ScanJet 3c is a 30-bit scanner offering an optical resolution of 600 x 1200 and an interpolated resolution of 2400 x 2400 dpi.

The ScanJet 3c automatically does a preview scan each time it acquires an image, even if you don't want one. Fortunately the scan is quick. This can be a inconvenience at worst, especially if you don't need to do a preview scan. However, the software is still quite workable, and on balance, the 3c is an excellent product.

Info Peripherals

ImageReader FB

The Image Reader FB is a 30-bit flatbed scanner. It offers an optical resolution of 600 x 1200 dpi and an interpolated resolution of 2400 x 2400 dpi. It uses an 8.5 x 14-inch scanning bed and 32-bit Windows 95 (but no Windows NT) drivers.

The ImageReader FB flatbed scanner from Info Peripherals

The Info Peripherals's ImageReader FB includes some well-thought-out features. For example, its lamp turns itself off so it doesn't continue burning if you leave it on for extended periods. Also, a large dial locks the lamp in place for transport rather than using a traditional flimsy plastic stopper. Although the styling may look a little old-fashioned, the important part of a scanner is inside. Inside the ImageReader is completely modern.

Installing the ImageReader is easy and quick. Info's scanner model numbers refer to the hardware and software included in the ImageReader FB package. Refer to the model numbers to determine which package best suits your needs.

155

Image quality is good. The levels of sharpness and color will match most other scanners. Also, changing resolution and adjusting color and contrast are relatively easy to do. Its default settings leave a slightly washed out image, but boosting the contrast drastically improves the quality.

The preview scan is very slow (over a minute, which is more than twice the typical speed). This makes the entire job of scanning a single image longer. However, the ImageReader is as fast as most scanners for the final scan. Also, because it uses 32-bit drivers, you can use other applications while the scanner is working.

ImageReader is bundled with an image editor (Ulead's ImagePals 2 GO!) and Info Peripherals's proprietary scanning control software.

Image Reader Express

The Image Reader Express is a 24-bit color single pass flatbed scanner. It offers optical resolutions of 300 x 600 dpi and interpolated resolution of 4800 x 4800 dpi. It can scan documents up to 8.5"x11.7" in size.

The Image Reader Express flatbed scanner from Info Peripherals

The Image Reader Express is compact in size. It weighs only 11 pounds and measures 16.7 x 11.5 x 2.5 inches in size. It connects to your PC through the parallel port so no interface card is needed.. Once installed, use it to scan in color, gray scale or black and white images, tweak them and perform color corrections. It's bundled with image editing software (Image Pals GO) and Info Peripherals' own InfoCenter.

InfoCenter combines a viewer with additional features like a digital copier, OCR software and fax capabilities.

The ImageReader Express includes a TWAIN driver so you'll be able to use it with any TWAIN compliant application.

Image Reader Elite

The ImageReader Elite is a 24-bit color single pass flatbed scanner. It offers optical resolutions of 300 x 600 dpi and interpolated resolution of 4800 x 4800 dpi. It can scan documents up to 8.5"x11.7" in size.

The Image Reader Elite flatbed scanner from Info Peripherals

The Image Reader Elite is a fast and compact scanner. It takes advantage of the new USB interface so installation is easy: it's a simple as plugging in a lamp. If your PC system doesn't have a USB interface, an interface card is included.

Once you've installed it, use the ImageReader Elite to scan color, line art or halftone images. Then use the image editor (Image Pals GO) bundled with ImageReader Elite to tweak them and perform color corrections. It's also bundled with Info Peripherals' own InfoCenter.

InfoCenter combines a viewer with additional features like a digital copier, OCR software and fax capabilities.

The ImageReader Elite includes a TWAIN driver so you'll be able to use it with any TWAIN compliant software. Installation of these drivers is done using the Info Technician.

Microtek

Microtek ScanMaker III

Arguably the most famous of all scanners is the ScanMaker III. The ScanMaker III is a fast, 36-bit flatbed scanner, offering an optical resolution of 600 x 1200 dpi and interpolated resolution of 4800 x 4800 dpi. Its 3.4 dynamic range is very impressive, as are the vivid colors produced by its incredibly powerful optics.

The ScanMaker III scanner from Microtek

An added bonus with the ScanMaker III is the bundled Transparent Media Adapter for scanning filmstrips and transparencies. It's also bundled with, among others, a full working version of Photoshop, Fractal Painter 4.0, Ulead's Image Pals 2 Go! and Caere OCR software. An automatic document feeder is available as an option.

It also includes a video tape to help you install the ScanMaker III correctly.

Microtek ScanMaker E6

The ScanMaker E6 is a single-pass 30-bit high-resolution scanner. It offers an optical resolution of 600 x 1200 dpi and an interpolated resolution of 4800 x 4800 dpi. It can scan documents up to a size of 8.5 x 14 inches.

It's bundled with some superior software, including Microtek's award-winning ScanWizard scanning software, Caere's OmniPage Limited Edition, U-Lead's PhotoImpact 3.0 (full version) and ImagePals 2 Go! for Windows.

The ScanMaker E6 is a solid scanner that produces good images. Despite its relatively simple controls, the scanner offers enough power for most scanning jobs. It's especially appealing to anyone looking for high quality and top value.

159

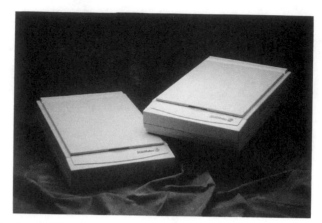

The ScanMaker E3 and ScanMaker E6 scanners from Microtek

Microtek E3

The ScanMaker E3 is a 24-bit single-pass scanner with an optical resolution of 300 x 600 dpi and an interpolated resolution of 2400 x 2400 dpi. It features a very large scan bed (8.5 x 13.5 inches) and uses an improved cover design that reduces reflection of extraneous light to obtain better image quality.

The E3 also includes a video tape that will help you through the installation. It's bundled with several software programs, including Ulead's PhotoImpact SE, Ulead's ImagePals 2 Go! and Caere OmniPage Limited Edition (OCR software).

Mustek

Paragon 1200SP

The Paragon 1200SP is a single-pass, 30-bit flatbed scanner. It offers an optical resolution of 600 x 1200 dpi and an interpolated resolution of 9600 x 9600 dpi. It can scan documents up to a size of 8.5 x 14 inches.

The image editors bundled with the Paragon 1200SP include Picture Publisher from Micrografx Inc. and iPhotoPlus. It's also bundled with TextBridge Classic from Xerox, which is an OCR package. One useful tool if you plan to do much OCR work is the Mustek Scanning Desktop icon toolbar. Using this toolbar, you can send OCR scans directly to your word processor or fax.

The Paragon 1200SP uses Mustek's exclusive ONE-PASS scanning technology, which is a unique combination of a true-color charged-coupled-device (CCD), hardware, software and firmware. The 1200 SP is almost six times faster than three-pass scanners and up to twice as fast as competing single-pass scanners.

The Paragon 1200SP is perfect for any designing, publishing or prepress need.

Paragon 800SP

The Paragon 800SP is a single-pass, 30-bit flatbed scanner. It offers an optical resolution of 400 x 800 dpi.

The single-pass 800SP also has high speed text reading capability. It's bundled with the Image Pals 2 GO! image editor. It also provides the JPEG compression program to minimize your storage space.

The Paragon 800SP also uses Mustek's exclusive ONE-PASS scanning technology (see above).

Paragon 600 II SP

The Paragon 600 II SP is a 24-bit flatbed scanner. It offers an optical resolution of 300 x 600 dpi and an interpolated resolution of 4800 x 4800 dpi. It's a small scanner (11.4 x 16.1 inches) but on the bright side, it will require very little desk space. The overall dimensions of the 600 II SP have been reduced by over 50%, making it one of the most compact and efficient flatbed scanners in the world. It's also a less expensive scanner (about $299), so it won't take much from your budget.

The Paragon 600 II SP is a complete scanning system, including everything needed to scan photographs, logos, illustrations or text. Software and interface kits for both Macintosh and PC compatible computers are included.

The Paragon 600, like the 800 and 1200, uses Mustek's exclusive ONE-PASS scanning technology. The innovative design of the 600 II SP makes it up to 6 times faster than three-pass scanners and up to 2 times faster than competing single-pass scanners.

It's bundled with the Image Pals 2 GO! image editor. It also provides the JPEG compression program to minimize your storage space.

Nikon

Scantouch 210

Although this is an expensive scanner (about $700), it may be worth considering if you're looking for speed and versatility. Its optional add-ons are equally as expensive. The optional automatic document feeder is about $695 and the transparency adapter is about $495. The software bundled with the scanner is another indication of its higher cost. It includes Adobe Photoshop LE (not to be confused with the limited PhotoDeluxe) and Caere's OmniPage LE software.

The 24-bit, single-pass Scantouch previews a letter-sized scan (8.5 x 11 inches) in 5.9 seconds and scans the document in about 24 seconds at 300dpi. Its resolution is 300 x 600 dpi optical or 4800 x 4800 interpolated.

Even images scanned at a low dpi by the Scantouch came out with excellent quality. The slow, powerful scanner reproduced photo images faithfully and would be a useful tool for someone in graphics design or other areas where superb image rendition is necessary. This is an excellent machine that epitomizes everything about traditional scanners—including the price.

Pacific Image Electronics

ScanAce

The ScanAce is 30-bit color flatbed scanner providing an optical resolution of 600 x 300 dpi and an interpolated resolution of 9600 x 9600 dpi. It's touted as a high-quality, low-cost, single-pass flatbed scanner

ScanAceII

The ScanAce II has an optical resolution of 600 x 1200 and an interpolated resolution of 9600 x 9600. Its scan area is 8.5 x 14 inches.

Although the ScanAce II will give you quality scans, the tradeoff is speed. The ScanAce II can take minutes to scan the same image that takes several seconds on other scanners.

It is bundled with ImagePals 2 GO! from Ulead for image editing and TextBridge Classic from Xerox for an OCR package.

Unless you have a lot of patience or time or don't use a scanner very often, the slow speed of the ScanAce II may be a problem for you.

ScanAce III

The ScanAce III is a 36-bit flatbed scanner offering an optical resolution of 1200x 1600 dpi and 9600 x 9600 interpolated resolution.

Plustek

Plustek FBII

This is a 24-bit color single-pass flatbed scanner. It offers an optical resolution of 300 x 600 dpi and an interpolated resolution of 4800 x 4800 dpi.

The FBII was one of the first 24-bit color flatbed scanners to break the $300 price barrier. It connects to your PC through the parallel port so no interface card is needed. Designed for non-technical users who are likely to be attracted by the price, the FBII specifications and features include a no-tools-needed installation and an "action button" on the scanner body.

The generous software bundle includes an OCR package (Recognita OCR), image editor (Image-In) and Plustek's own Action Manager that allows the scanner to redirect scanned images to other software or peripherals for faxing, copying or other processing (such as language translation).

Sharp scanners

JX-330

The Sharp JX-330 color image scanner may be overkill at $1,499 if you're only scanning images for the Internet. However, this 600-by-1200-dpi scanner includes a *full* version of Adobe Photoshop 3.0, which alone is an $895 product.

The Sharp JX-330 is a 24-bit scanner and offers an optical resolution of 600 x 1200 dpi and an interpolated resolution of 2400 x 2400 dpi. The preview scan is one of the fastest for a consumer-level flatbed scanner.

Tamarack Technologies Inc. scanners

Z1-600 and Z1-1200 scanners

The Z1-600 is a single-pass 30-bit scanner (1.07 billion colors). It offers an optical resolution of 300 x 600 dpi and interpolated resolution of 2400 x 2400 dpi. It features a scanning size of 8.5 x 11 inches. It's easy to learn and simple to use—the scanning solution for all your business needs.

The Tamarack Z1-600 flatbed scanner

It uses an advanced modified ASIC chip to achieve scan speeds up to 40 percent faster than conventional scanners. For example, it can scan a 300-dpi, 30-bit color letter-size document in less than a minute.

It includes software drivers, an image editor and OCR software. An optional transparency adapter is available for slides, transparencies and negatives.

The Z1-1200 is another 30-bit scanner and is a larger version of the Z1-600. It offers an optical resolution of 600 x 1200 dpi and interpolated resolution of 4800 x 4800 dpi. Most of its other features are identical to the Z1-600 scanner.

ArtiScan P24

The ArtiScan P24 is a single-pass 24-bit scanner. It offers an optical resolution of 300 x 600 dpi and interpolated resolution of 1200 x 1200 dpi. It features a scanning size of 8.5 x 11 inches. It's also a fast scanner (requiring about 70 seconds for a letter-size document).

One of the exciting features of the P24 is that it connects to your PC's parallel port. This makes installation very quick and easy. You don't have take apart your PC to install a SCSI card. One mouse click is all that's needed to install and begin using the ArtiScan P24. A pass-through connection is available that lets you connect your parallel printer and the scanner at the same time.

The P24 is bundled with Corel PhotoPaint and Xerox Textbridge (OCR software).

UMAX Technologies

Astra 600S

The Astra 600S is a new 30-bit single-pass scanner from Umax. It offers an optical resolution of 300 x 600 dpi and 4800 x 4800 dpi interpolated resolution. Its maximum scanning size is 8.5 x 14 inches in size.

165

A Quick Look At Some Of Today's Popular Scanners

Manufacturer	web site	Passes
Agfa scanners StudioScan IIsi	www.agfahome.com	Single
Canon IX-4015	www.ccsi.canon.com	Single
Canon IX-4025	www.ccsi.canon.com	Single
Epson ES-1000C	www.epson.com	Single
Epson ES-1200C	www.epson.com	Single
Epson Expression 636	www.epson.com	Single
HP ScanJet 4c	www.hp.com	Single
HP ScanJet 3c	www.hp.com	Single
Info Peripherals ImageReader FB	www.infoconnection.com	Single
Info Peripherals Image Reader Express	www.infoconnection.com	Single
Info Peripherals Image Reader Elite	www.infoconnection.com	Single
Microtek ScanMaker III	www.mteklab.com	Single
Microtek ScanMaker E6	www.mteklab.com	Single
Microtek E3	www.mteklab.com	Single
Mustek Paragon 1200SP	www.mustek.com	Single
Mustek Paragon 800SP	www.mustek.com	Single
Mustek Paragon 600 II SP	www.mustek.com	Single
Nikon Scantouch 210	www.nikonusa.com	Single
Pacific Image Electronics ScanAce	www.scanace.com	Single
Pacific Image Electronics ScanAceII	www.scanace.com	Single
Pacific Image Electronics ScanAceIII	www.scanace.com	Single
Plustek FBII	www.plustek.com	Single
Sharp JX-330	www.sharp-usa.com	Single
Tamarack Technologies Inc. Z1-600	www.tamaracktechnologies.com	Single
Tamarack Technologies Inc. Z1-1200 scanners	www.tamaracktechnologies.com	Single
Tamarack Technologies Inc. ArtiScan P24	www.tamaracktechnologies.com	Single
UMAX Technologies Astra 600S	www.umax.com	Single

This table is as accurate to our best knowledge but please check the manufacturers web site for more information. Prices, features and even models can change without notice. Also check their websites for other scanners which they may manufacture.

Bit depth	Optical resolution	Interpolated resolution
30-bit	400 × 800	2400 × 2400
24-bit	400 × 800	1600 × 1600
27-bit	300 × 600	1200 × 1200
30-bit	400 × 800	1600 × 1600
30-bit	600 × 600	2400 × 2400
36-bit	600 × 600	4800 × 4800
30-bit	600 × 600	2400 × 2400
30-bit	600 × 1200	2400 × 2400
30-bit	600 × 1200	2400 × 2400
24-bit	300 × 600	4800 × 4800
24-bit	300 × 600	4800 × 4800
36-bit	600 × 1200	4800 × 4800
30-bit	600 × 1200	4800 × 4800
24-bit	300 × 600	2400 × 2400
30-bit	600 × 1200	9600 × 9600
30-bit	400 × 800	6400 × 6400
24-bit	300 × 600	4800 × 4800
24-bit	300 × 600	4800 × 4800
30-bit	300 × 600	9600 × 9600
30-bit	600 × 1200	9600 × 9600
36-bit	1200 × 1600	9600 × 9600
24-bit	300 × 600	4800 × 4800
24-bit	600 × 1200	2400 × 2400
30-bit	300 × 600	2400 × 2400
30-bit	600 × 1200	4800 × 4800
24-bit	300 × 600	1200 × 1200
30-bit	300 × 600	4800 × 4800

Get Creative: Scanning Tips And Using A Scanner

Chapter 9

Get Creative: Scanning Tips And Using A Scanner

Installing And Planning

Don't Know What To Scan? Try These Ideas

Getting Quality Scans

Obviously, one uses a scanner is to turn a copy of an object or image into a digital file that you can load into your PC. Then you won't have to retype, redraw or otherwise recreate the object or image. Using a scanner is usually very simple and involves only a few steps. However, even experienced users can occasionally become frustrated at the results of their scan. We'll provide some tips on using a scanner to avoid these frustrations in this section. Remembering that your scanner isn't much different from a photocopier may remind you how easy scanning really is.

Although you'll probably be scanning your favorite photos mostly, keep in mind that you can also scan many everyday objects. Experiment a little bit with watches, ties, pens and coins. You can scan virtually anything that you can fit on the bed of your scanner. These objects become digital images after you've finished scanning them. What does this mean? Well, it means you can edit, tweak, manipulate and even insert text or apply magical special effects.

For example, we scanned the following photo and loaded the file in an image editor called PhotoStudio:

Then we applied a special effect called "Spiral" to one of the buildings:

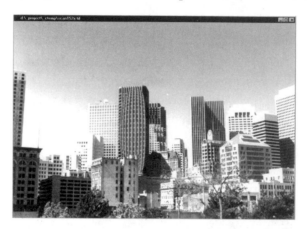

We'll talk more about image editors and how to use them in Chapters 10-14. First, we need to talk about installing a scanner and how to get a high-quality scan.

Installing And Planning

System requirements for scanners

Today's Pentium-class PCs are perfect for using with a scanner. These fast and powerful processors should have no problem running and controlling a scanner. However, some older (pre-486 class) PCs may not work as well with a scanner. So before buying a scanner, make certain your computer system meets all the requirements listed by the scanner manufacturer.

Today's scanner typically requires a Windows PC with at least a 486 processor. The amount of RAM that is installed on your PC is also important. Keep in mind that using a scanner and an image editor are memory-intensive operations for a PC, so make certain your PC system has at least 12 Meg of RAM installed (although we recommend at least 24 Meg). A good idea is to base the system requirements on the image editor you plan to use. By meeting the system requirements for the image editor, your PC should have no trouble running and controlling a scanner.

Always make certain to power down (switch off) your PC system before installing a scanner. This is especially true when installing the SCSI card and connecting the scanner to your PC. **Never** connect a scanner to your PC until you switch off the power for both.

Installation tips

Today's scanners are mostly "plug and play." In other words, plug in the SCSI card so your scanner can "talk" to your PC and install the scanner software. Then you're all set to start scanning your favorite images.

However, despite being "plug and play," you can still run into installation problems. Maybe the following tips will help you avoid some of these common problems:

1. Insert the scanner card (the SCSI card) into an empty expansion slot on your PC. Read the owner's manual for both the scanner and the interface card for information on installing the card.

2. Connect your scanner cable from the scanner card to the scanner.

3. The scanner should include installation software that you'll find on one or more floppy diskettes. These disks contain drivers allowing your PC to communicate with your scanner.

4. Once you've installed the drivers, load your favorite image editor. The quickest way to scan an image and then work with the scanned image is to "call up" your scanner from the image editor. Most image editors today are TWAIN compliant. Select the **File/Acquire...** command. When the image editor has connected to your scanner, you'll see a TWAIN dialog box appear (similar to the following):

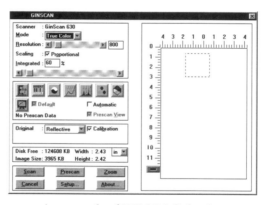

An example of TWAIN dialog box between a scanner and an image editor

Don't overlook the manual

Although it sounds obvious, the owner's manual is probably the best source to find correct installation information. We say "probably" because, unfortunately, many scanners are manufactured overseas. Therefore, the manuals are not always well written or don't give clear directions. If possible, look at the manual before buying a scanner. Make certain all the instructions are clear and easy to follow.

174

Also, some manufacturers include accessories that are designed to make the installation easier. For example, a few manufacturers include a videotape that shows how to install a scanner. Other manufacturers include books that explain color scanning in greater detail. These accessories can add to the price of the scanner, but they'll help you understand how to install and use your scanner faster.

Connections

We've mentioned the SCSI card already but you'll, of course, need something to connect the card to your scanner. The scanner should have a cable included for this. The length of the cable when connecting a PC and a scanner should be under 12 feet to maintain a quality signal. This usually isn't a problem if you're using the PC and scanner at home. However, this could be a problem if you're connecting the scanner and your PC at work or in an office. A simple solution if the cable length becomes a problem is to move your scanner and PC closer together. A more expensive and undesirable option is to consider another type of scanner.

Be careful with proprietary interface cards

Some manufacturers include a special type of SCSI card with their scanners that will support only their scanner. This card is called a *proprietary interface card*. Although these cards usually work fine, they can sometimes cause problems. Here are a few problems you might have when using (or trying to use) a proprietary interface card:

➤ A proprietary interface card isn't as versatile as normal SCSI cards.

➤ Since these cards are sometimes older, 8-bit cards, they cannot process data as quickly as a 16-bit card.

➤ Some proprietary interface cards may require additional installation steps, such as setting small switches or jumpers.

➤ They may conflict with other devices already installed in your computer.

The easiest way to prevent the problems of using proprietary interface cards is to avoid buying a scanner that requires one. Consider a scanner that uses a proprietary interface card only if you feel you're getting a great deal or prefer that particular type of interface.

SCSI is a much better alternative

A scanner that uses a SCSI interface is a better alternative than one using a proprietary interface card. The main advantage with a SCSI interface is that you can use the same interface with several devices. A proprietary interface card can be used only with one device (the one with which it was intended to be used). You can connect a SCSI interface to any combination of CD-ROM drives, removable hard drives, tape drives, modems and even other scanners.

> Many hand-held and sheet-fed scanners don't require a SCSI card because they connect to the parallel port on your PC.

Don't Know What To Scan? Try These Ideas

OK, so now you've connected and installed everything and you're all set to start scanning. Now you have a new problem—what do you scan? Fortunately, that shouldn't be much of a concern because today's scanners let you scan virtually anything. It simply takes a couple of mouse clicks to scan an object. Maybe not everything will scan perfectly or as expected; for example, the entire image may not be in focus or aligned correctly. However, be optimistic and consider that maybe it will only add to the "artistic value" of the scan.

For example, are you tired of looking at the same wallpaper on your PC? Try scanning some neckties and use the resulting scans as new wallpaper. The following image is an example of some bland, old wallpaper.

An example of tired and old wallpaper

However, by scanning a necktie and then using an image editor to tweak the image, we created this new wallpaper:

Example of new wallpaper created by scanning a necktie and then using an image editor to tweak the image

If you haven't bought a scanner yet, maybe the information in this section will help persuade you to buy one. You'll see that a scanner can be used for more than just scanning documents and paper. We'll talk about several interesting, neat and fun things you can do with a scanner. Of course, we'll also talk about the practical reasons for using a scanner (such as archiving important documents).

Create a visual database

Perhaps you've been an unfortunate victim of a fire, theft or other damage, or know someone who has been. If so, you'll understand how valuable pictures can be when it is time to talk to the insurance adjuster. You can create a visual database by combining photos and your PC. This is a great way of keeping a complete record of valuable property such as art, coins or other collections. Owning a picture of a valuable item that is lost can be very useful in settling disagreements about its ownership or condition.

Scan photos of your valuable collections, insert the scans and a description in a Word document

This is an easy project to do. Start by using a camera (35-mm or even digital) to snap pictures of your collection and valuable possessions. Then scan the photographs. Use an image editor to enhance or enlarge the photos, if necessary.

Insert the photo in a word processor document with information about the item, such as its condition, purchase date, purchase price, current value, etc.

First, try scanning the jewelry or other small items. This may avoid the costs and time involved with the photography. Later in this chapter we'll talk about scanning 3-D objects.

Catalog your collection

A related idea is to use a scanner to catalog your collection. A collection doesn't have to be limited to coin or stamp collectors. Perhaps you're a collector of other items: pinup calendars, comic books, recipes or even newspaper clippings, for examples.

Use a scanner to scan your collection. Then import the scanned file into a database or word processor and catalog every item in your collection. Then you'll be able to find anything in a fraction of the time. If you're using a database, you can sort the items in a particular order (i.e., alphabetical, value, date, etc.). This is also a good idea if the collection is valuable (see above).

Magazine/newspaper articles

Use a scanner to keep copies of newspaper articles and magazine articles. A scanned image of a magazine or newspaper article is usually better quality than a photocopy of the same article. Besides, you can add the article into a letter by importing it into a Word document.

Examples os some recent headlines scanned from a newspaper

Also, newsprint fades after a short time and magazines can become lost or thrown away. However, if you scan the article you want to keep, you'll always have a copy of it. This is a great way to keep copies of important and unusual news headlines, interesting stories, etc.

Is your pet missing?

You've probably seen "LOST PET" messages on telephone poles or grocery store bulletin boards. Did you remember much about the message other than a group of words? Well, if your pet ever decides to run away, you can also use a group of words to describe the lost pet. However, why not scan a photo of your lost pet and import the photo into a Word document. This will add more impact to the message and is much more effective than simply creating a flyer describing the pet. Potential rescuers are more likely to remember a picture of the missing pet with a description than just a description alone.

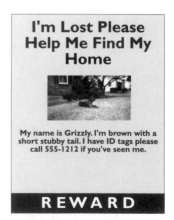

Archiving important documents

Using a scanner is also an excellent way to archive important documents. These include savings bonds, deeds, tax forms, sales receipts, birth certificates, important family documents, etc. These documents are easy to misplace but hard to replace. Most electronic files of tax forms, receipts, etc., are considered legal documents by the IRS (check with your tax consultant first).

Scan your important documents and store all the images on a floppy diskette or removable storage device such as a Zip drive. Then keep this diskette or cartridge separate from the original documents. You can then print files that are stored on the diskettes or cartridges if necessary.

Add a professional touch to your documents or start a family newsletter

We mentioned that pictures help break up text or add emphasis to a story. So instead of sending long-winded letters to your friends, add a few scanned photos of your trip, your child's birthday party, wedding or whatever.

A family, especially a large family, usually always has news of some sort to share. If so, why not start a family newsletter. A family newsletter is great for grandparents and other relatives that you don't get to see often. The best part is that everyone in the family can add to the newsletter by writing stories about the news in their lives. Use your scanner to scan photos and emphasize the stories and news.

Don't panic; you won't need expensive desktop publishing programs to create a family newsletter. Most word processors have basic page layout features that you can use for a simple newsletter. You can also use a program like Microsoft Publisher to create the newsletter.

Save your signature

You're probably one of the millions who are sending and receiving e-mail messages today. If so, you've probably also noticed that communicating by computer can be very impersonal. How many e-mail messages have you received with a signature? The answer is probably very few, if any. However, you can personally sign your e-mails. Simply scan your signature and save it as a TIFF file. Then add it to your e-mail or fax documents to add a more personal touch to e-mail messages.

You might even be able to send photos as an "attachment" using your e-mail service. If so, this is a great way to use scanned images to emphasize the text in your e-mail message.

Use a photo to help the sale

A picture of what you're selling or promoting can usually do more to generate interest than using plain text to explain the item. Scan a photo of whatever you're selling and add the photo to the text. The item for sale can be as large as a house or boat or as small as articles for a summer garage sale.

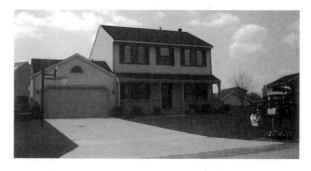

Use a scanner as a photocopier

Use your scanner instead of a photocopier. For example, you're leaving for vacation and want friends to know your itinerary. You could write down the itinerary for everyone but something could be overlooked. A better way is to write down the itinerary once and then scan it. Then you can e-mail the itinerary to those on your list.

Some scanners include OCR (optical character recognition) software. You can use this type of software to create a cookbook of favorite recipes by manipulating scanned text in a word processor or desktop publishing program. For more information on OCR software see Chapter 6.

Make a visual family tree of old photos

Millions of people are interested in genealogy and use their PCs to create or maintain a family tree. Most genealogy software will let you add a scanned photo to accompany information on each member in your family tree. This is a great way to add "personality" to your genealogy. You may be surprised (and maybe depressed) at who resembles who in your family.

Use a scanner to "archive" old or important photos. Then, in a sense, you have backups of important photos. Photos that are passed from person to person, family photos for example, can become lost or are never returned. Use a scanner to send quality copies to everyone that wants a copy. You'll find the image quality to be better than using a photocopier.

Removing unwanted subjects or objects from images

If you're like most people, you've probably suffered through a bad divorce or breakup or maybe you just want to forget a former best friend. Unfortunately, you probably have good photos in which these people appear. Instead of throwing away all the photos, use a scanner and an image editor to remove the unwanted person from your photo. Add a high-quality color printer to your setup, and you'll even be able to print out replacements for the original.

The following is an example of how you can remove unwanted subjects or objects from an image. We'll talk more about this in Chapters 10-14.

The top is the original photo, the bottom is the same photo but with the people removed

Immortalize your child's artwork

Turn your child's artwork hanging on the refrigerator door into a screen saver or wallpaper for your PC. You can scan virtually anything. Paintings, crayon scribbles or even projects made with yarn can be scanned and saved. Many image editors have a screen saver feature that will turn your child's artwork into a screen saver or slideshow.

In addition to showing off your children's drawings on the refrigerator door, you can show off the same artwork on the Internet. Don't worry if the artwork isn't paper or even completely flat. We'll talk soon about scanning 3-D objects.

Make your web site sizzle

Graphics make the World Wide Web visually interesting. The web sites that not only win awards but get the attention of Internet surfers use graphics. This is especially true for Web site home pages. Web sites displaying only text will not get much attention (or at least not the right kind of attention).

To add some "umph" to your web site, scan in photos that relate to the subject of your page. Use the photos to emphasize the information in the text. Add some inviting pictures to attract visitors to a link, add personality to your pages and encourage the surfer to look through your complete site. Web surfers are impatient, so use color graphics to consolidate important information and maintain their attention. Make certain to use photos at small sizes and at low (4-bit or 8-bit) color depths. Otherwise, the images may take too long to download.

Create your own holiday cards and wrapping paper

You may never need to buy greeting cards again. Use your scanner to scan personal items (family photos, objects from a collection or an illustration you drew by hand). Then repeat the pattern over the entire page and print to create a customized card or even gift wrap.

Create a digital photo album

Try creating a digital photo album to memorialize a family reunion or vacation or just to organize your photos. Software is available (such as Creative Wonders Family Album Theatre) that you can use to create a digital photo album.

A new kind of slide show

Don't bore your friends and neighbors with old fashioned slide shows. Many image editors, including those we talk about in Chapters 10-14, can create slide shows. So, use your scanner and these image editors to create slide shows of your photos. There's no guarantee that your guests won't still be bored, but it will at least be a new type of slide show for them.

Use a morphing program

Have some good laughs with your scanned photos. Use a morphing program to add some crazy fun to family photos or other images. Blend several photos of your children at different ages and watch them grow. Turn photos of your cat into the neighbor's dog. The results will be entertaining, at the very least.

Scan 3-D objects

Use your scanners to scan more than just images on paper. A fun and creative activity is to scan 3-D objects with scanner. Don't be afraid to experiment; if something doesn't look good or scan just right, all you've lost is a little time. Any 3-D object that you want to scan should be relatively flat but, more importantly, the object must fit on the scanning bed. If you don't want the white background of the scanner cover to appear in the scan, place a colored sheet of construction paper on top of the object for an added effect.

We mentioned neckties above but try other articles of clothing too (i.e., your favorite dress pattern). Try a sheet of fabric softener or a handful of lint from the dryer. Scan other objects such as keys, paper clips, push pins, cotton swabs or cotton balls, sand or dirt (**don't spill** any inside the scanner and **don't scratch** the glass).

Other items you can try include buttons, pencils, pens, nuts and bolts and countless other items.

Notice the shadow that appears on some 3-D objects in one direction after they're scanned (see the needles/buttons example below right).

This shadowing effect can make the image look better than the same scanned image without shadows. This effect can add some perspective or depth to the 3-D objects.

Scanning food

Some food can be fun to scan—try M&Ms, jelly beans, sugar. The resulting scan of many foods can look surprisingly good. As we mentioned above, the scanner creates a soft, natural shadow that is similar to the effect of studio lighting.

One note of caution: feel free to experiment but don't damage your scanner. Also, remember to clean the scanning bed carefully when you're finished scanning food.

Examples of how lint (previous page), paper clips (top) and nuts/bolts/pushpins (middle, scanned with a black background) and buttons/needles (bottom) appear when they're scanned

We don't suggest scanning any liquid—it's simply too dangerous.

The following page shows some examples of how sugar and rice appear after they're scanned.

After scanning food or another 3-D object, take the time to clean your scanner.

187

Scanning some sugar (left) and rice (right), both against a black background

Scanning great background effects

Use a textured background to add depth and interest to multimedia presentations, web sites or even wallpaper for your PC. You may never run out of background ideas to scan. As we've said, don't limit yourself to paper and photos. Place leaves, coins, cloth, keys, certain foods (no liquid!) or even tinfoil on the bed of your scanner. Then save the scanned file for use in later projects.

*Money and coins can make interesting effects for
projects or computer wallpaper*

*Scan money and coins or even tinfoil (left) and sandpaper (right)
for some great background effects*

Example of using the tinfoil scan (above) as a background for our PC wallpaper

You can find many items around your house that can make an interesting backdrop or computer wallpaper. Check your closets, drawers and especially "junkboxes." Whatever you use as a background effect, be careful not to scratch the glass of the scanning bed (for example, with the sandpaper in the example above).

Copy road maps when you need to give directions

If you've ever had out-of-town or out-of-state friends or relatives visiting you've probably sent them a list of directions. Now you can use your scanner to scan a map and indicate the best route to reach you right on the map.

This is a much more effective way of showing directions than a list of "Right turn at the fourth light (not flashers) and left onto the street just before the Big Boy." Instead of sending them just a list of directions, scan a map and add that image to the directions.

Scan a map showing the best route(s) when you have out-of-state friends or relatives visiting

Getting Quality Scans

Despite, or maybe because of, the recent increase in scanner sales, many users still have problems getting the best quality scans possible. Even users who are "experts" on virtually everything else when using their PCs have less-than-satisfactory results when using scanners.

However, using a scanner doesn't have to be a scary adventure. Scanning is really an easy process: You simply place the object, document, photo or whatever you want to scan on the scanner, load your TWAIN-compliant image editor and select the **File/Acquire** command. The scanner starts the scanning process and then sends the image to your image editor so you can tweak it or store it as a file.

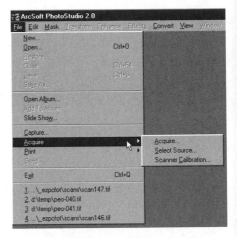

*The **File/Acquire...** command in PhotoStudio*

Although using a scanner is fairly simple and straightforward, there are a few things you should know before you start scanning. The following suggestions will help you get the best results from your scans.

Plan ahead

Keep the following goals in mind when you plan your scanning project. These questions will become increasingly relevant as you get more familiar with your scanner and software.

1. How do you want the final scanned image to look?

2. Where will the final scanned image be used?

3. What image editor do you plan to use?

4. How will the image be reproduced, on what type of printer and what type of paper?

Scanning for quality

We've said that using a scanner is easy and straightforward. However, there's more involved than simply placing the object you want to scan on the scanning bed. You need to consider a few other factors, too. With these in mind, we'll show you how to get high-quality scans from your scanner. We'll also provide a few other tips and suggestions.

1. Make certain that you're using the correct hardware and everything is connected correctly. For example, make certain your PC has enough RAM and that enough space is available on your hard drive to store scanned images. We've said it before so keep it in mind: Scanned images, especially color, require a lot of hard drive space. So you may need to add RAM, use a larger hard drive or use another storage device.

2. Make sure your scanner matches your scanning needs. A 36-bit scanner can produce better color and grayscale scans than a 24-bit scanner.

3. Make certain that your video card and monitor support the resolutions necessary to display high-quality images. Use a 24-bit (also called true color) video card that is set to "millions of colors" or "16.7 million colors" for the best quality.

4. The original image or photo must be good and clean. Remember, better originals will always produce better scans. Types of photos to avoid include those that are out of focus, dirty or poorly exposed (see the following example).

*This is an example of what happens when a
poorly exposed photo is scanned*

Even the best scanning software or image editor can only improve image quality to a certain point, no matter how much time you spend retouching.

Also, if possible, avoid scanning halftone images or printed images (i.e., pictures from magazines). Scanning these images usually results in a *Moiré* (mwa-ray') effect. This is an undesirable pattern in color printing. Image editors may be able to remove some of the Moiré effect, but it's best to avoid the problem if possible. In other words, start with a clear original (see below for more information on Moiré patterns).

*This image is an example of the Moiré patterns that
usually result from scanning halftone images*

193

5. Keep your scanner clean. Use rubbing alcohol on a lint-free cloth to carefully clean the scanning bed before you scan images. This will help avoid scanning flecks of dust along with the image. Don't think this can be a problem? Check the following image:

*An otherwise acceptable scan except we did
not clean the scan bed before scanning the photo*

The bed was not cleaned before this image was scanned so a small hair appears near the bottom of the image.

6. Choose the right image type and set the correct resolution and scaling before you scan. Scan line art as line art (even if it isn't black and white). To produce smaller files and save some time, scan black and white photos as grayscale (not color). Also, produce smaller file sizes by scanning a color image as gray scale if you're planning to print it in black and white.

7. Use the color correction feature in the scanning software if it's included with your color scanner. This feature will help you obtain more accurate colors when scanning color images.

8. Finally, take your time and don't be afraid to experiment. Every combination of PC, software, printer and scanner is different. If something doesn't look right, simply do it over, maybe adjusting the settings. Have some fun learning how to get the best results from your scanner/PC combination.

194

Overcoming typical scanning problems

Bad contrast

The term *contrast* refers to the difference between light and dark pixels. A sharper contrast is produced when the range between light and dark pixels is higher. The following example shows the contrast in the photo is too low. The contrast must be increased in this photo.

The contrast in this photo must be increased

Askew

This is a frequent problem when using a scanner. It's when the scanned image appears crooked or out of line. The reason is that the photo was placed incorrectly on the scanning bed. Notice how the image in the following illustration is slanted, or crooked, to one side.

*Example of what happens to a scan when the photo
is placed incorrectly on the scan bed*

Avoiding this problem is simple. Make certain the photo or image is straight and aligned with the side and bottom/top of the scanner. Then rescan the image. Another possibility is to use the **Rotate** command in an image editor. The problem with using the **Rotate** command to line up a crooked scan is that it requires a lot of guesswork. So it's probably faster and easier to just rescan the photo.

Pixelization

A problem associated with scanning images at resolutions that are too low is called *pixelization*. If the image doesn't look right because the resolution was too low, rescan the photo at a higher resolution.

The file size of the image will, of course, change dramatically. However, the resulting scan will be much better. Another alternative is to use an image editor to adjust the focus. Select the focus or sharpen commands to smooth sharp areas or enhance dull ones.

Moiré patterns

Moiré patterns are a common problem when scanning photographs from a magazine or a book. The best solution to this problem is to avoid Moiré patterns altogether. This is especially true if high-quality scans are crucial to your project.

However, since this may not always be possible, use an image editor that can reduce Moiré patterns. An even better idea is to rescan the original image. Scan the image at the highest resolution possible. Then select the Despeckle filter or command in your favorite image editor. Then decrease the number of colors used to fewer colors.

Another possibility is to use the descreening function that the TWAIN driver may have. Unfortunately, using the descreening function often affects the overall quality of the scan. It won't hurt to try the descreening function before scanning the image. Compare that scan with the scan using the Despeckle filter or command.

Unneeded backgrounds

Sometimes background data, such as a border or text, results from having too large of a scanning area. Try reducing the scanning area or use the cropping tool in an image editor to remove the unneeded area. You're only increasing file size by having a scanning area that's too big.

Although you can use the Crop tool in an image editor, there's no reason for you to scan this extra area. Notice how large we set the scanning in the following example (highlighted by the dark border):

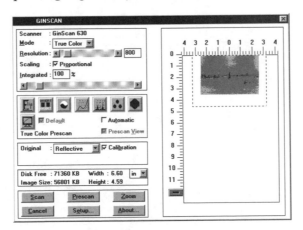

To scan this image would require several extra (and unnecessary) minutes and take up unnecessary hard drive space. However, by adjusting the

scanning area, not only did the file size become more manageable (almost half the size) but the scan time was much faster. Further, even more time was saved because we didn't need to crop the image.

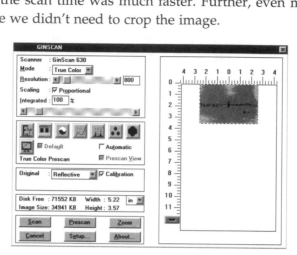

Color and brightness

The software included with most scanners lets you adjust color and brightness levels before you scan an image. Since these levels are set *before* the image is scanned, it's very easy to set the levels incorrectly. The result can be images that are too bright or contain too much of a single color (see the example below).

*This was not a foggy day at the Mackinaw Bridge
—the brightness level was set too high in the scanner*

If you need to adjust the brightness or contrast levels, use an image editor instead of the scanner's software levels. Not only can you determine levels more accurately, setting these levels is much easier and faster using an image editor.

Part of the image is distorted or blurred

This problem is usually from a wrinkle, tear or other problem in the document or photo. If the photo is not torn or wrinkled, make certain the document is as flat as possible.

Also make certain it touches the scanning bed completely. The document may have moved if you accidentally moved the scanner while it was scanning. Also, make certain the scanner is clean, on an even surface and not tilted.

Scanning thin paper

Scanning thin paper can result in images or text on the "back side" showing through on your scan.

A scan that is distorted, damaged or blurred may have several causes

To prevent this, place a sheet of black construction paper on top of the paper you're scanning before closing the cover. Then lower the threshold or increase the brightness to compensate for the black paper. The quality of the image may suffer a little but the scan will be much cleaner.

The following illustration shows a scan of an original image (left) and the same image after following these steps.

> **GEMINI (May 21 - June 21)**
> Working with your hands is a natural for you, for manual dexterity is a gift of your Sun Sign. But as an air sign you are also intellectually gifted, so a hobby that enables you to express both these talents will satisfy you most. Thus you would probably enjoy making and playing complicated scientific games like chem-chess (chess played with chemistry formulas) and Latin scrabble. Of course, you will probably wind up being a crazy old, eccentric kook, hiding your money in coffee cans and living alone, with a horde of schizophrenic cats and maybe one dog or lizard. Sure it's sad, but that's the price of genius. And it's well worth it.

> **GEMINI (May 21 - June 21)**
> Working with your hands is a natural for you, for manual dexterity is a gift of your Sun Sign. But as an air sign you are also intellectually gifted, so a hobby that enables you to express both these talents will satisfy you most. Thus you would probably enjoy making and playing complicated scientific games like chem-chess (chess played with chemistry formulas) and Latin scrabble. Of course, you will probably wind up being a crazy old, eccentric kook, hiding your money in coffee cans and living alone, with a horde of schizophrenic cats and maybe one dog or lizard. Sure it's sad, but that's the price of genius. And it's well worth it.

Scanning thin paper, like newsprint, often presents its own problems but by following the suggestions on page 199, you can avoid most of those problems (original on the left, tweaked image on the right)

Put some distance between your scanner and your printer

Don't place your scanner too close to a printer, especially a dot matrix printer. This is particularly true if you plan to use both at the same time. The vibrations resulting from the printer can cause scans to come out blurred or unfocused.

Keep your scanner clean

We've said this before but it's so important we'll repeat here (and probably many other times, too): Keep your scanner clean. Clean both the lens and the scanning bed frequently. Some scanners include pre-moistened towelletes for cleaning the lens and glass. Another option is to use a chamois cloth or Tyvek and rubbing alcohol. Do not use any abrasive cleaning cloth or materials to clean the lens and glass bed. Read your owner's manual for specific cleaning instructions.

Check the focus

Here's a tip if you think your scanner's focus may be offline. Set your scanner to its highest optical resolution and make certain it's in full-color mode. Then scan a sheet of graph paper. Then use an image editor to zoom in on the edges of horizontal and vertical lines. Look for blue and red fringes at the edges of lines. This is a sign that the scanner is improperly calibrated.

200

Scanning thick or warped documents or images

The edges of the image may be discolored if the document you are scanning is very thick or warped at the edges. Use a sheet of black construction paper and cover the edges of the document to block outside light. A document extending beyond the limits of the scanning bed may also produce discolored edges. In this case, you would need to change the position of the document.

Finding the "sweet spot"

To determine the sweet spot by following these steps, you must use an image editor that has an Equalize command (or its equivalent). See Chapters 10-14 for more information on using an image editor.

All flatbed scanners have spots within the scanning area that are better than others. This is true regardless of the optical resolution and even of the manufacturer and model. Try using this area, called the *sweet spot*, to get the best and most consistent scans. In other words, this is the area on the scanning bed where you should place the object you're scanning.

The problem is that locating or finding the sweet spot can be difficult. We cannot list or show the known sweet spots of even the best-selling scanners. The sweet spot isn't in the same location on each scanner. This is true with even the same models of scanners. However, we know how you may be able to find your scanner's sweet spot:

1. Make certain to clean the scanner, especially the scan bed, before continuing.

2. Place a clean white sheet of paper on the scanning bed. Make certain it covers the entire scanning bed of the scanner.

3. Scan the object using a very low resolution (for example, less than 100 dpi).

4. Use the **Equalize** command (or its equivalent) in your image editor to show minor differences within the image area. You're looking for dark spots or dark areas on the image. Your scanner's sweet spot will be an area void of these dark spots. These minor imperfections

accumulate over time due to normal wear, so you'll want to periodically recheck your scanner's sweet spot.

> Once you determine whether your scanner has a sweet spot, make a cardboard template of the sweet spot. This template will help you find the location of the sweet spot when scanning objects in the future.

Tips on OCR software

We've talked about OCR (Optical Character Recognition) software in Chapter 6 and how it converts scanned images into text. However, keep the following in mind if you're using OCR software. Most OCR software works well with modern fonts (those designed in the 19th and 20th

Running the test on our scanner shows that even a relatively new scanner can have some bad areas

centuries). However, older printed material or bad reproductions of any font will probably create problems. Typical problems for OCR software include broken letters, ligatures, uneven inking and old fashioned letterforms.

We recommend trying a test scan before scanning in a large amount of text. Not only can this save time but it might help reduce the error rate of the OCR software. Remember, the error rate should be *low* but not *zero* for most modern fonts. The error rate can increase as the size and clarity of the text decrease. Try adjusting the brightness and resolution settings on the scanner to lower the error rate. There's no benchmark for this, so you'll have to experiment to find the settings that are best for your scanner and OCR software. Unfortunately, you won't be able to do much with a badly faded photocopy or a 17th- or 18th-century font.

Errors usually result from any problem that breaks the shape of the letter. The following are some examples of how the OCR software may misread letters:

➤ The letter "d" may be read as "cl"

➤ The number "1" may be read as the letter "l"

➤ The letter "h" may be read as "b"

➤ The letter "e" may be read as a "c"

➤ An exclamation point "!" may be read as "l" or "1"

➤ If you're scanning text from a page with tinted or color areas, scan each colored area separately using different threshold and brightness levels.

Resolution tips

Resolution determines the level of detail recorded by the scanner. It's measured in dots per inch (dpi). In Chapter 6 we talked about the two types of resolution (*optical* resolution and *interpolated* resolution). Optical resolution is the more important and accurate resolution number. Interpolated resolution is resolution enhanced through software. Interpolated resolution may be useful for certain tasks (i.e., scanning line art). However, scanning color photos and other images with interpolated resolution usually produces inferior results.

It's probably obvious that image quality improves with higher resolutions. Scanners with higher dpi numbers have higher resolutions and usually provide higher quality scans. However, you can reach a point where increasing resolution only increases file size; the image quality won't noticeably improve. Also, it takes longer to print images that were scanned at higher resolutions. For most of your work at home, scans from 300 dpi to 600 dpi are usually good enough.

Choosing the best resolution setting

You may think that scanning at a higher resolution is always the best choice. However, this requires more time, memory and disk space. So, before scanning at the highest possible resolution, first consider the type of image you're scanning and what you'll be doing with the scanned image.

A simple way to determine the best resolution for your intended output is to learn the lines per inch (lpi) capability of your output device. Then multiply that number by a factor between 1.5 and 2.0. Don't be confused by the term "lpi." Many names are used for lines per inch (including screen frequency, screen ruling, halftone frequency and probably others). However, they all mean virtually the same thing. It determines the size for the halftone cells (which consist of printed dots) that make up a printed image. The size of the dots are measured in lines per inch. This is important because the relationship between lpi and dpi influences how fine or coarse an image appears on the printed page.

> This formula is a general rule of thumb. Your scanner or requirements may be slightly different. It is, however, a good place to start.

The level of lpi determines the quality of the printing job. The following are some common examples:

➤ Newspapers use low lpi levels (about 85)

➤ Magazines and books (including this one) use lpi levels from 133 to 150

➤ Fine art books may use up to 300 lpi.

So, for example, if you plan to insert your scanned images in a book or magazine, multiply 133 by either 1.5 or 2.0 to determine the best resolution for a scanned image. This gives us an answer of 199.5 or 266 for this example. So, the optimal resolution setting for your image would then be 200 dpi to 266 dpi (depending on how high the output quality will be).

If you're outputting images to a monitor (such as creating web pages), you don't need to scan images higher than 72 dpi. Monitors can only display images up to 72 dpi. Although you can use a higher resolution image, the only result will be larger file sizes; the image itself will not be any clearer.

When to use interpolated resolution

We've mentioned that the only time you should use interpolated resolution is when scanning line art. Examples of line art include logos, ink sketches or even mechanical blueprints. Although many people think of line art as only black and white, it can also be a one color graphic.

Scanning line art

When scanning line art, try setting the interpolated resolution to the level of your output device. For example, if your output device will be a 1200-dpi imagesetter, try setting the interpolated resolution to 1200 dpi.

This will produce smoother lines and eliminate some of the unwanted "jaggies" that usually appear in line art scans.

Enlarging small originals

Another example of when you may want to experiment with interpolated resolution is scanning small photographs. Small school pictures are a good example (or other photos that are about 1-inch x 2-inch). We'll assume the maximum optical resolution of your scanner is 600 dpi.

To enlarge the photo to two times the original size without losing detail, interpolate the resolution to 1200 dpi. This way, the image might retain clarity and sharpness even if you double the print size.

Scaling tips

When you hear the term "scaling" with scanners, we're talking about creating larger or smaller images. Scaling images with a scanner means you won't have to resize the images later using your image editor. Scaling in a sense has an inverse relation to resolution. In other words, the lower you set the resolution, the larger you can scale the image, without increasing the file size or appreciably degrading the quality.

For example, you're trying to scan a small photo at 600 dpi. To double the image size of the photo without losing any detail (yet keep the resolution at 600 dpi), increase the scaling to 200%. This will create a much larger file. To keep this file smaller, scale it to 200% and halve the resolution to 300 dpi.

You can, of course, scan the image at 100% and then enlarge it in your image editor. The image will, however, lose some quality. In this case, it's better to have the scanner do the work instead of the image editor.

Lower the DPI

You'll read it more than once in this book but we'll say it again here: Don't scan an image at a level much higher than that of your final output resolution. You'll just be wasting time and hard drive space making the files unnecessarily large. Another argument for this is time. Most scanners work much slower at resolutions above 600 dpi.

Dynamic range

Another important factor in obtaining quality scanned images is the dynamic range of a scanner. Dynamic range is the ability of the scanner to register a range of tonal values. This range of values is from near white to near black. A scanner with a good dynamic range can map input shades correctly to the output shades. Then you'll be able to see more detail in an image.

However, a scanner with poor dynamic range cannot detect as wide a range of tonal values. In this case, the scanner will fill in the shadow areas or lose all detail in the highlights in an attempt to map the colors correctly. The resulting image will have much less detail.

A rule to remember concerning dynamic range is that anything above 2.0 is acceptable and anything above 3.0 is impressive. See Chapter 7 for some more information on dynamic range.

Part 3

Image Editors

Image Editors: The Darkroom Of Image Editing

Chapter 10

Image Editors: The Darkroom Of Image Editing

The image you just snapped with your digital camera or scanned with your scanner is only a starting point. The next step is using an image editor to manipulate (or what we like to call "tweak") the image. You might even tweak the image to the point where you can't recognize that it's related to the original.

A simple example of "tweaking" an image

At this point you may be asking, "Why would I want to manipulate a photo?" If you're asking that question, you may be surprised to learn that your photolab has been manipulating your pictures for years. A good photolab is usually able to "fix" pictures that were taken at the wrong f/stop or shutter speed.

In fact, photographs have been manipulated as far back as the mid-1800s. These changes included adding or removing subjects, adjusting contrast or cropping the photograph. These tweaks required very special darkroom equipment and a lot of expertise (not to mention large amounts of time and patience). However, now anyone with a computer, the right type of software and a few minutes of time can tweak an image. The right type of software is called an *image editor*.

Introducing Image Editors

Image editors have joined digital cameras and scanners in the "hot" category of the consumer market for the same main reason: Today's powerful PCs generate the necessary horsepower and speed. In case you're not familiar with image editors, we'll talk about what they are and what they're capable of doing in this section.

214

What is an image editor?

We'll start by explaining what we mean by the term *image editor*. An image editor is a software program that includes commands, features and functions that let you improve or enhance a less-than-perfect photograph. You can also use an image editor to change or modify a part of a photo.

Countless numbers of image editors are available. Many scanners and digital cameras include an image editor, but they're usually limited or special edition versions of other, more capable programs. We recommend getting the full working version of an image editor that has all the features and power. Don't panic; you won't have to get a loan to buy one of these programs. Most of the image editors we're talking about here cost under $100 yet include the features and capabilities you'll need to perform your magic on an image.

Basic features

Even the most basic image editor will let you do many things to an image. These image editors give you total control over every *pixel* (or dot) in your image. This lets you manipulate even the smallest detail. Easy ways to start tweaking an image are simple cropping, retouching, color correcting and adjusting the brightness/contrast levels. These are the same tasks that are done in a darkroom (but it would take a lot more time in a darkroom).

A simple example of cropping an image (original is on the left)

Slightly more advanced work would involve removing a freckle from a subject or fixing a problem or small mistake in a photo. You can do this type of work in a few seconds or a few minutes using an image editor. For example, look at the following photo:

An example of a simple mistake that can be corrected using an image editor

I made a mistake here when I wrote information on the back of the photo (date, location, etc.) because the ink went through to the front of the photo and appears in the upper right corner. However, using an image editor and a color printer, I was able to "fix" the photo and print out a new color copy:

The same photo after the "mistake" was removed

You can use an image editor in this same way to fix small tears or creases in a photo or even remove people and objects from the photo.

An example of removing a person from an image

More fun stuff you can do with imaging software is to add "special effects." These effects can include collages, bizarre color combinations, applying texture, distortions, morphs and more. Use an image editor to blend an image of a lake into a desert scene, for example. You probably have some photographs that you're considering throwing away because an "ex" (fiancee, spouse, friend, etc.) appears in them. Don't throw the photos away—use an image editor to remove the "ex" from the photo. Or morph an image of your boss into a pig. The possibilities are virtually endless.

A simple example of applying a special effect to an image
(originals are on the left, changes on the right)

You can take one image and combine it with a third image to create a third image:

The first image is of a skier

218

The second image is of a sunset

The third image is a combination of the first two images

Evolution of image editors

Photo editing software and image editors have evolved from "paint" programs such as *Paintbrush* and *PC Paint Plus*. Many of today's experienced users probably started with one or both of these programs (maybe even the "Paint" program that is included with Windows). Obviously, things have evolved quite a bit from the original paint programs. In fact, about the only similarities are that today's image editors can still work with the BMP and PCX files used by the old paint programs and they also include many of the paint functions.

219

Paint programs are still used today; Paint remains a part of Windows 95

The first image editors were very expensive (costing several hundred dollars for one program) and designed primarily for professional editors and graphic artists. So if you were new to image editing or wanted to experiment with image editors, software like Photoshop was an expensive overkill. Fortunately, many publishers have released image editors designed specifically for the home market. Although these editors are much less expensive, they included many of the same features as the powerful editors. Again, most of the image editors that we use in this book cost about or under $100.

Although the programs we're talking about do have paint features like their ancestors, they're *image editors* because they let you actually *edit an image*. Remember we said at the top of this chapter that you can change the original image in so many ways that it can become unrecognizable. For example, does the following image on the left look anything like the image on the right? Well, it is the same image, only it's undergone several changes courtesy of an image editor.

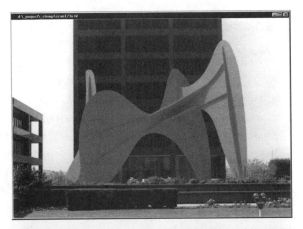

Granted, we carried the idea to an extreme by using combinations of special effects and other changes that aren't normally used together, but you can see that the new image doesn't look very much like the original.

Using an image editor doesn't need to be difficult

At this point you're probably asking, "How hard is it to use an image editor?" Whether it's easy or hard depends on you. Working with today's image editors is much easier than working with the image editors that were available a short time ago. However, there is still a lot to learn. It may take you some time to explore and understand all the tools and features of the your new image editor. Certain tasks can require a lot of practice and patience if you want to do them well.

One thing you're likely to discover about image editors is that even when you think you know everything, you'll find there's still more to learn. However, this is a good thing because you'll be amazed by what a little time, patience and an image editor can do. You'll probably find that you're spending a lot of time just having fun when you're really investing time learning something new.

> Besides understanding how the image editor works, you should be familiar with the terms the program uses. You'll see terms like colors, palettes, hue, brightness, contrast, threshold, equalization and many more. If you're uncertain on what a term means, check the glossary (Appendix D) for a complete explanation. Don't panic, many terms sound more formidable than they really are.

Let's Talk About The Software

Hardware requirements

You've undoubtedly heard the term "bigger is better" when it comes to computer hardware and software. Image editors are a good example. The following table shows what we recommend for *minimum* hardware (middle) and *recommended* hardware (right) for using a typical image editor:

System	Minimum	Recommended
Processor	486/66	Pentium-class
Hard drive	300 Meg free on your hard drive	1.2 Gigabyte or better hard drive
	These images are normally very large—a few 4 x 5-inch color photos that I've scanned were over 20 Meg each in size.	
RAM	8 Meg	32 Meg
	Try to have 3 times as much RAM as the largest image on which you're working, plus enough for your software and operating system.	
Video card	SVGA Video card (2 Meg of video RAM)	
Monitor	14-inch	17-inch
CD-ROM drive	4x speed	6x or higher

Keep in mind that if you're limited to using the minimum hardware requirements, the image editor will probably run dreadfully slow on your PC. Don't even consider anything less than the minimum requirements; you'll only be frustrated.

Another system component that you might want to consider is a removable storage device such as the Zip drive or the Jaz drive (both from Iomega). The Zip uses discs similar to floppy diskettes but these discs can store 100 Meg of data. The Jaz drive uses a removable 1 Gigabyte cartridge.

Also, many of the image editors we talk about in this book are for Windows 95. If you're using Windows 3.x, check with the publisher or dealer. A Windows 3.x version is probably available as well.

Important features you'll need in an image editor

An image editor should have certain basic features and functions. Before you invest in an image editor, make certain it has these capabilities. Regardless of price and other features, you should look for the following basic features/ functions in an image editor:

Zooming in and out

You can zoom into and out from an image by using the Zoom tool. How you select and use the Zoom tool depends on the image editor, though the effect is the same. It works like a magnifying glass so you can get a close-up look at your work. Notice in the following illustrations how much easier it would be to work on small details after zooming in on a specific part of the image.

Being able to zoom in on part of the image lets you tweak small details that may be missing in a larger size of the image

The image only appears to be larger on the screen; the Zoom tool has no affect on the file size of your image or the size of the printout.

Undo command

Since everyone makes mistakes, it's always a good idea to use an image editor that has an Undo command. Select this command if you want to reverse ("undo") a mistake. In other words, this command reverses the last edit to the current image. Some image editors have several levels of undo so you can correct the most recent mistake and a mistake you may have made before that one, and so on.

Say for example, that you used the Paint tool to paint part of an image. However, you decided that maybe the Pen tool would look better instead. In that case, select the **Edit/ Undo** command to reverse the action of the Paint tool and restore the image to its appearance before you used the Paint tool.

Restore command

Since you may not be able to use the Undo command in some situations or if Undo won't be able to fix a mistake you made several steps earlier, image editors include a Restore command (also called "Revert" or something similar). Use this command to abandon all changes you've made to a file since you saved it last. Most image editors will prompt you to confirm that you want to restore or revert back to the original file.

Reversing orientation: Flip, mirror, skew

An image editor should include commands that let you reverse an image's or selection's orientation along the vertical and horizontal axes. These commands are usually called *Flip, Mirror* and *Rotate* (or something similar).

A Flip command reverses the image or selection vertically. In other words, what was the top becomes the bottom and the bottom becomes the top.

*Original image is on the top but it has been
flipped in the bottom illustration*

The Mirror command reverses the image or selection horizontally. Then what was the left side becomes the right side and the right side becomes the left side.

Original image is on the top but
it has been mirrored in the bottom illustration

Note that the Mirror command reverses everything in the image. This includes billboards, street signs, clocks, and anything with words and letters so be careful when applying this command. For example, note how the player's numbers in the following photo have changed after the Mirror command was applied:

227

The Mirror command reverses everything in an image,
which is why one needs to be careful when using it

Also, keep in mind when applying the Mirror command that people who are right handed will appear left handed, watches and rings will appear on the opposite hand and drivers will be on the right side instead of the left side in their cars.

Another useful option to look for in an image editor is the Rotate command. This lets you rotate the image clockwise or counter clockwise in precise degrees that you specify.

Original image is on the top and it has been rotated in the bottom illustration

A related feature is called *skewing*. This feature slants a selection vertically or horizontally.

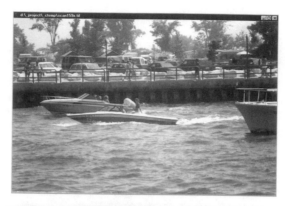

Original image is on the left; it has been skewed on the right

In other words, you can slant a selection left, right, up or down. You move one side of the image or selected part of the image parallel to the opposite side.

Cropping an image

One of the easiest-to-use features yet one of the powerful features is *cropping*. Using an image editor to crop an image is similar to taking scissors to a photograph: you cut off one or more of the outside edges to remove unwanted parts of the original graphic. In the example below we cropped the picture to remove part of the sky and the moon.

Cropping is an easy-to-use yet powerful feature in an image editor

By cropping this image, we were able to emphasize the beach, waves and water more than the sky. However, you have to be careful when cropping. You don't want to be overeager and crop important details or throw off the image's visual balance. Although this is especially true with people or animals, it also applies to other objects as well. For example, notice the difference in the following two images. Although the bottom of the photo was cropped effectively, too much was cropped from the top. This resulted in part of the top of the house being removed:

Be careful not to crop too much from an image

It's usually a good idea to crop an image as early as possible in your work. You'll find that cropping an image will reduce the file size and speed up your work.

Special effects

One of the reasons many people want an image editor (and maybe the only reason for some people) is to apply special effects to an image. For example, silhouetting an image can produce impressive results. The best part is that you won't need to spend much time or money on an image editor to get these results. You'll find it's easy (and quite likely, fun) to make both subtle and dramatic changes to your photos and images.

Some special effects are unique to a specific image editor. However, most image editors should have Emboss, Negative and Motion Blur special effects.

An example of the Emboss special effect

An example of the Negative special effect

An example of the Motion Blur special effect

A feature related to special effects is called *filters*. Filters use a combination of mathematical algorithms to produce unique effects on the image or part of an image. Again, some filters are unique to a specific image editor. However, most image editors should have a Find Contour, Add Noise, Blur and Sharpen filters.

An example of the Find Contour filter

234

An example of the Add Noise filter

Brightness and contrast

One feature that an image editor must have is the ability to adjust the levels of brightness and contrast in an image. Brightness refers to the overall lightness of an image or a selected area of an image. Contrast, on the other hand, is the difference between the lightest and darkest part of an image or selected area of an image.

Scanned images are often too dark. So using an image editor to increase the brightness level will help compensate for the scanning process. You may also want to look at the original image if the scanned image is too dark or too light. It's possible the original is underexposed or overexposed.

If the contrast of an image is too low, the image will look dull and flat. Taking pictures on a sunny day with harsh shadows can often result in high contrast. An example of a low contrast image is one taken on a cloudy day with diffuse light. Increasing the contrast will lighten the light areas and make the darker areas darker.

A term you'll need to understand when working with brightness and contrast is *histogram*.

*Examples of a Brightness and Contrast dialog box (top)
and Histogram window (bottom)*

Adjusting Highlights/Midtones/Shadows...

Another feature that you should look for in an image editor is called
Highlights/Midtones/Shadows in most image editors. Other names you might
see include *Tone Adjustment* or *Tonal Adjustment*, etc. Regardless of its name,
this command is used to control the highlights, midtones and shadows of an
image.

The Brightness and Contrast controls only shift the entire image up or down
in brightness or contrast. The Highlights/Midtones/Shadows command
gives you more precise control over brightness in an image than the Brightness/
Contrast command.

Example of a Tone Adjustment dialog box

Clone tool for touching up problem areas

As its name suggests, an image editor must be able to edit an image. To let you edit an image, two features (usually called "tools") that an image editor should have are called *Airbrush* and *Clone* (or something similar). The reason we recommend using an image editor that has these tools is because they will make your work much easier and faster. You can use them for anything from removing blemishes and fixing a small tear to removing people and objects from your photos.

The following image is from an old post card. Notice all the marks, small tears and other problems in the "sky" of the image. Using an image editor, we can remove these problem areas in just a few seconds.

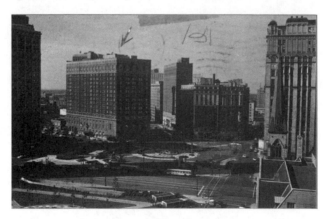

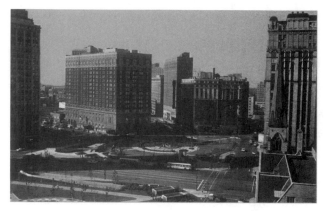

*An image editor can be used to remove small tears
and other problems in your images*

Although these tools are powerful, we're not talking about completely recreating a photo. The following photo, for example would require an extensive amount of work to fix. In a case like this, it would be better to use a different photograph or image.

However, it maybe too late for some photos

Other useful features

One useful feature that you may not find in some lower cost image editors is called *masking*. Masks let you protect part of an image while you tweak other parts of the image.

Section summary

We'll talk about specific image editors in the next several chapters, showing examples of what you can do to your images (most take only a few minutes). Keep in mind that this is only a sampling of the countless image editors that are available. We're including the information to give you an idea of the image editors that are available and their capabilities. We're not necessarily recommending only these programs or only these publishers.

You could, of course, spend some major money for some major programs. Adobe Photoshop 4.0 ($895), Fractal Design Painter ($549) or Live Picture 2.5.1 ($995) are available. However, we don't want to help you take out a loan for an image editor, so we'll talk about more affordable programs that use many of the same features used in these high-priced programs.

Basic Image Editing

Regardless of how or where you'll be using a scanned image or an image from a digital camera, don't expect it to be perfect. You should always consider image editing to be an important part of the project. How (or if) you edit an image is an important consideration. Fortunately, you have a huge advantage that wasn't available a few short years ago: Your PC and an image editor.

If using high-quality images is important in your work, you may want to consider buying images from stock photo companies. See Appendix A for more information.

In this section examples will illustrate editing tips. See Chapters 11-14 for examples of using specific image editors.

Before starting: Checking for common errors

As we mentioned, regardless of the quality of scanner that you're using, a scanned image is seldom perfect. You'll need to use an image editor to start tweaking the image.

The first step is to check the quality of the scanned image. In other words, see what needs to be tweaked. Besides reviewing the image on your computer monitor, you should also print a copy of the image before you begin tweaking it. You may be able to spot some problems on a printout that you might miss looking at the image on the monitor.

The following is a short list of many common image problems that you should look for when using an image editor:

Is the image "dirty"?

Check the image for dust specks, scratches, hair , etc., that might appear on the image. You may be able to remove some of these with a Clone tool or Airbrush tool in the image editor. Otherwise, you may need to rescan the image (after cleaning the scanner bed, of course!).

An otherwise acceptable scan except we did
not clean the scan bed before scanning the photo

Is the image straight or is it crooked?

A crooked image is a common problem when using a scanner and is usually the result of the photo being placed incorrectly on the scanning bed. You may need to rescan the image; make certain the photo or image is straight and aligned with the side and bottom/top of the scanner.

Example of what happens to a scan when the photo
is placed incorrectly on the scan bed

Some image editors have a Rotate command that you could use to straighten a crooked image. However, using the Rotate command to line up a scan often requires a lot of guesswork, so it's usually faster and easier to rescan the photo.

Is the image out of focus or blurry?

If the image is out of focus or blurry, the details will be either too harsh or too subtle.

Check for color cast

Does the image contain a distinct overall tint? This is is usually caused by using an incorrect film for the lighting conditions.

Underexposed or overexposed

When the whole image or portions of the image are too dark or too light, the film was over- or underexposed. Even a photo that has the proper exposure can look underexposed or overexposed after you scan it.

241

The contrast in this photo must be increased

Improper saturation

Images with low color saturation look faded and dull. On the other hand, an image with too much color saturation will appear too vivid and unnatural.

Flat tonal range

The image may have a compressed range of gray or color values. The limited number of grays or colors produces a flat appearance.

Image correction tips

You cannot start just anywhere when working with an image editor. How and where you begin to manipulate an image is often important. The following lists some possible image correction steps. We say "possible" because every job is a little different, but this is a good general guideline.

1. Before you start working, make a backup copy of the image. This is a good idea regardless of the amount of tweaking you're planning to do.

2. If you have enough space on your hard drive, save the file under a different name as you make changes. This is especially true if you make several large changes. Remember, many image editors will

only let you Undo an action once, so any changes before that cannot be "undone". By saving files under different filenames, you can return to an earlier version without repeating (or remembering) your work. Just remember to keep track of available hard drive space. Save the file using consecutive numbers, such as "IMAGE01," then "IMAGE02," "IMAGE03", etc.

3. Don't try to reverse image corrections by performing the opposite correction. For example, don't reverse an action that increases highlights by increasing shadows. Instead, use the Undo command if you can or use the Restore command to start again from the most recently saved version of the image.

4. The first step to tweak an image should be to correct tonal range and color balance. We recommend starting here for the simple reason that if the tonal range and color balance of the image cannot be improved, you'll probably have to rescan or use another image.

5. The next step should be sharpen or blur the image to soften or enhance detail.

6. Make any necessary changes to the content of the image. These changes include repairing torn areas, cropping to improve the composition, etc.

By using the image editors that are available today, you can greatly improve most photographs, regardless of how poorly exposed, out of focus or badly composed they are. We'll use the tools and features of several image editors in the next few chapters to further explain using an image editor. You'll find that most image editors will have similar tools and functions.

Example #1: Using PhotoStudio

Chapter 11

Example #1: Using PhotoStudio

Like most image editors, PhotoStudio from Arcsoft is in a different class than Photoshop. However, that's all right because PhotoStudio has just about all the features you'll need to work your magic on your favorite images. These include all the features we mentioned in Chapter 10 that you should look for in an image editor.

The opening screen in PhotoStudio

We like PhotoStudio because it includes a powerful variety of tools, filters and special effects. You'll be impressed with how these tools are organized and by other elements of the program's user interface.

An image loaded in PhotoStudio

Unfortunately, we cannot talk about all the wonderful features you can do with this program. That would require a book in itself. We will, however, show you many examples of what you can do with PhotoStudio, including using the smoothing and sharpening filters, special effects and other popular effects.

Light on resources

One reason that PhotoStudio is a good choice for an image editor is that it's light on resources. Although we still recommend using PhotoStudio on nothing less than a 486 PC, you can use it on a 386-based PC. It doesn't require much hard drive space (6 Meg for program files) but, of course, you'll need room for all your images. PhotoStudio needs a minimum of 4 Meg of RAM (but, again, more is better).

> Anxious to try PhotoStudio. We've included an evaluation copy of PhotoStudio on the companion CD-ROM that you can use. This is a full working version of the program. It is a "time bombed" version that you can use for 30 days or 100 accesses, whichever comes first.

PhotoStudio Effects

We'll start by showing how easy it is to apply some of the PhotoStudio effects to an image. You'll find the commands to change your images in interesting, novel or unusual ways in the **Effects** menu of PhotoStudio.

All the commands in the **Effects** menu (shown on the right) require the image to be either a 24-bit (16 million colors) image or an 8-bit grayscale image. If necessary, select the **Convert/To 24-bit RGB True Color** command to change your image so you can use these effects.

We'll use the following image to show you many of the effects you can use:

Some simple effects

You can be silly and apply special effects such as Cone and Cylinder. Let's look at the Cone effect first. Use this effect to pull the image in at its center.

You can apply this effect to either a selected area of the image or the entire image. You just select the area you want to change or make certain that no area is selected to change the entire image.

Select the **Effects/Cone...** command. This opens the Cone dialog box, which is where you can set the "Intensity" level. As its name suggests, this is how much of an effect you want to apply to the image.

The Cone dialog box lets you set how much of an effect you want to apply to the image

Move the small slider box left or right to set the level. The higher (to the right) you move the slider box, the greater the intensity of the effect. Also look in the "Before" and "After" windows for an idea of how the effect will change your image.

In our example, we applied an intensity of 100. Now the image of our friends looks like this:

The Cone effect pulls the image in at its center

You can follow the same steps for three of the other effects (Whirlpool, Fisheye and Spiral). They also use a dialog box to set the "Intensity" level in a similar way to the Cone dialog box.

*To make your image appear to be twirling around its center, select **Effects/Whirlpool** (intensity 25)*

The Fisheye effect causes the image to bulge from its center (intensity 75)

251

The Spiral effect twists the image around its center (intensity 10)

Sphere, Cylinder and Ribbon

The Sphere, Cylinder and Ribbon effects are slightly different. The Sphere effect is similar to the Fisheye effect. The difference is the image bulges from its center in the shape of a sphere instead of a fisheye. There are no options with the Sphere effect; the effect is applied to the image when you select the command. You can, however, apply the effect to the whole image or a selected part of the image.

The Sphere effect is similar to the Fisheye effect,
but the bulge in the image is spherically shaped

Select the Cylinder effect if you want your image to appear as if it's wrapped around a cylinder. There are no options with the Cylinder effect, either; the effect is applied to the image when you select the command. You can, however, apply the effect to the whole image or a selected part of the image.

The Cylinder command "wraps" the image around a cylinder

The final effect is called "Ribbon." It stretches the image into a thick, wavy ribbon. You can apply the effect to a selected area of the image or the entire image. To apply this effect to your image, follow these steps:

You can apply this effect to either a selected area of the image or the entire image. You can either select the area you want to modify or, to change the entire image, make certain no area is selected.

Select the **Effects/Ribbon** command. This opens the Ribbon dialog box. Set the amount of ribbon waves in the "Frequency" level by moving the scroll bar left (fewer) or right (more).

Set the thickness of the ribbon in the "Amplitude" level. Move the scroll bar left (less) or right (more) to determine the thickness. Check the "Before" and "After" windows for an idea of how the effect will change your image.

Click OK to apply the effect to the main image.

Example of the Ribbon command
(Frequency set at 25; Amplitude set at 25%)

Emboss

The Emboss effect removes most of the color from an image. Your images then seem as if they're stamped onto porous paper or fossilzed stone.

You can apply Emboss to a selected area of the image or the entire image. You can either select the area you want to modify or, to change the entire image, make certain no area is selected. Then select the **Effects/ Emboss...** command. This opens the Emboss dialog box.

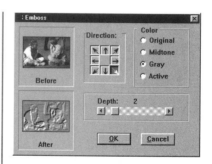

The Emboss dialog box lets you set how much
of an emboss effect you want to apply to the image

Enter a number in the "Depth:" field to determine of the background depth. Move the slider box to set the depth between 1 and 10. Enter a higher number for a greater depth.

Next, determine the type of the effect with the "Color" option. Click "Original" to create an embossed image in the same color as the original. Click "Midtone" to create an embossed image in gray but keep the color contour lines in the original color. Click "Gray" to create a monochromatic image in gray. Click "Active" to create a single color image using the foreground color.

Finally, select the direction that you want the shadows to fall with the "Direction" option. You have a choice of eight directions. Click OK to apply the Emboss effect to your image.

Example of using the Emboss effect
(Right direction, Gray, Depth set at 2)

Example of using the Emboss effect
(Up direction, Active, Depth set at 10)

255

Motion Blur...

As its name suggests, the Motion Blur filter produces an illusion of motion across the image.

You can apply Motion Blur to a selected area of the image or the entire image. You can either select the area you want to modify or, to change the entire image, make certain no area is selected. Then select the **Effects/ Motion Blur...** command. This opens the Motion Blur dialog box.

The Motion Blur dialog box lets you set how much of an motion effect you want to apply to your image

Enter a number in "Speed" (2 to 32) to determine the speed of the motion. A higher number represents a higher speed. Next, select the direction in which you want the shadows to fall with the "Direction" option. You have a choice of eight directions. Click [OK] to apply the Emboss effect to your image.

Example of using the Motion Blur effect (Left direction, Speed set at 32)

Additional effects in PhotoStudio

You'll find most of the effects that we've mentioned above in many image editors. However, PhotoStudio includes other unique effects that you can also use. You'll find these effects in the **Effects/Liquid Effects** command.

Squeeze

This is one of the few special effects commands and filters where you must use a grayscale image. Use Squeeze when you want to squeeze your image by different amounts and in different places.

PhotoStudio includes some unique commands in Effects/ Liquid Effects

Start by making certain that the image is not selected if you want to apply Squeeze to the entire image. Otherwise, use one of the selection tools to select the area of the image you want to change.

Next, select the **Effects/Liquid Effects/ Squeeze** command. This opens the Squeeze dialog box.

Set the intensity of the squeeze in the "Rate:" field (1 to 100) by moving the slider box. Set a higher value in "Rate:" for a stronger squeeze effect. Next, select the direction of the distortion (horizontal or vertical).

When you're set, click OK.

The Squeeze dialog box lets you set how much of an effect you want to apply

257

Image after applying the "Squeeze" effect (horizontal with rate set at 100)

Splash

The Splash filter produces an illusion of patterns on the surface of water, as if a stone had been thrown into it.

Start by making certain that no area of the image is selected if you want to apply Splash to the entire image. Otherwise, use one of the selection tools to select the area of the image you want to change.

Next, select the **Effects/Liquid Effects/ Splash** command. This opens the Splash dialog box.

Move the Intensity scroll bar to the right to strengthen the effect or to the left to weaken the effect (ranges from 1 to 100).

When you're set, click OK.

*The Splash dialog box lets you set how much
of an effect you want to apply*

Image after applying the Splash effect (intensity set at 35)

Wrinkle

Apply the Wrinkle command to make your image appear to have been crumpled in your hand. In other words, you can now intentionally see how a crumpled photo looks. Before using this filter, double-check your background color. Make certain this is the color you want to use. The open areas created by the Wrinkle filter will be filled with the background color.

Also make certain that the image is not selected if you want to apply Wrinkle to the entire image. Otherwise, use one of the selection tools to select the area of the image you want to change.

Next, select the **Effects/Liquid Effects/ Wrinkle** command. This opens the Wrinkle dialog box.

Move the Intensity scroll bar to the right to strengthen the effect or to the left to weaken the effect (ranges from 1 to 100).

When you're set, click OK.

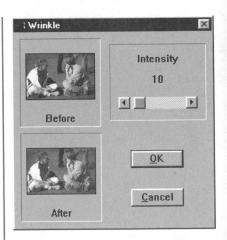

The Wrinkle dialog box lets you set the intensity of the effect

259

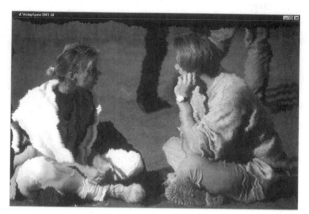

Our image after applying the Wrinkle effect (intensity set at 100)

Ripple

Select this command to show your image as it would appear through ripples of water (like those from a canoe moving slowly by).

Start by making certain that the image is not selected if you want to apply Ripple to the entire image. Otherwise, use one of the selection tools to select the area of the image you want to change.

Next, select the **Effects/Liquid Effects/Ripple** command. This opens the Ripple dialog box.

Move the Intensity scroll bar to the right to strengthen the effect or to the left to weaken the effect (ranges from 1 to 100).

When you're set, click OK.

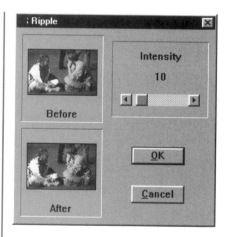

The Ripple dialog box lets you set how much of an effect you want to apply

260

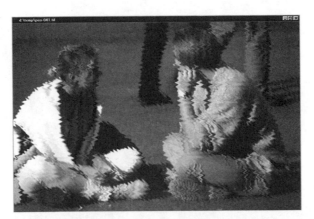

Our image after applying the Ripple effect (intensity set at 50)

Using the Liquid effects for even more dramatic effects

Using Ripple for a dramatic border effect

You can give your images a dramatic border effect by applying the effects in the Liquid Effects menu in a special way. This requires that you use a photo that has a wide white border. However, don't worry if your photo doesn't have a white border because you can probably create one in PhotoStudio. If you need to create a white border, follow steps 1-4 first. Otherwise, if your image already has a white border, start with step 5 (but make certain the border is white).

1. The first step is to make certain the background color is white.

2. Select the entire image by using the **Mask/All** command (or press Ctrl + A).

3. Then select the **Mask/Border...** command. This opens the Border dialog box where you can enter the size (width) of the border.

For this example, we usually recommend entering a wide border. However, the border size may also depend on your photo. We recommend starting at the maximum of 32 pixels for this example.

261

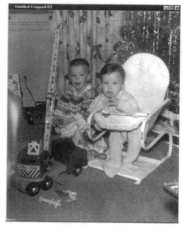

*Our image after setting the border width
at 32 pixels (not the dotted lines)*

4.	Next, select the **Edit/Cut** command to replace the selected area of the image with the background color. This is why it was necessary to have the background color set to white.

*Replacing the selected area with the
background color (should be white)*

5.	Next, we need to select an area inside the image. In other words, we want to leave the area next to the border outside the selected area. This will create, in a sense, a second border. Use the rectangular tool

to select the area inside the image. The part of the image outside the selected area should be slightly smaller than the width of the white border.

Selecting a second border which will become part of the rippled effect

6. Select the **Mask/Invert** command. This will switch the selected area from the image (see the illustration above) to the white border and the small area of the image beside the border (see the illustration below).

Switching (or inverting) the selected areas

263

7. Finally, select the **Effects/Liquid Effects/Ripple...** command. The intensity level you set in the Ripple dialog box will depend on your taste and the image. Check the "Before" and "After" windows for an idea of how the new border will look. Keep in mind, however, that the effect is probably stronger in the "After" window than how the new image will look. We used the maximum level of 100 in this example.

Our finished image with its new border

As you can see, this gives an image a very dramatic and interesting new border.

You can follow these steps and apply other effects to an image. The following are some examples:

264

Using the Splash filter (intensity is set at 100)

Using the Wrinkle filter (intensity is set at 100)

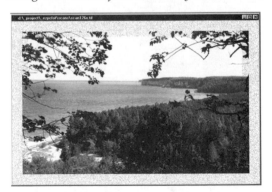

Using the Film Grain filter (intensity is set at 100)

265

Experiment with several of the other effects and filters. For example, applying the Whirlpool filter to an image with a white border will produce a "warped paper" texture. Other filters you can try include Spiral and one of the Tiling commands. You'll probably discover that sometimes the effect or filter won't change the image very much or will in a way you don't like. However, you'll have fun experimenting anyway.

Using the Effects commands to create new images

You can use an image editor for more than tweaking photos and images. For example, apply the Add Noise filter to a new image with a solid white background to create a speckled, grainy pattern. Then use the pattern as an element in another PhotoStudio image or in a document in another application.

1. Select the **File/New...** command to create a new document and select the size in the dialog box. We're using 24-bit color and a size of 900 x 585 and 300 pixels.

2. Make certain to have a white background before continuing. Select the **Enhance/Special Filters/Add Noise...** command.

3. Enter a number between 1 and 100 for the "Intensity" level.

4. Click (OK) or press (Enter).

The following is an example of an "Add Noise pattern:"

Use the Add Noise filter to create a pattern (Intensity level set at 70)

Creating a woven pattern

Another example is to create woven textures or spaghetti textures. Follow these steps to create a woven texture:

1. Select the **File/New...** command to create a new document and select the size in the dialog box. We're using 24-bit color and a size of 900 x 585 and 300 pixels.

2. Select the **Special Filters/Add Noise...** command.

3. Enter a number between 1 and 100 for the "Intensity" level.

4. Click (OK) or press (Enter).

5. Select the **Effects/Motion Blur** command.

6. Click the lower-right pointing arrow and set the "Speed" to "32" using the sliding bar.

7. Other options include using the Brightness/Contrast to adjust the levels if necessary. You can also add a wave to the texture by applying the Whirlpool command filter to it.

Example of a woven pattern you can create in PhotoStudio

*Adding a wave to the texture by applying the Whirlpool
command filter to it (intensity setting of 100)*

Spaghetti-like texture

Follow these steps to create a spaghetti-like texture:

1. Select the **File/New...** command to create a new document and select
 the size in the dialog box. We're using 24-bit color and a size of 900
 x 585 and 300 pixels.

2 Select the **Special Filters/Add Noise...** command.

3. Enter a number between 1 and 100 for the "Intensity" level.

268

4. Click (OK) or press (Enter).

5 Select the **Enhance/Smooth Filters/Gaussian Blur** command.

6. Use the slider box to select 3 and click (OK).

7. Select **Enhance/Smooth Filters/Find Contour...** command

8. Use the slider box to select 120 (you can go higher or lower than this if you want). Then click (OK).

9. You can also apply the Sharpen filter to the image.

Some different "lighting" effects can be done with brightness and selected areas.

Removing Subjects, Objects And People

We've mentioned one reason to use an image editor is to remove subjects, objects and even people from your images. To do this, an image editor needs at least two powerful tools. These two tools are called the Airbrush tool and the Clone tool. They might have different names in other image editors, but they should have similar functions to PhotoStudio's Airbrush and Clone tools.

269

Airbrush

Use the Airbrush tool to simulate painting with an airbrush or spray can. In other words, it uses the color you set as the foreground color to "spray" over the image.

Clone

Use the Clone tool to copy part of an image to another part of the image. In other words, the Clone tool takes an area of an image that you want to copy and uses it to paint over another part of the image. You can use it to copy within the same image or between two images.

The Clone Tool icon (left) and
Airbrush tool icon (right) in the Toolbox

The Clone tool copies pixels from one part of the image to another part of the image. So, you're really painting with the contents of the image, regardless of the colors, instead of a specific color or gray value. Once you define the area you want to copy, the clone tool behaves like any other painting tool.

Example of removing an unwanted object

We mentioned the Airbrush and Clone tools are essential tools in an image editor. One reason is that they're very useful for removing unwanted objects and people. For example, we'll start with the following photograph of the Mackinaw Bridge.

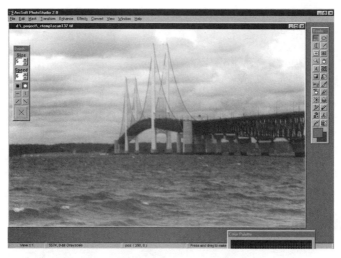

Maybe we want to be a magician and make the bridge disappear, but keep the rest of the picture intact. To do this, we used the Clone tool and then the Airbrush tool for some touch up work. Don't panic—this won't be an all day project. This example required only a few minutes.

When using the Clone tool, you're selecting a source point (from where you're copying pixels) and a destination point (to where you copy the pixels). To use the Clone tool, we started by removing the twin towers of the bridge.

Since it was a cloudy day when the photo was snapped, we need to replace the towers with some clouds.

We started by positioning the cursor over the area we wanted to clone (the clouds in this case). Then we clicked the right mouse button to let PhotoStudio know that this is the source of the cloning.

A blinking crosshair (+) appears to indicate the source location for our reference. Then we moved, or in a sense "painted," with the left button across the towers. To do this, we simply dragged the cursor like any other painting tool. This action "cloned" the clouds onto the towers.

The Clone Tool icon (left) and Airbrush tool icon (right) in the Toolbox

When you're using the Clone tool, the image editor doesn't know exactly what you want to clone. Therefore, don't move the mouse too wildly. Otherwise, you could put part of the lake above the bridge or a cloud inside the lake.

Also, each time you release the mouse button and press it down again, you're telling PhotoStudio that you want to make another clone in the current location. Therefore, unless this is the desired effect, uncontrolled clicking will create a jumble of the cloned area.

Next, we need to remove the bridge supports. However, notice that many of these supports were along the same horizontal line as the land. So, we need to move the mouse pointer to the land area so PhotoStudio knows this is the new source of the cloning. Then we simply follow the same technique as before to remove the bridge supports with the land.

Then we used the Airbrush tool for a little touch up work and we had our result. The Mackinaw Bridge was removed from our photo:

Example of removing unwanted people

Have you ever noticed that a problem when snapping pictures in public places or popular areas is that other, "unwanted" people appear in our photo. Of course, the other people are saying the same thing about us appearing in their pictures. However, since we have an image editor, we can remove *them* from *our* photos.

Similar to removing the Mackinaw Bridge in the example above, we can use the same technique to remove unwanted people from an image. For example, note the three people in the background of the following photo. (Two people are partially hidden in the smoke from the guns. We'll remove them, too. Then you'll see how easy it is to remove people from even seemingly difficult areas of a photo):

We'll start by removing the woman leaning against the building on the center-left of the picture. We used the Clone tool to remove her by cloning the wall of the building and using the airbrush tool to do some touch-up work.

Next, we wanted to remove the man standing in the center-right of the picture (partially hidden in the smoke). We used the Airbrush tool for this job and another important tool called the Eyedropper tool. Use this tool whenever you want to select a specific color on the image as the foreground ("active") color, or in this case, to match the intensity of the smoke.

275

Finally, we removed the third person. He's leaning against the post, far right side of the picture and partially hidden in the smoke. To do this we used the Clone tool to clone part of another post and copied it over the person. Then we used the Airbrush tool and the Eyedropper tool for some touch-up work.

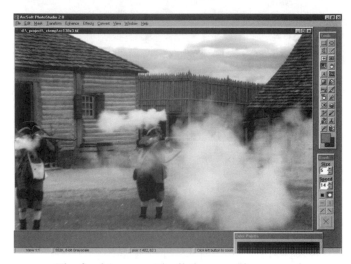

The final image with all three people removed

Cloning between two images

PhotoStudio even lets you clone between images. We recommend positioning the images side-by-side so you can view your work better.

Then position the cursor over the area of the image you want to clone. Press the right mouse button. A blinking crosshair appears to indicate your source location. Move the cursor to the area in the other image. Drag the cursor as you would any other painting tool. For more information on using the Clone tool, see the information earlier in this section.

An example of cloning between images

Fixing a flaw in an image

Another reason to use the Clone tool and the Airbrush tool is to fix small tears in images. These tears usually appear in the scanned image as a ragged white edge area.

An example of using the Clone tool to fix a tear in an image
(original is on the left and the fixed image is on the right)

277

The Clone tool is the perfect tool here because the area with the tear will usually contain colors and patterns similar to the area around it. Therefore, the Clone tool can copy these surrounding areas into the tear.

Combining Images

PhotoStudio has several ways of combining or merging images into a *composite image*. You can combine images using the **Copy** and **Paste** commands, masks or using the **Composite** command.

The familiar commands

You're probably already familiar with one way you can use PhotoStudio to combine images. This involves using the Cut, Copy and Paste commands. These commands let you move parts of images from one image window to another using the Windows Clipboard. They're used the same way in PhotoStudio.

➤ **Edit/Cut** places the selected area in the Clipboard. The area cut is filled with the background color. The image on the right is an example with a selected area cut.

➤ **Edit/Copy** places a copy of the selected area on the Clipboard. The image itself doesn't change.

➤ **Edit/Paste** pastes the Clipboard contents as a new selection. Use the Area Move tool to move the pasted area to a new area on the image. The image on the right shows an area that is pasted.

278

➤ **Edit/Clear** fills the selection area with the background color and doesn't copy anything to the Clipboard.

Actually *combining* images

Instead of pasting an image on top of another, you can tell Photostudio to combine two images. This is called *compositing* and can be done using the **Effects/Composite...** command.

Before using the **Effects/Composite** command make certain the two images are the same size and have the same number of pixels. If necessary, use the **Transform/Resample** command to resize one of your pictures.

*Use the **Transform/Resample** command to resize one of your pictures if necessary*

For example, we'll combine this image:

And this image:

Unfortunately, the image of the sailboat is smaller than the sunset scene. So, we'll need to resample one of the two images. This can be a difficult problem. In this case, for example, we cannot select the "Keep Aspect Ratio" check box in the Resample dialog box. We don't want the sailboat to look stretched too much or the sunset to be too crunched or shortened. In this example, we decided to match the size of the sunset to that of the sailboat.

The next step is to decide which image we want as "Principal" and to make it the active image. For this example, we'll use the sunset as the "Principal" and the sailboat as the "Secondary" image.

Then we selected the **Effects/Composite** command. This opens the Composite dialog box.

*Selecting the **Effects/ Composite** command*

280

The first step here is to select the Secondary image. Click the down arrow to the right of "Secondary:" to see a list of images. Then select the Secondary image by clicking on it.

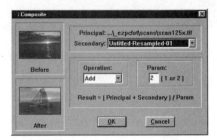

Next, select the type of "Operation:" you want to use by clicking the down arrow and choosing from the list of options. In this example we want to simply "Add" the two images. Enter a value into the Parameter box if necessary.

Check the preview window. Click OK if you're satisfied with the composite or Cancel if you want to make a change.

This is the result of our example:

281

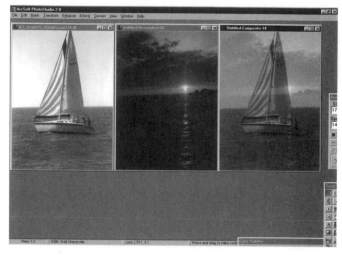

Don't be afraid to tweak the final image. You may need to use the **Enhance/ Brightness and Contrast** command, for example, to tweak the composited image.

Merging two images

Use the **Effects/Area Merge...** command to merge a selected area of an image with another image. This is similar to compositing except you're merging an image into a selected part of another image. This command is especially useful when you want to smoothly merge an image with a completely different background.

Select the area in the first image that you want to be merged. Then select the **Effects/Area Merge...** command. This opens the Area Merge dialog box. Select one of the grayscale images in "Mask:" for a mask. Check the "Invert" check box if you want to invert (reverse) the brightness values of the mask.

Finally, select either Underlying or Active color as the source to be merged with the floating selection in "Merge Source."

Check the "Before" and "After" windows for an idea of how the effect will change your image. Click [OK] to apply the effect to the main image.

282

We're starting with the following images. The image on the left has an area selected. The image on the right will be merged into that selected area.

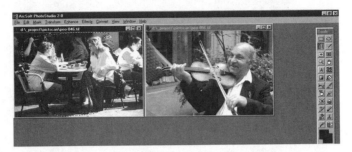

Two images we're using with the Area Merge command,
the image on the left has an area selected

The following shows the result of the merge. The image on the left now has part of the image on the right merged into it.

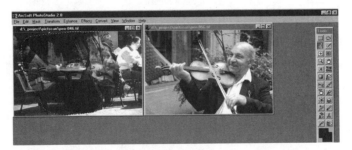

The result of using the Area Merge command
is shown in the image on the left

Compositing an image and a graphic

You can use Composite with other tools in PhotoStudio. For example, you can load an image and then select the **Edit/Duplicate** command to make a copy of the image. Then apply an effect to the duplicate. For example, we started with the following photo:

283

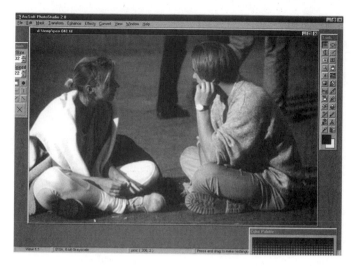

We then selected the **Edit/Duplicate** command to make a copy of the image. Next, we applied **Effects/Fine Art/Sketch/Pencil/Threshold 0** to the duplicate to create a pen-and-ink look.

Next, we selected the **Effects/Composite...** command and the "Blend" option for the "Operation" setting.

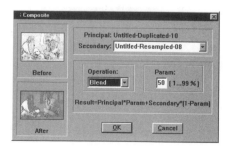

284

A new image window opens with the blended image.

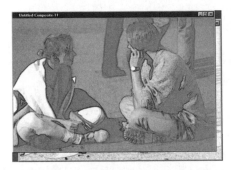

Experiment with the other commands, too. The gradient fill, for example, can produce some neat images. The Add Noise command is another good example. Use one of the Transform commands (Flip, Mirror, etc.) on the duplicate image and then apply the **Composite...** command. You'll find by experimenting that you can create many interesting combinations.

*Examples of applying Add Noise (left) and Flip Horizontal (right)
on the duplicate image and then applying the **Composite...** command*

Filters

A filter is used to change the color of a pixel based on its current color and the colors of any neighboring pixels. The results can range from a small adjustment of a single image characteristic (such as luminance) to a complete change in the appearance of the image.

285

In this section we'll talk about some of the filters you can use in PhotoStudio. The filters are grouped under different categories in the **Enhance** menu. One of the advantages of using a filter is that most can be applied to the entire image or part of an image. Some filters are applied immediately after you select the command. Other filters, however, have additional options that you can select from a dialog box.

Don't be too confused by the terms "filter" and "effect." Although there is a technical difference between the two, all you really need to know is that both affect the image somehow.

The filters require the image to be either a 24-bit (16 million colors) image or an 8-bit grayscale image. If necessary, select the **Convert/To 24-bit RGB True Color** command to change your image so you can use these effects.

Find contour

This filter changes a continuous tone image into a contour drawing on a black background. For the best effect, try applying the Find contour filter to an image or selected area of an image that has many shapes and colors.

Select the **Enhance/Special Filters/Find Contour...** command. This opens the Find Contour dialog box. You can set different options in this dialog box. The "Threshold:" setting (1 to 254) determines which edges will be traced.

You can also determine which color to adjust with the "Channel" option. The default setting is the RGB button, but you can also select only "R" (red), "G" (green) or "B" (blue). The following is an example of applying the Find Contour command to an image:

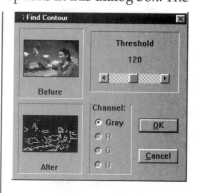

The Find Contour dialog box lets you determine the style and shape of the contour

Applying the Find Contour command to the original which is on the left
(Threshold set at 50 and Gray)

Blur

This filter sounds as if it changes the image so you need eyeglasses to focus on it. However, that's really not the case. Instead, the Blur filter subtly blends the colors of an image. For example, if you have an image of small red polka-dots on a blue background, using the Blur filter would make the edges of the dots blurry and purplish. For example, select **Enhance/Smooth Filters/Blur Lightly** to produce less of an effect:

287

A lot of smoothing would make the whole area purple. For example, select **Enhance/Smooth Filters/Blur Heavily** to proud a much stronger effect:

So, remember, use the blur filter to decrease contrast between pixels.

> Instead of using Blur Heavily, try using Blur or Blur Lightly twice to magnify the effect. Use the blur tool to smooth small details on the image.

Sharpen

One problem that has occurred with scanners is that the scanned image often appears "soft" or out-of-focus. This is true regardless of which type of scanner was used. Even images scanned on high-end drum scanners sometimes have this problem.

To "fix" this problem we need to use a feature called *sharpening* (or what the professionals usually call *unsharp masking*). Regardless of its name, sharpening is a standard technique that emphasizes the differences between adjoining areas of significantly different hue or tone.

In a sense, Sharpen is the opposite of Blur. This filter can be useful if the image was blurry before you scanned it or became blurry as a result of scanning.

288

For example, select **Enhance/Sharpen Filters/Sharpen Lightly** to produce less of an effect:

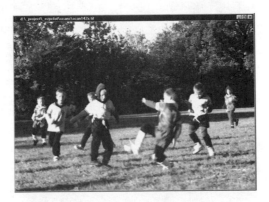

Selecting **Enhance/Sharpen Filters/Sharpen Heavily** produces a much stronger effect:

Use the Unsharp Mask filter to adjust the contrast of edge detail. This will help the image to appear sharper. You'll usually use the Unsharp filter to correct the focus on blurry images. In other words, use Unsharp Mask to fix the focus of an image that has become blurry from interpolation or scanning. It produces a lighter and darker line on each side of an edge, which helps emphasize the edges.

289

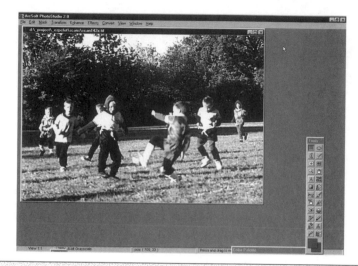

It may take some time and experimenting to determine the best combination of settings for an image. This is the reason some scanning software packages now feature sharpening as an option during image capture.

Also, use the sharpen tool to sharpen small details on the image.

Add Noise and Despeckle

Use this filter to add random colors on the image. Applying the Add Noise filter to a current image creates a grainy, high-speed film effect.

You can either select the area you want to change or make certain no area is selected to change the entire image. Select the **Enhance/Special Filters/Add Noise...** command. This opens the Add Noise dialog box.

Move the small slider box left or right to set the intensity level. The higher (to the right) you move the slider box, the greater the intensity of the effect. Also, check the "Before" and "After" windows for an idea of how your image is changed.

Click (OK) to apply changes or click (Cancel).

Example of the Add Noise filter
(intensity set at 13)

 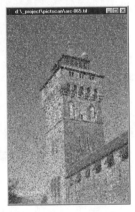

Another example of the Add Noise filter with the original on the left,
tweaked image on the right (intensity set at 35)

Despeckle

Use Despeckle to remove "noise" from your images. You can also use Despeckle when trying to remove Moire patterns from your images.

Retouching With Gradients

A gradient is a popular tool in PhotoShop and other higher cost image editors. PhotoStudio is a welcome exception among lower cost image editors because it does include this useful tool. A gradient is simply a transition from one color to another color. You can use this tool in PhotoStudio to fill the current mask or the entire image with a gradient from the background color to the foreground color.

The following is a simple example of a gradient. The image starts black on the left side. However, it gradually becomes lighter as it moves to the right until it is all white on the right side.

An example of a gradient...the image starts black
and gradually becomes lighter until it's all white

Using the Gradient tool

To apply the gradient tool, click at the point where you want the gradient to start. Then move the mouse to drag the cursor. This designates the length and direction of the transition.

For example, if you want a gradual, sunset-like gradient, set the background color to a light blue and the foreground color to a dark orange. Start at the top of the image.

Click where you want the gradient to begin and drag straight down to the bottom. You don't necessarily need to drag completely down or across the image. If you want the transition to occur more quickly, drag for a shorter distance. Also, you can have part of the transition occur outside the current mask or image by dragging past the boundary of the mask or image. The gradient line will not move outside the image but the effect will still work.

In the illustrations below, the arrows show the direction where we dragged the mouse to fill the gradient.

Applying a gradient to an image

If you want to apply a gradient fill to an image, double-click the Gradient tool in the toolbox (shown on the right). This opens the Fill Gradient Options dialog box.

This is where you set the level of fill, style of gradient and other options. Move the small slider box left or right to set the level in "Transparency" (0 to 99). The higher (to the right) you move the slider box, the greater the transparency of the gradient. In other words, lower numbers represent opaque and higher numbers are very transparent.

The Fill Gradient Option dialog box lets you determine the level of fill, style of gradient and other options

The "Color Sweep" option lets you select multiple gradients. If you set it on 10, for example, the transition will occur between the background and foreground colors for a total of ten bands of changing colors.

The options in "Transition" let you select a soft or hard transition between the colors. "Soft" creates a gentle and smooth change between colors, while "hard" is a harsh and abrupt change between colors.

The options in "Gradient Style" determine the shape, or appearance, of the gradient. A linear gradient, as its name suggest, is a line-by-line shape. You can change the shape of the gradients to be circular, elliptical, square, or rectangular.

Most gradients are made according to the RGB scale. However, you can switch this to the HSV color scale (hue, saturation, brightness values). This results in a rainbow-like transition between the colors.

The gradient on the left was set at Linear/Transparency 30/Color Sweep at 1 and the gradient on the right was set at Circular/Transparency 36/Color Sweep at 71

The gradient on the left was set at Elliptical/Transparency 36/Color Sweep at 1 and the gradient on the right was set at Square/Transparency 69/Color Sweep at 1

This gradient was set at Rectangular/Transparency 43/Color Sweep at 100

295

Applying a gradient to text

You can also apply a gradient fill to text. Double-click the Text tool to open the Select Font dialog box. Select the font, style and size (and effect) of the text you want to use. We're selecting GillSans, Bold and 150 for our example (see illustration on the right). Click the (OK) button when you're finished.

Move the cursor onto the photo near where you want the text to appear. Click the left mouse button to open the Edit Text dialog box. Enter the text you want to appear on the image. For example, we're using the line "Lake Michigan Shoreline" in the example on the right.

If you need to make a change to the text, such as size or font, click the (Font...) button and make the necessary changes. Click the (OK) button when you're finished.

Then, if necessary, use the Area Move Tool to move the selected text to the spot on the image where you want it to appear. Make certain not to deselect the text or you'll have to start again.

Next, set the foreground and background colors to those that you want to use in the gradient.

Double-click the Gradient tool to open the Fill Gradient Option dialog box. This will not deselect the text on the image. Set the options to the way you want the text to be filled. We're using "0" for "Transparency" and "100" for "Color Sweep" and "Linear" for "Style" (see illustration on the right).

Drag the cursor on the selected text in the direction you want the gradient to appear. We're using a linear gradient from the top to bottom in this example:

297

If the gradient fill isn't what you expected, select the **Undo** command before you do anything else. Then try a different fill pattern or direction.

You can still use the Move selection area tool to move the text (if it's still selected) to a new location. Select the **Mask/None** command to deselect the text. Now you've not only added text to your image but you're also added a gradient to the text.

The final image; gradient fill was set for Linear,
Transparency set at 0 and Color Sweep set at 100

Apply Effects Without The "Special Effects" Commands

You don't have to use the commands in the **Effects** menu we talked about earlier to add special effects to your images. For example, we started with the following image:

Although the changes may be difficult to notice on the black-and-white printed page, we used the Rectangle selection tool to select different areas of the image. The areas don't have to be the same size or even rectangular (you can use the Freehand Select Tool to select an odd-shaped area). Most commands can be applied to either the entire image or a selected area of the image.

This is the original image before we had some fun

The area in the upper-left corner was changed using the **Enhance/Negative** command. This command is called "Invert" or "Reverse" or similar names in other image editors. It reverses the brightness and color values of each pixel in the image or selected area of the image. The area immediately below this wasn't changed, but is part of the original. The lower-left corner was changed using the **Enhance/Hue and Saturation** command. Slide the "Hue" level and "Saturation" level all the way to the left to remove all color from the selected area. This is a great way to remove color from, for example, the background but keep the foreground subject in color.

After selecting the upper-right corner area in this example, we applied the **Enhance/Threshold...** command. This command is used to create high-contrast black-and-white or color images. You may use Threshold to create black-and-white silhouette images or to modify grayscale images so they can be printed at a low screen resolution.

The bottom-right corner was changed using the **Enhance/Equalization** command.

This is the original image after we had some fun

This example is a bit of an exaggeration. However, you can create some special effects even without using any of the special effects commands. Don't limit yourself to using only the special effects commands. Select different areas of your image and experiment with some of the other commands, too.

Before We Leave

We need to mention just a few more of the features of PhotoStudio before we conclude the chapter.

Exchanging images

PhotoStudio also lets you exchange images with other Windows applications (such as Microsoft Word, Adobe PageMaker and others) by using the Windows Clipboard.

For example, say we want to use the image on the right in a Word document. Start by copying the image. Select either the **Edit/Cut** or **Edit/Copy** command to bring an image on the Clipboard. You can also use the Clipboard dialog box itself.

Then select the **Edit/Clipboard...** command. This opens the Clipboard dialog box. As with most applications, the PhotoStudio Clipboard is a temporary image storage area. You can use the Clipboard to transfer data between different images or images between different applications.

*The PhotoStudio Clipboard
dialog box*

300

The image should be displayed if you selected either the **Edit/Cut** or **Edit/Copy** command. If not, click the [Load...] button and select the image you want to load into the Clipboard. This is similar to loading an image into PhotoStudio.

Click the [Export] button to export the Clipboard image to the Windows Clipboard. Click the [OK] button to exit the dialog box.

Then switch to or load the other application (Microsoft Word in our example). Move the cursor to the location in your other document where you want to paste the image. Select the **Edit/Paste** command and the image will appear!

*Importing the image from the Clipboard
into our Microsoft Word document*

301

Summary And Contacting Arcsoft

We hope this chapter has given you at least a glimpse into using PhotoStudio. Again, we could not explain all the features and power of this fine program. We have included a fully functional version of PhotoStudio on the companion CD-ROM. This is the "real" program and you can use it for 30 days or 100 accesses (whichever comes first).

For more information on PhotoStudio, contact Arcsoft:

Arcsoft, Inc.
4015 South Clipper Court
Fremont, CA 94538

(800) 762-8675

(510) 440-1270 (fax)

http:\\www.arcsoft.com

Example #2: Using MGI PhotoSuite

Chapter 12

Example #2: Using MGI PhotoSuite

You won't find many reasons not to have fun using PhotoSuite. In fact, you may have so much fun using PhotoSuite from MGI that you'll forget that it's designed for much more than fun. Many of us have wondered what our pictures would look like on the cover of a magazine. Now with PhotoSuite you can place your image (or any image) onto a magazine cover. Simply select one of the magazine templates that's included with PhotoSuite.

Now, PhotoSuite is indeed fun to use but it has its serious side, too. Use PhotoSuite to tweak photos, eliminate red-eye and fix other flaws in your photos. You can also take screen captures, organize pictures into photo albums or acquire images from TWAIN-compatible scanners.

> Anxious for a closer look at all the features of PhotoSuite. We've included a demo version of PhotoSuite on the companion CD-ROM. See the Appendix for more information.

Introducing PhotoSuite

In this section we'll show you how easy it is to use MGI PhotoSuite. Aptly named, it's a suite of photo editing and management software suited for Web development, office work and home projects.

Includes standard image editor features

PhotoSuite naturally includes many of the features we mentioned in Chapter 10 that any image editor must have. These include the following:

You can flip your images in PhotoSuite

306

You can rotate your images in PhotoSuite
(Rotate Right is shown here)

You can mirror your images in PhotoSuite

You can also reverse colors (which is essentially the same as "Negative")

However, PhotoSuite also includes many unique features and options, which we'll talk about next.

Having fun with PhotoSuite

You can start your work with PhotoSuite from the Activity Guide:.

The ten large icons in the Activity Guide let you start various image editing projects

308

The ten large icons let you start various image editing projects. These include importing or editing images, viewing albums and slide shows and printing images. (You can also go right to the main screen of PhotoSuite by clicking the [Work on your Own] button. The same features associated with the Activity Guide icons are listed individually in the **Fun** menu. You could also select the **Fun/Activity Guide...** command.)

You can also choose among several image "publications." The following table explains these publications:

Publication	Explanation
Posters	Put your images into a poster template.
Sports cards	Put your images into a sports card template.
Magazine covers	Put your images on the cover of a Magazine template.
Greeting cards	Add your images to personalize your greeting cards (including birthday and major holidays).
Calendars	Add your images to create custom calendars.
Body switch	Perform body switches with the faces of your friends, family and co-workers and cartoon bodies.

This will be a good starting to point for having some fun. We'll use a photo that we've scanned to create a calendar.

Creating a calendar

Creating a calendar in PhotoSuite could not be any easier or faster. Make certain to start with an empty window (otherwise the calendar will use the current, or active, image). Select the **File/New** command if necessary. Your screen should like the following:

Select the **File/Open...** command to load the image you want to insert into the calendar (shown on the right).

This opens the Open Image or Album dialog box.

Now you need to specify the name and location of the image file that you want to open. Select an image file and click the ⌑Open⌑ button to load the photo and display it in a new window. The file name, image size and resolution are displayed in the title bar of the Photo window. The full file name is displayed in the Help line located at the bottom of the application window.

We're inserting the following image into our calendar:

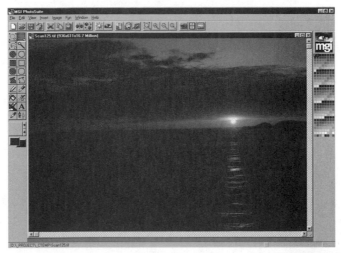

Select the **Fun/Calendars** command (shown on the right). Soon the Print Preview: Calendars window appears:

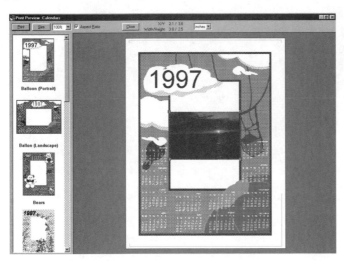

The Print Preview: Calendars window shows
the selected image inside a calendar

311

The image you selected should appear inside the calendar. If you don't like the default calendar, select another calendar from the selections on the left. You have several choices of different calendars from which you can select. Click on the slider bar (but don't let go of the mouse button yet) and move the it up or down to view more calendars. You can also click the arrow buttons in the scroll bar. For example, we used the slider bar to scroll down the selection list until "1997" appeared (see illustration on the right).

When you see a calendar that you like, or one that's appropriate to your image, simply click it one time. PhotoSuite automatically adds the photo into the calendar:

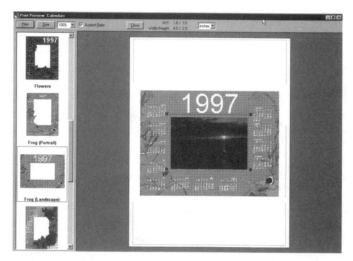

PhotoSuite automatically adds the photo into the calendar

Notice that some calendars are wider and some are taller. The calendar templates that have a wider frame area are in *landscape orientation*. The templates that have a taller frame area are in *portrait orientation*. Sometimes you may like a calendar that is in one orientation but your photo is in the other orientation. When this happens, use the Auto Fit feature to fill the frame. For example, if we used a portrait orientation instead of a landscape orientation for this photo's calendar, too much white space would appear:

When this happens, click the Size button. This lets you adjust the size of the photo to fill the entire white space in the calendar:

You may need to move, or scroll, the photo so the desired area appears in the frame area of the calendar. To do this, move the mouse pointer onto the image in the calendar. The cursor should appear as a four-pointed arrow. Press and hold down the left mouse button, then move the mouse until the photo is exactly where you want it to appear:

*Once your image is placed properly,
you're ready to print the calendar*

Once everything looks good, release the left mouse button. Now you're ready to print the calendar. To do this, simply click the Print button. You've just created and printed a calendar featuring an image that you selected!

You can follow similar steps to create magazine covers, posters, sports cards and greeting cards.

Example of a magazine cover

314

Example of a poster

Example of a sports card

Adding a word balloon

You can use one of the word balloon templates in PhotoSuite to place word balloons in your photos. Word balloons have been used in comics, editorial cartoons and many other drawings for many years. A word balloon is basically the border surrounding an area of text. A small arrow usually points in the direction of the "speaker."

Using a word balloon is usually more effective than simply adding text to the image. This is especially true with pictures of people or animals. PhotoSuite includes several word balloon templates that you can use to surround text that you want to apply to an image.

We'll start with the following image and add a word balloon to it:

Start by selecting the **Insert/Word Balloons...** command. This opens a dialog box showing the different word balloon styles from which you can select.

*The Insert Word Balloon dialog box shows the
different word balloon styles that you can use*

Select the desired balloon that you want to use. If necessary, click the slider
bar at the bottom of the dialog box (but don't let go of the mouse button yet)
and move the slider left or right to view more balloons. You can also click the
arrow buttons in the scroll bar.

Click the OK button when you've selected the balloon you want to appear in
your photo. Use the sizing handles on the corners of the balloon to resize it,
if necessary

You may also need to move the word balloon. If so, move the cursor onto the balloon. The cursor should appear as a four-pointed arrow. Press and hold down the left mouse button, then move the mouse until the balloon is exactly where you want it to appear.

You can then use the text tool to add any text that you want. Start by selecting the color of the text you want to use. The new text will appear in the foreground color. Double-click the Text Button in the Toolbox. PhotoSuite opens the Text dialog box.

Enter the text that you want to add to the image in the large text box. The cursor should already be blinking inside the text box right after you open the Text dialog box. Otherwise, simply click inside it to access the text box.

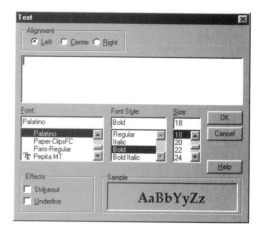

Enter and format your text in the Text dialog box

Next, select the alignment of the text (Right, Centered or Left). The Text Tool supports three font properties: font (typeface), style and size. Select the properties from the combo boxes in the dialog box.

The Text Tool provides two text effects (Strikeout and Underline). A text effect is on when its check box is filled.

Finally, click the (OK) button or press (Enter) to close the Add Text Dialog Box.

In our example on the right, we're adding the text "Peek - A - Boo" to the word balloon. We're also using a font called Kids-Writing1 with a size of 14 and bold-italic. We did not use either of the two "Effects".

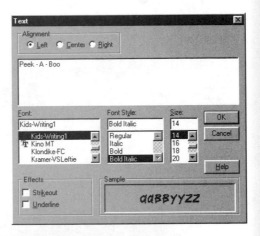

Then after clicking the OK button, PhotoSuite added the text to the balloon. Now our image has the word balloon and looks like the following:

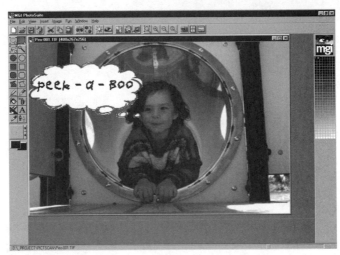

The image after applying a word balloon and text

You can follow similar steps to add props and even a picture frame to your images and photos.

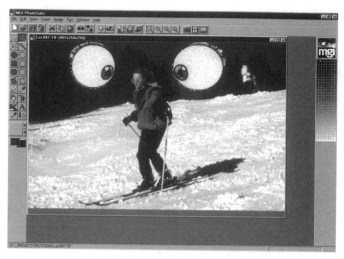

Example of using a prop

Example of using a picture frame
(originals are on the left)

Now For Some More Serious Work

OK, we've talked about having fun using MGI PhotoSuite. Now it's time to show PhotoSuite's serious side: the necessary tools and functions for serious image editing work.

Adjust the brightness of an image

We've often mentioned that you'll use your image editor frequently to adjust the brightness/contrast levels of your images. This is done using the **Image/Brightness...** command in PhotoSuite.

Start by selecting the **Image/Brightness...** command or the Adjust Brightness icon from the button bar. Unfortunately you cannot adjust the brightness or contrast on only part of the image; this command affects the entire image. Also, the **Image/Brightness...** command affects all colors in your image equally.

The Adjust Brightness dialog box appears after you select the **Image/Brightness...** command.

Set the levels in the Adjust Brightness dialog box as if you were changing the brightness knobs or buttons on your monitor. In other words, adjust the settings with the slider bar as you would turn the knobs on the monitor.

To lighten an image move the slider bar above zero (0). To darken the image, move the slider bar below zero. Click the ⌈Preview⌋ button to see how the change affects the image. For example, by clicking the ⌈Preview⌋ button we've discovered the following image was brightened far too much:

If you don't like the change or decide not to use the Brightness command, click the ⌈Cancel⌋ button. This cancels any changes you've made and closes the dialog box.

Click the ⌈OK⌋ button if you're happy with the tweak.

Color correction

PhotoSuite doesn't use a "Contrast" command. Instead, to adjust the contrast of your images, you'll need to select the **Image/Adjust Colors...** command. It lightens or darkens the entire image or specific colors within the image.

Start by selecting the **Image/Adjust Colors...** command.

Selecting the Image/Adjust Colors... command

322

This opens the Adjust Color dialog box. You can set different settings for Red, Green and Blue in this dialog box. In other words, you can lighten or darken the entire image or specific hues within the image by adjusting the colors of the image.

The Adjust Color dialog box

Use the sliders to set gamma values for the three colors. Color correction (also called *gamma correction*) uses a mathematical formula that leaves very light and very dark color values relatively unchanged.

Mid-range colors, however, are more strongly affected (either lighter or darker). Notice the default gamma value is "1.0"; the value of "1.0" does not affect the color.

Move the slider above 1.0 to lighten the desired color; move the slider below 1.0 to darken the color. If you want to synchronize all the sliders to the Green slider, select the "Link Sliders" check box. This moves all three sliders at the same time.

Click the Preview button to see how the image is affected by the change. For example, in the following illustration, we needed to darken the blue levels and lighten the red levels. (The differences are probably difficult to notice in the black and white image here.)

323

*Adjusting the colors in PhotoSuite is done using
the Adjust Colors dialog box*

Click the [Cancel] button to restore the image to its original appearance. Click
[OK] if you're happy with the tweak.

Enhance colors command

Another color command in PhotoSuite is called **Enhance Colors...** You can
use this command to adjust the intensity, or saturation, of colors in an image.

Start by selecting the **Image/Enhance Colors...** command or the Enhance
Colors icon from the button bar.

This opens the Photo Enhance dialog box. Use the options in this dialog box to adjust the intensity of the colors of an image. The **Image/Enhance Colors...** command affects the entire image. Move the slider above 1.0 to brighten (but decrease the intensity of the colors) the image. Move the slider below 1.0 to darken the image (but increase the intensity of the colors).

*Photo Enhance
dialog box*

Click the Preview button to see how the image is affected by the change. Click Preview to restore the image to its original appearance. Click OK if you're happy with the tweak.

Color increase/decrease

Before you can use some commands and functions in many image editors, you may have to set the image at a level of 16 million colors. Most of these commands and functions (including special effects, filters and other imaging tools) can only work on 24-bit images (also called 16 million color images).

So, you may need to increase the color depth of your image so you can use a particular command or function. Start by selecting the **Image/Increase Colors** command. Then select the desired level.

> The menu item representing the current color depth is always disabled ("16 Colors" in this illustration).

Decreasing color depth

Although you'll need to increase the color level of an image before you can use most functions and commands, you may also need to reduce the color depth of an image. For example, reducing the color depth decreases the memory size of an image. You may also need to display an image on a monitor or PC that cannot show all the colors in the current image.

Select the **Image/Decrease Colors** command and select the desired level.

The Color Reduction dialog box opens if you selected "16 Colors" or "256 colors." This is where you reduce the number of colors in the image.

We usually recommend selecting the "Optimal Palette" option—it will generally provide the best image quality. The other two options use a standardized palette for color reduction. Although this palette uses a variety of colors, they may not always correctly represent images that do not have a wide range of shades.

Click OK when you've selected the right color depth.

Special Effects

A lthough we usually consider special effects part of the "fun" of using an image editor, they really do have a serious side. Also, as we mentioned, no image editor is complete without at least a few special effects. PhotoSuite includes several sophisticated tools that you can use to apply special effects to your images. To see these, select the **Fun/Special Effects...** command. This opens the Apply Special Effect dialog box.

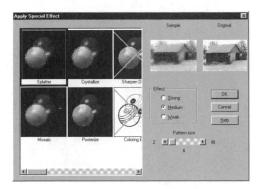

The Apply Special Effect dialog box

This dialog box shows how each effect changes the image. Each effect has specific attributes that can you can apply to the image. We'll use the following image to show you some examples of different special effects you can use in PhotoSuite.

The original image we'll use in showing
several special effects of PhotoSuite

327

Example of using the "Mirage" special effect
(intensity set at 50)

Example of using the "Spherize" special effect
(intensity set at 100)

Example of using the "Oval Frame" special effect
(intensity set at 20)

Example of using the "Relief" special effect
(intensity set at Medium)

Lens Effect Kit

Use the Lens Effect Kit to add different types of effects to your images. They include fog, smoked glass, glamour, moonlight, tan and many others. These effects act as color filters. Use one of these effects to add warm reddish tones, a soft blue incandescent lighting effect or a fog-like mist to your images.

329

To see these effects, select the **Fun/Lens Effect...** command. This opens the Apply Lens Effect dialog box. This window shows the effect the filter has on the photo you select.

This dialog box shows how each effect changes the image (look under "Sample" and "Original"). Each effect has specific attributes that can you can apply to the image. We'll use the following image to show you some examples of different special effects you can use in PhotoSuite:

As we mentioned before, most functions and commands only work with 24-bit images (16.7 million colors). So, you'll need to make certain your images are set for "16 Million" colors. See above for information on increasing the color of an image. The filters in the Apply Special Effect dialog box are marked with an X if the current image has less than the required color depth.

Also, the Lens Kit Effects are obviously better viewed in color. Therefore, these black and white photos are not truly representative of the effects of these filters.

330

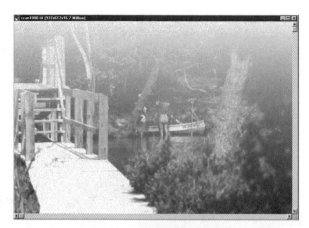

Example of using the "Fog" effect

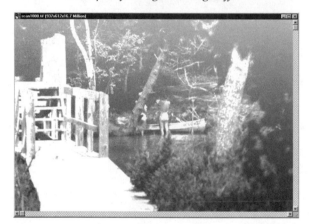

Example of using the "Antique" effect

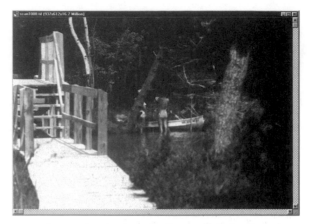

Example of using the "Moonlight" effect

Removing objects and people

MGI PhotoSuite includes several tools that you can use to apply art, text or other creations to your photos and images. They include Air Brush, Clone Tool, Eraser, Eyedropper, Magic Wand and other selection and drawing tools.

Let's use one of these tools to remove a person from an image. For example, let's start with the following photo:

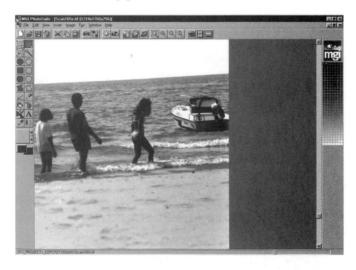

What we want to do in this example is completely remove the person in the middle from the image. We can do this by using the Clone tool. You'll find the Clone tool very useful when you're trying to tweak an image that has a *texture*. You'll often discover textures to be big problems when tweaking images. The more troublesome textures include water, cloudy skies, skin or any other texture made up of noncontinuous tones or shapes.

Since this photo includes one of those troublesome textures (the water), it's a good example of cloning a texture. The best way of working with textures is to use the textures themselves. For example, by simply cloning certain areas of the lake that closely match the area where the person is standing we can remove him from the image as if he were never there.

This is a snap in PhotoSuite. The first step is to select the desired type and size for the Clone tool. This is done by selecting the Pen tool. Select the size and shape in the Pen dialog box. Although you're using the Pen tool to set the size and shape, it also applies to the Clone tool. Then move the cursor to the area of the image you want to be the source. Press the (Shift) key and click the right mouse button to select this spot. Notice how a small "+" remains blinking at this spot.

When doing this type of work (or any work in an image editor), don't be afraid to zoom in to get the small details.

Next, move the large cursor to the place you want to be the destination area (the area where you want to clone to). Then press and hold the left mouse button while moving the mouse. You'll be "cloning" the colors from the small cursor to the large one. Releasing the mouse button "drops" the small cursor again. It's that simple.

Now, by continuing to use the Clone tool and making adjustments to either the style and size and changing the location of the source area, we're beginning to notice we have two people walking the beach where before there were three:

Finally, we have a finished image. Now there are only two people walking on the beach where before we had three. Believe it or not, this only took a few minutes—no, that's not a typo. It really did only take seconds (and we needed to use the **Edit/Undo** command only a few times).

334

The final image after the person was removed

Creating transparent .GIF files for the Internet

You can create transparent .GIF files in PhotoSuite. These files are great for the Internet and Web work. PhotoSuite supports two features of the GIF file format specification that let you create better looking World Wide Web pages.

Start by selecting the **File/Save As...** command. Make certain to set "Save File as Type" to "GIF (*.gif)."

Notice the "Interlaced GIF" and "Transparent Background" check boxes near the lower left corner of the Save Image dialog box.

335

The Save Image dialog box

Interlaced GIF Image Files

Selecting a GIF file with the "Interlaced GIF" checkbox set creates your graphic in alternating horizontal bands. The graphic image will appear to fade in as the file is received by a Web browser. Your Web pages will appear to load faster if you make your Web page graphics interlaced. Otherwise, the Web browser must receive the whole file before the graphic can be displayed. This can, depending on the graphic, require a lot of time. Keep in mind that Web surfers usually don't want to wait very long for a graphic to appear.

Transparent Backgrounds

Logos and non-rectangular graphics usually look better when their background color matches the color of the Web browser window. However, since you won't know beforehand what the background color of the Web browser window will be, you cannot create your graphics with any one specific background color.

MGI PhotoSuite and GIF89a files support specifying which palette entry is to be treated as the background, or transparent, color. After you have created your graphic, use the mouse pointer to select the color in the Color Palette that you wish to be transparent. Then click on that color and select the "Transparent Background" checkbox in the Save Image dialog box before saving your image file. You can create some interesting effects by having transparent images "floating" over browser window graphic backgrounds.

Make a screen saver or wallpaper

Two commands in the **Fun** menu let you turn your photos into Windows wallpaper or a screen saver. Select the **Fun/Set as Windows Wallpaper** command to set the current photo as the wallpaper for your PC.

Now, close (or minimize) PhotoSuite. You'll see that you now have new wallpaper!

You can also add a personal touch to your screen saver programs in Windows 95. Select the **Fun/Set as Windows Screen Saver** command.

Note that you must restart Windows before the screen saver can run.

338

Click the OK button to close this message box. Then the next time you start Windows you'll have a new screen saver! If you want to change any settings, select Start/Settings/Control Panel.

Then double-click the Display icon (shown on the right). Click the Screen Saver tab. You're looking for the screen saver called "MGI PhotoSuite Image" in the list of Screen Savers. Click the small arrow to view all the screen savers. Set a time (in minutes) in the Wait: box to determine how long Windows will wait before launching the screen saver.

Before We Leave

We need to mention just a few more of the features of PhotoSuite before we conclude the chapter.

Body Switch

Use the Fun/Body Switch command to place the face of a friend or relative on a cartoon body. These cartoon bodies can be a mighty space warrior, to an ice skater to a sumo wrestler to the family pet Rover.

339

Select the **Fun/Body Switch** command. When you select the Body Switch, you will have to select the photo you want to use. Once you have selected the photo then you will have to select the body that you want to use. You will then have to select the head that you want to put on the cartoon body by using one of the selection tools.

Then you can drag and drop the selected head from one image to another by clicking on your selection when it has the movement cursor on it (the four arrows) and move it from one image to the next.

Move the head where you want it on the photo and click outside the selected area. Then touch up the new image and print it out.

Summary And Contacting MGI Software

We hope this chapter has given you at least a glimpse into using PhotoSuite. Again, we could not explain all the features and power of this fine program. Don't forget to take a look at the demo of PhotoSuite that we've included on the companion CD-ROM.

For more information on PhotoSuite, contact MGI:

MGI Software Corp.
40 West Wilmot Street
Richmond Hill, Ontario L4B 1H8

(888) MGI-SOFT

(905) 764-7000 (fax)

http:\\www.mgisoft.com

Example #3: Using LivePix

Chapter 13

Example #3:
Using LivePix

LivePix (published by Live Picture and distributed by Broderbund) is one of the first programs to use the new FlashPix technology (see Appendix A). LivePix gives you virtually everything you need to create amazing projects with your photos. These projects include art, cards, calendars, flyers, T-shirts, e-mail attachments and more.

The opening screen in LivePix

343

If using an image editor is a new experience, you'll appreciate LivePix. Although it's designed to be easy to use, FlashPix combines features and capabilities that were previously available only to professionals. It includes the tools that you should expect in an image editor (see Chapter 10), including:

➤ Flip ➤ Rotate

➤ Skew ➤ Crop

➤ Resize ➤ Color correction

➤ Contrast/brightness adjustments

Plus, it features FlashPix image-format and editing tools for creating masks and silhouettes.

Another reason that LivePix is great for new users is that you don't have to worry about making mistakes with LivePix; it features unlimited Undos—a useful feature for everyone, especially for those who are new to image editors. Besides the FlashPix format, LivePix supports BMP, TIFF, GIF, JPEG and Photo CD formats. It is, of course, TWAIN compliant.

Furthermore, LivePix has bundled several excellent templates and photos so you're ready to begin working with digital images immediately. Finally, if you don't own or use a scanner, LivePix hasn't forgotten you. They've included a special offer from Kodak for users without a scanner. This offer lets you get your photos digitized for free!

System requirements

Like most FlashPix applications, LivePix is very light on system requirements. However, as with other image editors, we again recommend that bigger is better. The following lists the minimum system requirements for LivePix:

➤ 486 100Mhz (Pentium-class processor recommended)

➤ Windows 95

➤ 8 Meg RAM (16 Meg recommended)

➤ 20 Meg of available hard drive space

➤ SVGA (640 x 480) monitor with 256 colors

➤ Microsoft Windows compatible mouse

➤ CD-ROM drive

Examples of its features

LivePix includes many special-effects tools. These include distortion, adjustable shadow casting and red-eye removal. LivePix will also pack a library of photographs and templates for creating cards, calendars, photo albums and posters.

Some of the features of LivePix include:

Change colors

Tweak a specific color in your photo by increasing or decreasing its level.

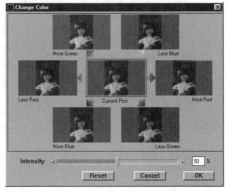

Tweak your photos

Use one or more of the LivePix tools to tweak your photos. For example, you can resize, distort, rotate, flip, shadow, feather, color correct and add text to your photos.

345

Example of Edge feathering

Distort

This amazing digital tool lets you stretch or compress just about anything in your image. You can make your distortion as subtle or spectacular as you like.

Make your distortion subtle or spectacular in LivePix

Enhance

LivePix includes special color-enhancing and contrast-correcting tools so you can turn your "oops" into a masterpiece.

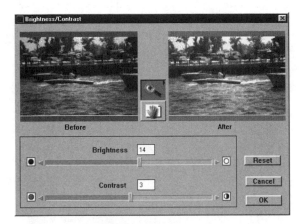

*Use color-enhancing and contrast-correcting
tools to tweak your images*

Gallery

Store your digital photos in the Gallery. This is like a photo
album, except you're working with digital images. You can then
drag and drop the photos into each project.

Put in Perspective

Another way to tweak your images is to rotate or skew them.
Change the perspective of an image by squeezing the sides
together.

*The
LivePix
Gallery
stores your
digital
photos*

347

Use one of the skewing tools to add a
3-D perspective to your images

Stick-On Disguises

Add fun disguises onto pictures of your family and
friends. Put a wig on the head of your boss or a mask on
your best friend's face.

Text

You can have a lot of fun working with text in LivePix.
You can make your text virtually any size or color. You
can even skew it or make it fuzzy. Text can even appear
as a stencil so you can fill it with photos.

Publish!

Once you have tweaked (or distorted) all the photos for
your masterpiece (you can use up to 50 images in one
picture) you're ready to paste it all together.

Add fun disguises
to your pictures

348

Using LivePix

In this section we'll show some examples of using LivePix. After starting LivePix, the next screen you'll see following the introduction screen is the Getting Started dialog box.

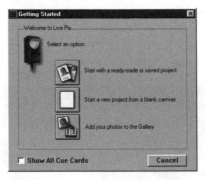

The Getting Started dialog box

This is where you decide how you want to start and work with your photos in LivePix:

➤ If you want to start from a LivePix template, a previous project or a photo in the Gallery, click the "Start with a ready-made or saved project" button.

➤ Click "Start a new project from a blank canvas" button to start with a blank canvas. Another dialog box will open to let you determine size and orientation.

➤ Click the "Add your photos to the Gallery" button if you want to add photos to the Gallery. We'll talk about the Gallery a little later.

The New... dialog box

For now, we'll start by clicking the "Start a new project from a blank canvas" button. This opens the New... dialog box.

349

A *project* in LivePix is simply a document. A project can be one photo or it can be a collage of photos with text and other objects. Enter a name for your project in the Title: text box. We've entered a name of "TEST" in this example (see the illustration on the right). Next, select the orientation or one of the card formats. We're selecting the default "Portrait" in this example. You can also specify a custom size if this is a special project.

Click the OK button. Now we're ready to add a photo to the project.

Now we're ready to add a photo to the project

Adding a photo

The next step is to add a photo into the project. You have three ways to do this. One is to select the **File/Insert...** command. This brings up the Open dialog box.

350

*Double-click the photo in the Open
dialog box that you want to use*

Locate the folder that contains the photo you want to use. Double-click the name of the photo. You can also preview the photo in the Preview window. For example, we've selected an image file called SCAN140.TIF in the following example. Notice the image appearing in the Preview window.

*Check the Preview window to verify this
is the image you want to use*

A second method of opening a photo involves using the Gallery. Click the Photos tab in the Gallery. Select the album containing the photo you want and click the [Insert] button.

The third method is to drag the photo from the Gallery, the desktop or a folder to the project window and drop it into the project. Click the image in the Gallery that you want to use. In the following illustration we've selected the image called "1101027."

351

Press and hold the left mouse button and drag the image to the project window. Release the left mouse button and the image appears in the project window.

Now you're ready to tweak the photo.

Distorting a photo

We'll start with the fun tool first. You've probably stood in front of a funhouse mirror before and noticed how your features changed. This is the same type of effect that the Distort tool can have on your images. In other words, as you drag the Distort tool, the image is also dragged in that same direction.

Start by selecting the photo you want to distort. Next, click the F/ X tool in the toolbar and then select the Distort tool.

You should now see a Distortion Strength slider in the control bar. Drag the slider to set a distortion strength from weak (left) to strong (right).

To distort a small part of the photo, keep the Distortion Strength slider towards the weaker side. However, if you want to distort larger part of the photo, move the Distortion Strength slider towards the stronger side.

The following are some examples of using the Distort tool. The first illustration is the original image. The other three illustrations show the effects of varying levels set in the Distortion Strength slider.

353

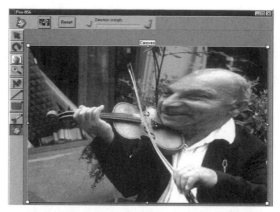

Examples of using the distort tool

354

Cutting out shapes

For creating selections, LivePix provides several tools that let you define the selection area on the image. The first tool that we'll talk about is the Freehand Cutout tool.

Cutting Out a Freehand Shape

The Freehand Cutout tool is good choice when you need to accurately trace the desired selection area. Also, you can usually create extremely accurate selections by using the zoom tool to magnify your views. You probably played the old game of connect the dots when you were a kid. Selecting an area using the Freehand Shape tool is done almost the same way. In other words, simply click around the area you want to select. Each time you click the left mouse button, the Freehand Shape tool creates an *anchor point*. Then when you're finished, the Freehand Shape tool joins the points together to define the shape.

Start by selecting the photo you want to edit. Next, click the Cutout tool in the toolbar and then the Freehand Cutout tool.

Finding the Freehand Cutout tool in the toolbar

As we said, the cutout works by setting a series of points along the path you want to cut out. Set the first anchor point by clicking at the point where you want to begin. Move the crosshair to the next anchor point and click again.

355

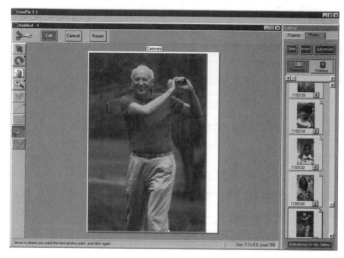

Repeat the clicking as often as needed until you've "clicked" your way around the shape. If When using the Freehand Shape tool, press (Backspace) to remove part of your selection path. To draw a straight line between two points, hold the (Shift) key as you click.

When you've almost returned to the starting point, double-click the left mouse button. LivePix will automatically draw a straight line from the point you double-clicked to the starting point. This completes the job of selecting the cutout.

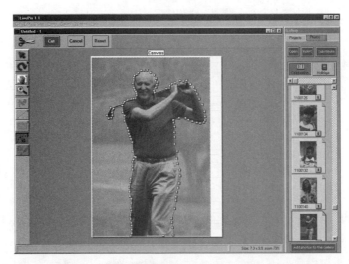

The area that you want to cut out should now appear differently from the rest of the image. Click [Cut] in the control bar to complete the cutout. If you're not happy with the cutout or want to cancel it, click the [Cancel] button.

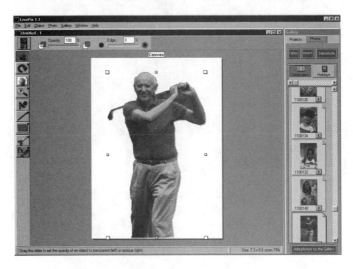

Creating a shadow

You can apply a three-dimensional effect to your image or an object by creating a shadow. A shadow is normally below and off to the side of an object. However, you're using a computer and a digital image so you can put the shadow just about anywhere you'd like. The shadow in LivePix keeps the same shape and size as the object.

In LivePix you can place a shadow behind photos, cutouts, line, shapes and text. You can set the color of the shadow, its location and its opacity and edge.

Start by selecting the photo you want to shadow. Next, click the F/X tool in the toolbar and select the Shadow tool.

This opens the Shadow dialog box.

Next, click the large Presets button and select one of the preset shadow types.

358

The default shadow can be changed by dragging the shadow in the Direction & Distance area of the dialog box to set its position relative to the object.

Set the opacity and edge of the shadow with the corresponding slider bars. Click Shadow Color and select a color for the shadow from the palette. Click the OK button.

An example of applying a shadow to a cutout...now we can add this to other cutouts and images to make a collage

Preset shapes

FlashPix includes several preset shape cutouts that you can use. These include the Rectangle Cutout, Oval Cutout, Heart Cutout and Star Cutout tools.

Start by selecting the photo on which you want to work. Next, select one of the preset Cutout tools (Rectangle Cutout, Oval Cutout, Heart Cutout or Star Cutout) from the Cutout tool palette.

Selecting a Cutout tool from the Cutout tool palette

Drag the cutout shape around the object until it reaches the size you want it to be. Hold down the (Shift) key as you're dragging the cutout shape to make a square or circle.

Example of using the Rectangle Cutout tool... now select the (Cut) button to create the cutout

360

Example of using the Oval Cutout tool...
now select the [Cut] button to create the cutout

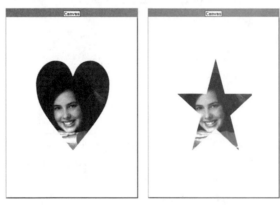

Example of using the Heart Cutout tool (left)
and the Star Cutout tool (right)

The area that you want to cut out should appear differently from the rest of the image. Click [Cut] in the control bar to complete the cutout. If you're not happy with the cutout or want to cancel it, click the [Cancel] button.

Why the cutout tools are so valuable

By using the Cutout tools, you can create interesting, amusing and even bizarre effects. Your friends will ask "How'd you do that?" when they look at your projects. For example, you might have a picture of a beach scene and a picture of a city skyline. Start your project with the city skyline, insert the beach scene and cut out the people in the beach. Then you have people in bathing suits in a big city.

The Gallery

Use the Gallery to organize your projects and individual photos. It works much like one of the photo albums you probably have stuck in a closet. Each photo in the Gallery is a thumbnail (a smaller version of the real photo or image). Click the "Add your photos to the Gallery" button. LivePix opens the same Open dialog box as above. Select the first photo you want to add to the Gallery.

The Gallery uses two modes called the working mode and the organize mode. As its name suggests, working mode lets you create or open projects, insert or change photos and add projects or photos to the Gallery. The organize mode lets you create albums, scan images and move items. You can also add/remove projects or photos to/from the Gallery in organize mode.

You can get information about an image in the Gallery by selecting the image. Then click the small "I" in the lower right corner of the thumbnail. This opens the information box shown on the right.

You'll see information about file size and type, creation date and more.

Working with text

You can add text to your project and then treat it like any other object. In other words, you can do this with text:

➤ Scale, rotate, and skew it

➤ Apply perspective

➤ Change its opacity and edge

➤ Substitute a photo from the Gallery inside the text characters

➤ Change its color or use the special Filter effect

You can also apply styles to text, such as:

➤ Bold, italic or underline

➤ Left, right or center alignment

➤ Fonts and point sizes

Adding text to your project

Start by selecting the photo on which you want to add text. Next, click the Text tool in the toolbar (see illustration on the right).

This opens the Text dialog box.

The Text dialog box in LivePix

Type in the text you want to add to your photo. You can enter more than one line of text by pressing the (Enter) key to start a new line. LivePix uses the fonts that you have installed in your PC.

Next, select the font and type size that you want to use. Select bold, italic or underlining with the corresponding buttons. We've decided to use "Cruising The Country!" for our text. We've made it bold and are using GillSans for the font. The size of the font is 8 point.

You cannot apply more than one attribute to the text in the dialog box. To create text with different attributes—for example, some bold text and some italic text—create a separate text object for each attribute.

If you've used more than one line of type, you can align the text by clicking the appropriate button to align the text either left, center or right. You won't see the alignment until you close the Text dialog box.

Click the (OK) to insert the text into your project.

Now you can move the text object to a better location on the image. Move the mouse pointer to the bounding box that surrounds the text and drag the text object to its new position.

Applying perspective to your text

You can also apply some special effects to text. For example, use the Perspective tool to apply three-dimensional perspective to any object, including text. Start by selecting the text object you want to change.

Then select the Perspective tool from the Position tool palette. Click a selection handle, and drag it up or inward or outward, depending on the effect you want.

365

The following show some examples:

366

Using text as a stencil

You can use text as a stencil by filling the text with a photo instead of with a solid color. Using this effect, the photo shows through the outline of the text.

Start by selecting the photo on which you want to add text. Next, either create new text (see above) or select the text object in your project that you want to use.

Selecting the text object to use

367

Then select the **Photo/Substitute...** command to open the Open dialog box. Select the photo you want to use for the stencil in this dialog box and click the Open button.

Move the new photo to the desired areas so the text is filled in the way you want.

When you're all set, click the Cut button.

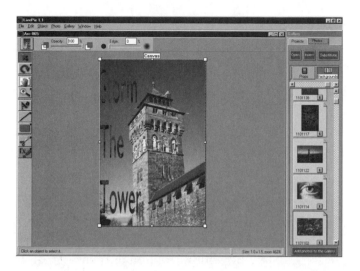

Aligning objects

One feature that LivePix has that the other image editors we talk about don't have is the ability to align objects in your projects. In other words, you can align objects horizontally (left, center and right), vertically (top, center and bottom) or both. You can also *distribute* the objects horizontally or vertically.

Start by selecting all the objects you want to align. Then select the **Object/Align** command.

This opens the Align dialog box.

*The **Object/ Align** command isn't in the other image editors we talk about*

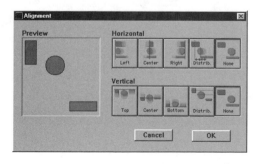

369

Click the button for the alignment option (or options) you want. If you decide not to use an alignment option after you've selected it, simply click [None] for that dimension. You don't have to cancel the alignment.

Click the OK button when the alignment is how you need it. As with many image editor features, experiment with aligning objects. You can always undo an alignment.

Changing object order

By changing the order of objects you're changing their location in depth. All objects are basically in a two dimensional relationship to each other. They're not only to the left or right of each other but they also exist in depth. In other words, some objects appear in front of, or on top of, other objects.

The first object you insert into a project is automatically at the back of the object order. Any new object is placed in front (on top) of the other objects.

So, unless you change the order, the most recently added object is always at the front of the object order. If you've inserted several objects, you'll probably need to change an object's position in the order. For example, you may need to move an object to the back or the front so it's in the right order. You can also move objects forward or backward just one position in the object order.

Sending an object all the way to the back

Start by selecting the object you want to move. Then select the **Object/Send To Back** command.

Bringing an object all the way to the front

Start by selecting the object you want to move. Then select the **Object/Send To Front** command.

Moving an object one position toward the back

Start by selecting the object you want to move. Then select the **Object/Move Backward** command.

370

Moving an object one position toward the front

Start by selecting the object you want to move. Then select the **Object/ Move Forward** command.

You can also arrange multiple selected objects this way. In that case, they retain their position relative to each other. The objects don't need to be adjacent in the object order. For example, if you move two objects to the back, the object that was originally in front remains in front of the other.

Summary And Contacting Live Picture

We hope this chapter has given you at least a glimpse into using LivePix. Again, we could not explain all the features and power of this fine program. If you're interested in trying LivePix, you can download a free version of LivePix from the LivePix website.

This will give a working version of LivePix that you can use for 30 days. For more information on LivePix, contact one of the numbers below:

http://www.livepix.com/main.html

or call **1 800 727 1621 to order LivePix today.**

Live Picture, Inc.
5617 Scotts Valley Drive, Suite 180
Scotts Valley, CA 95066

(408) 438-9610

(408) 438-9604 (fax)

EMail: info@livepicture.com

Example #4: Using PictureIt!

Chapter 14

Example #4:
Using PictureIt!

PictureIt! from Microsoft is another an example of how much fun you can have using an image editor, even though PictureIt! doesn't have all the advanced features of PhotoStudio (Chapter 11) and some other image editors.

For example, PictureIt! doesn't include cloning, drawing or painting tools. However, if you don't necessarily want to learn about image editors, but just want the program to do what's designed to do, PictureIt! May be your best choice.

What makes Picture It! so easy to use is that you don't need to know anything about image editing. Picture It! does most of the work for you. If you can follow on-screen prompts and directions, you can use PictureIt!. Although PictureIt! assumes that you're not an image editing whiz, it is, nevertheless, capable of some fanciful image editing.

PictureIt! features an easy-to-follow interface that presents six basic operations in a series of step-by-step tasks, which we'll explain in a moment.

PictureIt! uses FlashPix

But first, an important reason we're talking about PictureIt! is that it works with the new imaging standard called *FlashPix* (see Appendix B). FlashPix makes tweaking images easy, fun and fast. Your images will "flash" on your screen. In other words, you'll see the image change instantly with any edits and tweaks that you make. PictureIt! is the first home application that takes full advantage of FlashPix.

Another advantage of the FlashPix file format is that it saves any edits you make as a separate but linked file. This means you can make changes without affecting the original photo. So if you have added text to a photo, you can later reopen the file and just remove the text "layer" to change or omit the message without affecting any other elements.

You can reopen a file anytime and remove a "layer"
(text layer in this illustration) and change or delete
the layer without affecting any other elements

System requirements

These are the minimum system requirements for Microsoft PictureIt!. You'll find these to be typical for most image editors.

➤ PC with a 486/66 or higher processor

➤ Windows 95

376

➤ 8 Meg or more of RAM

➤ 75 Meg of available hard drive space

➤ 2x CD-ROM drive

➤ Super VGA color monitor

➤ Sound card with headphones or speakers is recommended

➤ Modem is required to use the Kodak Image Magic Print Service

Using PictureIt!

PictureIt! includes several Smart Tasks that can fix common problems such as red-eye, brightness/contrast and tint. They're called "Smart Tasks" because PictureIt! fixes those problems automatically. Also, you'll immediately see each change you make. You can skip the Smart Tasks and work on your own as you gain more experience using PictureIt!.

One thing you should immediately notice about PictureIt! is that it doesn't use any toolbars (see the following illustration).

Instead of the toolbar, you'll use the six large buttons located along the left side of the screen. These big buttons will help make your work easier because they're arranged in the order you need to use them. Simply click on the button to see a list of the different tasks you can use.

PictureIt uses these six large buttons instead of a toolbar

1. Get It lets you load an image or images into PictureIt!.

2. Prepare It lets you tweak the images.

3. Design It lets you create different projects in which you can use your photos. These projects include photo collages, greeting cards and calendars.

4. Frame It lets you add a border or frame around your images.

5. Just Add It lets you download additional borders and frames from Kodak.

6. Share It lets you print, send photos or slide shows to friends electronically, or upload your files to Kodak to have them printed and mailed to you.

Let's Use It

OK, we've talked about it enough. Let's use PictureIt! in a few examples. Let's start at the beginning by clicking the "Get It" button and loading an image.

As you can see in the following illustration, clicking Get It opens a menu that shows the five sources from which PictureIt! can load an image.

Get It opens a menu showing the five sources
from which PictureIt! can load an image

In this case, we want to work with one of our images so we'll click on the "My Picture" option.

This in turn opens the Get It Open pane:

The first step here is to choose the location of the image. This is probably your hard drive or CD-ROM drive. However, the Get It task lets you import pictures from a digital camera or scanner as well. Select your hard drive, folder and image.

The next step is to tell PictureIt! what type of file you want to load (if you know it). By default, PictureIt! first looks for files with MIX or FIX extensions. These are, not surprisingly, PictureIt! files. That's why the message "No pictures of this type in the current folder." appears in the illustration above. If your images are in a different format (such as TIF) choose that format in the "Display pictures of type:" box. If you know the file type, click the scroll box until the correct type appears. If you're uncertain of the file type, select the "All Pictures" option.

PictureIt! previews all the picture files that it finds in the folder you selected (according to the format selected in the "Display pictures of type:" box). This area is called the *Picture Pane*.

As you move the mouse pointer across the images, a small border appears on a selected image. Click and hold the left mouse button to select an image.

*Preparing to move an image to the Filmstrip...click and hold
the left mouse button to select an image*

Then drag the image to the Filmstrip located at the bottom of the screen. When
the image is in the Filmstrip, release the mouse button. As you can see, the
Filmstrip is similar to a real filmstrip. Each frame of the filmstrip holds a
separate image. You can scroll through the Filmstrip to either view or store
more images. Simply click the arrows that appear at either side of the
Filmstrip.

The desired image now appears in PictureIt!'s Picture Pane. That's all there
is to opening an image in PictureIt!.

*The image now appears in PictureIt!'s Filmstrip
and is opened in the Picture Pane*

381

Repeat these steps for each image you want to open. You don't have to click and drag all the images you want to open right now; you can add images at any time. When the images that you want to open are on the Filmstrip, click the (Done) button. Move the cursor onto the image in the Filmstrip that you want to open and click the (Open) button. You may also have to click the (Switch to) button (see below).

Zooming in and out is a bit different too

We mentioned at the top of this chapter that PictureIt! is different from other image editors because it doesn't use a toolbar. Another difference is that it doesn't use a magnifying tool to zoom in or out on your image. Instead, click the plus sign on the Zoom and Scroll tool to zoom in (enlarge the picture). This is located near the bottom right corner of your screen. Then to zoom back out (reduce the picture), click the minus sign.

You can also change the area in which you're zooming. Drag the scroll box in the Picture Pane to the area where you want to zoom in or out. The display in the Picture Pane will move based on how you drag the scroll box.

382

Adding another image

To switch to another image that is shown in the Filmstrip, simply click the picture in the Filmstrip that you want to open. This opens the retriever.

You can add a selected cutout of the new image or add the entire image. Click the (Switch to) button to open the new image. Don't panic—switching to another image in the Filmstrip won't delete the first image. The first image is back on the Filmstrip. You can follow these steps to switch back to it, if necessary.

Cutouts and trimming

Making a cutout in PictureIt! is very easy. You'll find it to be much easier than most other image editors. Unlike most other image editors, you won't have to worry about using a Magic Wand or similar tool. PictureIt! uses a Smart Edge Finder that lets you remove people and objects from photos in seconds by simply tracing them. It's one of the neatest capabilities in PictureIt!. It's also one of the best ways among all image editors to trace parts of a photo.

This is called a *cutout* in PictureIt!. You can use cutouts to make a new collage and add objects and text. You can change cutouts in most of the ways you can change whole pictures. A cutout is just what it sounds like. It's any part of a picture that you remove and separate from the rest of the picture.

To make a cutout of an image, click the Prepare It! button. Next, select the "Make Cutout" and then "Cut Out by Tracing" commands:

Selecting the "Make Cutout" and
"Cut Out by Tracing" commands

Notice the cursor changes to a "target" shape. Move the pointer to the part of the picture where you want the cut out to begin and click the left mouse button. Move the pointer a short distance along the path that you want to cut out and click the left mouse button again. Notice that a small tracing line has connected the two points. Repeat this at several points along the path. This

384

is especially true at corners and angles. Keep track of the small tracing line. Don't worry if the tracing line doesn't match the path perfectly. This step is only to get a "rough" cutout of the image. You'll be able to make any adjustments later.

Starting the cutout

Don't be afraid to zoom in on the image to make an adjustment or two. It's often easier to make very small adjustments when you zoom in to the area. Again, this is only a "rough" outline; you can adjust the tracing lines later.

Zoom in on the image to make a fine adjustment

Keep clicking these points along the path until the area you want to cut out is surrounded. (The outline may be hard to see in these black-and-white illustrations.)

385

The cutout is outlined

Note the small green flag in the Task Pane. Click this green flag if you need to adjust the cutout some more. Again, don't be afraid to zoom in on a particular spot. The cursor changes to a hand. Move the cursor to the part of the tracing line that you want to change. Simply pull the line into the correct position.

When you're satisfied the desired cutout is set, click the yellow flag in the Task Pane. Don't panic; the cutout area should appear darker than the rest of the image.

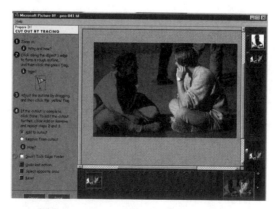

*The cutout area should appear darker
than the rest of the image so you'll know
that it is, in fact, a cutout*

Repeat these steps to add or remove other parts of the cutout. When the cutout is exactly the way you want it, click the [Done] button. You should also see the cutout added to the stack (in the top right of the screen).

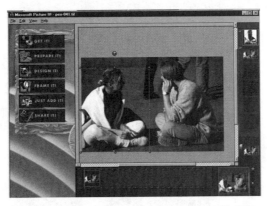

Now you should also see the cutout added to
the stack (in the top right of the screen)

You can also view the cutout by itself by removing the old picture from the stack. Select the old picture from the stack by moving the mouse pointer to it. Then click the right mouse button and select "Clear" in the pop-up menu. Don't worry, you're not deleting the file from your system. You're only removing the image from the stack to the right of the Picture Pane.

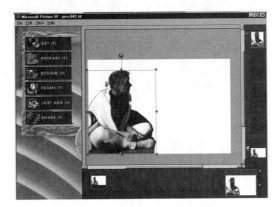

An example of a cutout in the Picture Pane

387

Using a predefined cutout

To use a predfined cutout, click the Prepare It! button. Next, select the "Make Cutout" and then "Cut Out with Shape" commands:

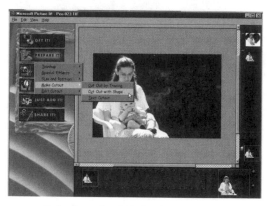

Selecting the "Make Cutout" and
"Cut Out with Shape" commands

Next, select a cutout in the Task Pane. Click the arrows to view more shapes, if necessary.

Selecting one of the predefined shapes

After you select the shape, use the sizing handles to resize or move the shape so it fits over your images better. When the cutout is exactly the way you want it, click the [Done] button. You should also see the cutout added to the stack (in the top right of the screen).

The cutout added to the stack (in the top right of the screen)

You can also view the cutout by itself by removing the old picture from the stack. Select the old picture from the stack by moving the mouse pointer to it. Then click the right mouse button and select "Clear" in the pop-up menu. Don't worry, you're not deleting the file from your system. You're only removing the image from the stack to the right of the Picture Panel

The following are some more examples:

Adding text to your images

Adding text is usually always a simple task regardless of which image editor you're using. This is also certainly true in PictureIt!. However, you'll add text to your images a little differently in PictureIt!. Let's look at an example. We've loaded the following image using the "Get It" button:

You can add text to anything on which you're working. A block of text in PictureIt! is called a *text cutout*. PictureIt! can use any TrueType font that's installed on your PC, and also installs several unique fonts. Regardless of the font you use, you can change colors and assign different font styles to your text.

The first step in adding text to an image is to click the Prepare It! button. Next, select the "Make Cutout" and "Text Cutout" commands.

This opens the New Text Cutout pane. Type the text that you want to appear on the image. We're adding the text "An Afternoon Of Boating" to this image.

Notice the text appears on the image at almost the same time as you're typing in the box. Don't worry about its current location on the image. You can move the text cutout later.

The next step is to select a typeface. Since PictureIt! uses its own fonts and TrueType fonts, many of these may be unfamiliar. If so, scroll through the list until you see some that you like and test them. As you scroll through the fonts, notice that the text cutout changes as well. In other words, you'll see the font change right on the image.

Once you've selected a font, determine how you want to align it on the screen. You can have it left justified, right justified or centered, and bold, italicized or underlined (or all three if you want). Although there's no setting for the type size, you can stretch or rotate the text later. We've decided to use Felix Titling as the typeface. We're also using bold and left justified.

The next step is to select a color for the text. This is where you'll see PictureIt! do some neat magic. One problem with coloring text, even in professional editors, is using a color that complements the hues used in the image. However, all you have to do in PictureIt! is click on a color in the image which you want to use for the text. PictureIt! does the rest for you by applying that color to the text.

Click the big color circle in the "Change text color" area. This opens the Change Text Color pane. Simply move the cursor onto your image. Notice how it changes to an eyedropper. Move the eyedropper to the color on the image that you want to use for the text. Then click once on that color. Notice how the small balls move around the color circle to match the color. Also notice the color of the text on the image changes immediately.

Click the [Done] button when you're all set.

Now you can move the text to any location on the image. You can also stretch or rotate the text to a different size.

Now we have our final image:

Frame It!

After you've finished tweaking your images use the Frame It! task to place one of several frames around your image.

393

You can, of course, add a frame or border to an image that wasn't tweaked. Select from more than 50 cool edges or from 250 custom mats. The cool edges include brush strokes, a torn paper look, different phrases or frames. The mats include textures, holidays, real wood, stone or photographic frames.

Examples of Cool Edges

The following are examples of applying a few of the 50 cool edges to an image:

Examples of Mats

A mat in Picture It! is simply a border surrounding your projects. However, these are more than simple borders. Each mat is digital art and you can select from several textures and colors.

A mat can be used by itself or with a project. The following are examples of the possible mats you can apply to one of your images:

Examples of Frames

A frame, like a mat, is a border surrounding your projects. However, also like mats, a frame is more than simple borders. You can select from several textures and colors for your frame.

A frame can be used by itself or with a project. The following are examples of the possible frames you can apply to one of your images:

397

Share It!

Click the Share It! button when you're ready to do any of the following:

➤ Print pictures on your printer

➤ Send electronic files to your friends

➤ Order photographic prints

➤ Send your pictures electronically to Kodak for photo-quality prints

➤ Create electronic slide shows.

399

Choose Print at Kodak to send your PictureIt! files electronically to Kodak. When you do so, you will receive high-quality long-lasting prints and gift items.

Just Add It!

Click the Just Add It! button and select from over 100 exclusive Kodak Image Magic Custom Creations templates.

Kodak Image Magic Custom Creations templates are ready-to-use templates to which you can add your images. The following is an example of the over 100 that are available:

400

Winter Wonderland 5 x 7 collage

You can also download more Kodak templates online using the Download Creations command.

Besides using the templates from Kodak, you can create your own templates in PictureIt!. A template is basically a collage that you can use many times.

Although PictureIt! includes dozens of card, calendar and collage templates, you can also create your own. To make your own PictureIt! template you design a collage using some static elements-a background for example-and then add placeholders for art and text. Once your templates are set up, it's quick and easy to update them and share them with family and friends. Just drop in the new photos and text, and you're done.

Summary And Contacting Microsoft

We hope this chapter has given you at least a glimpse into using PictureIt!. Again, we could not explain all the features and power of this fine program. For more information on PictureIt!, contact Microsoft:

Microsoft Corporation
One Microsoft Way
Redmond, WA 98052-6399

(206) 635-7070

http:\\www.microsoft.com/pictureit/

Part 4

Appendices

Other Ways To Work With Digital Images

Appendix A

Other Ways To Work With Digital Images

So far we've talked a lot about using digital cameras and scanners. However, since scanners and digital cameras have only recently become more popular, most of us don't yet own one. If you don't have a scanner or digital camera, don't feel the digital world is passing by you. For example, you can continue to use your 35-mm camera to snap pictures as you always have. Then, if you're lucky, maybe you can borrow a scanner from a friend or you can hire someone to digitize your photos.

That's all well and fine if you own or can borrow a 35-mm camera. However, what if you need to digitize some photos but you don't own either a digital camera, scanner or a 35-mm camera? Again, don't panic—you're not out of luck. Remember, the Internet is always ready, every day, 24 hours a day. And even if you can't log onto the Internet, there's still no need to panic. In this chapter we'll talk about alternatives you have for working with digital images.

Seattle FilmWorks And Pictures On Disk

One option is for Seattle FilmWorks to scan your photos from your processed film. You'll not only receive the scanned images on a floppy disk, but you'll also have the photos and negatives.

The images on the floppy disk are called *Pictures On Disk*. You can then use one of the image editors we've talked about or use the images in countless other ways. You can even create your Personal Home Page on the Internet using Seattle FilmWorks's free FilmWorksNet.

Seattle FilmWorks also includes a free copy of PhotoWorks software with your first Pictures On Disk order. PhotoWorks is specially designed to let you get the most out of your Pictures On Disk images. We'll talk more about PhotoWorks later.

Use PhotoMail if you're impatient

If you're impatient, you can download your Pictures On Disk files over the Internet. Seattle FilmWorks uses a service called *PhotoMail*. This service will deliver your images to you within minutes after they are scanned. You'll receive an e-mail message telling you that your images are ready for downloading within seconds after Seattle FilmWorks has completed the scanning.

Only a few minutes are needed to download PhotoMail files. The time depends on your modem speed, file size and the quality of the connection between your computer and their server.

It's very unlikely anyone will get access to your pictures. You must provide a personal Seattle FilmWorks customer number and a password before a file can be downloaded, both of which are in the e-mail notice you receive. However, you can let someone else download your images if you want to share your pictures. Simply give them the customer number and roll number(s) of the roll(s) you wish to share. Seattle FilmWorks will keep your images on file for 14 days. The file is deleted three days after you have downloaded it. You must save the image file you download because you do not get a disk with PhotoMail.

Resolution and image formats

You're probably wondering whether the resolution is good if the images are stored on a floppy diskette. The resolution of Seattle FilmWorks images is 640 x 480 pixels. Seattle FilmWorks uses a format with a, not surprisingly, ".SFW" extension. It was developed to provide fast display time and the most efficient compression for storing images on a floppy disk. The PhotoWorks software lets you convert .SFW files to 50 other formats so they can be used with other applications, such as image editors, word processors and many others. You can also convert more familiar formats like .GIF and .BMP to the .SFW format using the PhotoWorks "Plus" software.

PhotoWorks software

PhotoWorks was specifically created for Pictures On Disk images. However, you can also use it with other image files. You can use PhotoWorks to:

➤ Tweak your images

➤ Make albums

➤ Export images to other programs

➤ Process your PhotoMail images downloaded from the Internet

➤ Upload your Personal Home Pages to the FilmWorksNet

Although PhotoWorks is a Windows 95 program, SFW also includes a program called *Win32S*. This special program, included with your PhotoWorks on floppy disks, allows Windows 3.1 to run 32-bit programs. It's installed automatically only if you have Windows 3.1.

PhotoWorks is not a power hungry program, although, as with most anything, the bigger the better. The system minimum is a 386 with 4 Meg of RAM; a minimum 486DX with 8 Meg of RAM is recommended.

PhotoWorks Plus is an enhanced utility program for Pictures On Disk. It can work with over 50 graphics file formats and includes features such as color correction, screen capture, a built-in screen saver, warp, emboss, blur, sharpen, and more. You can use effects one at a time or combine different effects. This upgrade costs $14.95 through SFW.

PhotoWorks's Albums

PhotoWorks gives you powerful album management tools for organizing photos on your PC. Each album is a collection of photos and other graphics files that you have selected. It's easy to create new albums and move photos between albums. You can change the sequence of images within an album, add and delete images and set slide-show viewing preferences.

PhotoWorks's Slide Show

The PhotoWorks Slide Show viewer uses albums that you've created to present a slide show of your images. You can sequence the photos however you choose, even add special effects and set the display time for each photo.

PhotoWorks's Photo Enhancer

The PhotoWorks Enhancer lets you tweak your photos. This includes rotating, resizing and cropping your photos. You can also use it to adjust the exposure, contrast and color balance. The PhotoWorks Enhancer lets you preview any tweaks before the changes are made.

PhotoWorks's Screen Saver

PhotoWorks Plus includes a Windows screen saver interface that lets you choose any PhotoWorks album as your Windows screen saver. The screen saver uses the Slide Show settings associated with the album to control the display time and transition effects.

For more information, visit Seattle FilmWorks's website at http://www.filmworks.com.

PhotoNet

Another way to view, store, share and tweak your photos on the Internet is through PhotoNet. All you need to do is take your film to your nearest PhotoNet retailer. Be sure to indicate on the envelope that you want digital copies made. You'll receive your photos and negatives back like normal. However, digital copies of your photos are also available on-line.

How it works

PhotoNet will send you an e-mail message when your order is ready. When you pick up your pictures and negatives, you'll be given the film ID. This ID number is what you'll use to access your photos on-line. You'll also be given the Online PhotoCenter home page address. You'll be prompted at the Online PhotoCenter for your name and access code. After these are verified, you'll have access to the on-line images for your roll of film.

A proof sheet soon appears that displays thumbnails of all the photos from that roll of film. If you want to see a full-size version of a photo, simply click on its corresponding thumbnail. Your photos remain on-line for 30 days. PhotoNet will notify you before this time expires. You can buy an optional time extension if you want the images to remain on-line longer.

You can share your photos with family and friends while the photos remain on-line. Simply send the film ID or e-mail the images to your family and friends for free.

Download all or any of the images to your PC. Then you can use your photos to create exciting web pages, print low-resolution photos or edit them with an image editor. Downloading images is free.

Also, while your images remain on-line, you can order reprints and enlargements of your photos. They can be mailed to you or to someone else.

All photos are stored in a high-quality JPEG format. The photos you see on the Internet use a lower resolution to facilitate faster download times. The high-resolution image is used to generate reprints and enlargements by your PhotoNet Dealer.

The quality of the prints you order on-line is comparable to the quality of standard reprints developed in the store. The high-resolution image captured by PhotoNet retailers ensures that you receive a photographic print with all the detail and color you're used to from standard processing.

For more information visit the PhotoNet website at www.photonet.com.

PhotoDisc Helps You Find The Right Photo On The Internet

Maybe you've had the horrifying experience of frantically finishing a project only to discover you're missing a picture. Another time you may need an animal photo to add a certain "feel" to your newsletter. Other times you may need photos of cities, airports or other places where you've never visited. Where can you look for such a photo?

In these cases you may want to try PhotoDisc, Inc. The best way to describe PhotoDisc is to say it's a stock photo agency on the Internet. It's arguably the best collection of Web-ready photos you can find. In other words, PhotoDisc lets you search for and download images from the Internet.

You should find the right one among the 50,000 available images. (This was the number as we went to press; PhotoDisc expects to have 100,000 images on-line by January, 1998.) These images are available in low, medium and high resolutions (complete with Photoshop clipping paths). Furthermore, they're available 24 hours a day, every day. The photos are sold royalty-free, so you pay only a one time charge, which depends on the image resolution and the purpose for which you'll be using the image. Prices for images range from $9.95 to $189.95.

In 1991, PhotoDisc became the first to offer a royalty-free CD-ROM with a selection of random photos for businesses to use. Then, in 1996, PhotoDisc became the first royalty-free dealer to take its product onto the Internet. Conventional stock photo agencies, on the other hand, mainly negotiate individual per-use license agreements with customers. The cost is based on how the customer uses the photo.

Simply look through the photo files and select the one(s) you want to buy. As we've said, the catalog has thousands of images available. Several types of images are available and are ready for you to download. Considering that you can select from over 50,000 photos, you're sure to find anything you need. Once you've selected the image(s), you do a little secure transaction and download the images. Then you can use them almost any way you want. In most cases, you pay only once and use them as often as you wish.

Purchasing and downloading images

The Photodisc website includes step-by-step directions on buying PhotoDisc images. About 15 to 20 minutes are required for a typical single image search and purchase cycle.

The steps mainly involve entering search criteria according to keywords. Then you review the images matching your search criteria. Select a license and resolution. Continue until you've selected all the images you want and click the $$$$ PURCHASE button. Then click on "Download Image." When you see "Document Done" in the bottom left hand corner of the screen in Netscape, select the **File/Save As...** command. Then point to where you want the image saved.

Return to the Download page to retrieve other images you have bought for downloading.

The Photodisc Series

Photodisc has their images in categories called *Series*. Each Series includes hundreds of high-resolution 24-bit images for less than the cost of a single traditional stock photograph. The following are some examples:

PhotoDisc's Signature Series

This series features portfolios of several world renowned stock and commercial photographers. Categories include "Wild West," "Action Sports," "Details of Nature," "Panoramic Landscapes," "Everyday People" and more. Each disc includes at least 100 high-end images in three file sizes with embedded clipping paths for easy outlining.

Fine Arts

This series includes photos ranging from complete paintings, architectural elements, wallpaper and antique maps. Examples of categories in this series include "European Paintings," "Antique Maps and Heraldic Images," "American Fine Art and Illustration" and "Religious Illustrations."

ClipPix'

The award-winning photos in ClipPix are optimized for on-screen use and desktop printing. They give you a powerful edge for business communications, such as training presentations, financial reports, customer presentations and more.

Background series

PhotoDisc's new images in the Background Series represent different images from metal sculptures to hand paintings. They range from quirky to sophisticated. These are available individually on the Web or in eight thematic collections of 100 on CD-ROM.

Animation Series

The PhotoDisc Disc Animation Series is a collection of royalty-free animated GIFs and Shockwave files. The premiere title in the series is Metamoraphically Speaking. It features objects like traffic, a squawking goose laying an egg and a construction sign with a blinking light.

The Animation Series includes 8 CD-ROM titles with 120 photos in each title. Pricing starts at $149, with individual animations priced between $29.95 and $49.95.

For more information, visit the PhotoDisk website (www.photodisc.com).

Digitizing Services

Many print shops, photo shops, on-line services and some software manufacturers can digitize your photos. Kinko's, for example, will scan a 4 x 6 inch photo and even do basic editing for about $10 or $1 per minute. You'll get the scanned image back on a diskette or on a removable storage device. (See their website for more details: http://www.kinkos.com/products/listing/.)

America Online can digitize prints, slides and negatives for 99 cents each. The prints are then downloaded to you. You can also have AOL create an on-line photo album for only $24.95 per year. You can then store up to 100 images in this album. An option with the album is to create a Picture Circle. This will let your friends and family view the album on-line. This will cost 9.95 additional per year. The AOL keyword for this service is "pictureplace."

Photo shops will digitize photos and put them onto a Kodak Photo CD (see below). Check with the photo shops. You may save money by using prints from recently developed negatives instead of the printed images ("positives"). You'll probably be charged per image placed on the CD-ROM (and probably for the CD-ROM itself). Typical prices are about $10 for the CD-ROM and from about 99 cents to more than $2 per image. As you can see, prices vary widely, so we recommend comparing prices at as many photo shops as you can.

Keep in mind the prices we mention here may have changed since we went to press.

Service bureaus

Another method, if time is not a critical factor, is to hire a photolab to place the images onto a Kodak Photo CD. You'll usually get very acceptable quality images by taking your photos from a normal 35-mm film camera and hiring a service bureau to put them onto a PhotoCD. An average cost is about three dollars per image. Then use your PC, CD-ROM drive and image editor to view and tweak the final images.

One note about using service bureaus. Most will save your images as TIF files and on a special removable storage device called a Syquest drive or optical disk. However, some service bureaus are now working with compressed JPEG images that can be saved on a floppy diskette.

Service bureaus use a drum scanner to produce very high-quality, hi-res scans of prints, slides or negatives. We recommend using service bureaus if you need professional-quality scans. An 8x10 scan typically costs about $10 to $30.

Kodak PhotoCD

Arguably the most popular film-scanning service is Kodak's Photo CD. Along with its wide popularity and continued growing acceptance among computer manufacturers as a standard, the commercial Photo CD scan is often the least expensive (as low as $1.00 per image) and most rapid (it takes about three seconds per 35-mm frame).

To fully describe Photo CD and its technology would require a book (in fact, many are available). Therefore, we won't talk about Photo CDs in detail but instead will mention its main features and how to get started. PhotoCD isn't a scanner but it is, nevertheless, a good method of digitizing your images. You do, however, need a CD-ROM drive in your PC system.

Simply send the roll of film out to an authorized Kodak PhotoCD developer. (Contact Kodak for a list of authorized Kodak PhotoCD developers in your area.). Then for as low as $.80 per image, not only is your film developed, but you also get a CD-ROM containing your digitized images.

You'll find also that CD-ROMs are a great way to organize and store your image files. The quality of these scans is very acceptable. Although the images on Photo CDs can't be modified yet, you can copy the images to your hard drive where you can work on the file as needed.

A special note concerning CD-ROM drives: If you're planning on working with Photo CDs, make certain your CD-ROM drive is a multisession-compatible drive. Although most current CD-ROM drives are Photo CD compatible, some of the earliest CD drives could not read the Kodak format.

The speed of a CD-ROM drive is also important. By the time you read this, 10x and even 12x CD drives will be standard equipment in some PCs. Don't consider using anything less than a 4x CD-ROM drive.

Other Photo Services

Dale Laboratories

See your pictures on your PC by using any 35-mm camera. You'll receive beautiful prints, plus a floppy disk that fits in your computers 3.5" drive. An easy-to-use program is included on the disk with your pictures. The low cost of $5/24 or $7/36 is standard with any processing order.

Free demo: www.dalelbs.com

Dale Laboratories
2960 Simms Street
Hollywood, FL 33020-1579
800-327-1776
dalelbs@aol.com

Video Capture Devices

Do you have a lot of video tapes of home movies, reunions, vacations, etc., that may have some images you would like see on your PC? Several products are available that let you capture one still-frame of video from your VCR, camcorder, television and more. These devices, called *video capture devices* or *frame grabbers*, capture (or "grab") one frame of video. You can then transfer that frame to your PC. So now you can capture one or several frames in your favorite video tapes and convert them to a digitized photograph.

We'll talk about one device in particular and mention a few others as well.

Snappy

One of the most popular video capture devices is the Snappy Video Snapshot from Play, Inc. Snappy, as it's called, can capture a still image from the following video sources:

➤ TV

➤ Video camera

➤ VCR

➤ Camcorders

➤ Laserdisc players

➤ Video games

➤ Still-video cameras

Simply plug Snappy into your PC's parallel port and connect the cable to the video source. Then load the software that's included with Snappy. To capture an image, click the large blue [Snappy] button. Snappy captures images at resolutions up to 1500 x 1125 pixels and as many as 16.8 million colors.

421

Once you've captured the image, use the Snappy software to tweak or morph images. Then you can insert the images into any document that can handle graphics. You can also use one of the image editors we talk about in Chapters 10-14 for more extensive editing work.

Installing Snappy

One of the reasons this device may be called *Snappy* is because installation is, well, a snap. Simply connect the Snappy hardware module to the parallel port of your PC. Snappy includes a video cable for the connection to your video source. Then install the software. Your digital image capture system is now ready.

What exactly can Snappy capture

Snappy captures a single super high-quality still image from your video source. If you have access to the Internet, visit Play's website for examples of Snappy's captures (www.play.com). Their website includes several real and unretouched Snappy captured images.

Capturing images

Snappy's software has a black-and-white preview window that displays two video frames per second. When the image appears that you want to capture, click the (Snappy) button. In a way, it's like using a point-and-shoot camera. You can also watch your video directly on the TV or video camera, although it's usually better to follow the video in the Snappy preview window.

The following is an example that we've snapped:

Bundled software

Snappy is bundled with Fauve Matisse and Gryphon Morph (combined value of over $300.00). They're two of the most powerful graphic tools ever developed for the PC. This image editing combination is good for both serious work and fun. Fauve Matisse SE is a paint, compositing and retouching program developed specifically for Snappy. Gryphon Morph 2.5 lets you "morph" your images to create special effects by blending two images.

Examples of the Gryphon Morph 2.5
program included with Snappy

Snappy's file sizes and system requirements

You've read a lot about file sizes in this book and we need to talk about it here, too. The size of the files that Snappy saves depends on two factors:

1. The resolution at which you set Snappy

2. Whether you use JPEG compression when saving.

➤ A 1500 x 1125 file requires 5 Meg of hard drive space. However, that compresses down to less than 500K even with JPEG's highest quality setting.

➤ If your system is capable of running Windows, you can probably run Snappy. It requires a 486 or faster processor, 4 Meg of RAM and 8 Meg of available hard drive space. Also a VGA card (640 x 480/16 color) is recommended as a minimum video card.

Snappy is also TWAIN compliant, so you can send your video captures directly to an image editor.

VideoShot

A product similar to Snappy is called VideoShot (from VideoLabs). It lets you "grab" an image from any video source into your PC. Like Snappy, the VideoShot is connected to the parallel port of your PC so you won't need to install extra cards or open your PC. It captures real-time images in high

quality resolutions of 640 x 480 in true color (16.7 million colors). VideoShot is TWAIN compatible so you can send images directly to your favorite image editor (see Chapters 10-14). It also features NTSC/PAL dual system compatibility. An image editor is bundled with the complete package.

For more information, check out the VideoShot website at http://www.flexcam.com/html/prducts/vidshot.html.

GrabIT

Another example of a video capture device is GrabIT, from AIMS. It also connects to the parallel port of your PC. It accepts both video composite video or S-VHS inputs.

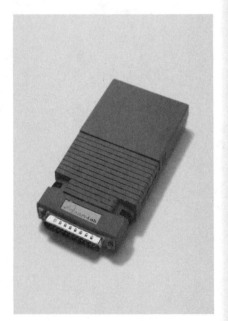

Use GrabIT to capture images in 24-bit color and save them in TIFF, BMP, Targa, JPEG or PCX format. One difference between GrabIT and the other video capture devices we talk about is its video preview. You can view the video in full color and adjust color at the same time, before capturing the images. It also has a video output that you can connect to a TV for full motion video previewing. Another advantage to GrabIT is that it doesn't require batteries or a power supply to work. Simply connect it to your PC's keyboard port so it can be powered by the PC or notebook.

GrabIT is bundled with award winning PhotoMorph II software. It's a powerful software tool that creates, manipulates and enhances digital video.

For more information, check out the VideoShot website at http://www.aimslab.com.

Is FlashPix The New Imaging Standard?

Appendix B

Is FlashPix The New Imaging Standard?

Reading through this book, you've probably noticed that we've mentioned FlashPix in several chapters. You may be wondering why all the excitement about a new image file format. After all, what's wrong with all the current file formats? Besides, if you consider all the formats available now (TIFF, BMP, GIF, JPEG, PCX, Photo CD, SCT, RAS, TGA, DIB etc.), you'll probably think there are too many already.

Each of these formats has, or at least had, an advantage over the others. For example, GIF, JPEG and PCX have built-in compression methods. TIFF features intelligent color-matching support. However, they all share a common weakness. Each format must be accessed and processed as a whole. This makes them fundamentally "dumb" and cumbersome with which to work.

The reason for the excitement over FlashPix is that it may become the standard for digital cameras, the Internet and even high-resolution printing. Some people even regard FlashPix as the logical successor to Photo CD. In this chapter we'll take a look at this new format and explain what it can do for your images.

What is FlashPix

Before we talk more about why FlashPix is creating such excitement, we should talk about what FlashPix is. Co-developed by Kodak, Hewlett-Packard, Live Picture and Microsoft, FlashPix is designed to ease the switch to digital photography without the loss of image quality. It will also make transferring digital images over the Internet and other networks easier and faster.

What makes FlashPix so "smart" when other formats are so "dumb" is it can randomly access individual sections or resolutions of an image. It also combines the best features of existing bitmap file formats. These features include rough resolution independence, optional compression (either lossy or lossless) and color matching provisions. This architecture maintains a transformation stack throughout the life of the image and stores an extensive inventory of information about the original image.

Advantages of FlashPix

The advantage for you is that FlashPix will make it easier to work with large photograph-quality images. You won't need the fastest computer or expensive image editors to use these images on your PC. You can see this in programs like PictureIt! (in Chapter 14) and LivePix (in Chapter 13).

The following lists some of many advantages predicted for the FlashPix format:

> ➤ Faster performance when editing and downloading images

> ➤ Tweaks and other changes are applied so that image degradation is minimized.

> ➤ The ability to immediately optimize output resolution

430

➤ FlashPix format was designed with the Internet in mind. You've probably waited a long time (perhaps too long of a time) for a graphic to appear on a Web site. However, by using FlashPix, high-resolution images can be displayed much faster on the Internet.

➤ You won't need a "monster" PC to manipulate high resolution images.

➤ You can work with several images on screen without clogging your CPU's workload.

➤ FlashPix files will serve as a universal link between software applications, on-line services and peripherals.

How FlashPix works

We can't go into the full details of how FlashPix works (and there's certainly more to it than we can talk about here). However, the basic idea behind FlashPix is that you usually won't need to work on the entire image at one time. So, images are stored in a rectangular region of continuous pixels called a *tile*. Each tile consists of equal-size rectangles measuring 64 x 64 pixels. This is probably similar to the square ceramic wall tiles you may have in your house. In this way you can save images of any size. Then as a program optimized for a FlashPix requests data, only the specific tile(s) required is loaded into memory.

This helps make the FlashPix format more efficient. You can open and edit images quickly and easily, regardless of the original file size. Dependable color results are always predictable because of the color management built into the FlashPix format.

Any changes made to a FlashPix image can be confined to one or more of the individual tiles. So if you need to tweak only part of the image, you won't need to load the entire image into RAM and use unnecessary CPU power. FlashPix applications will have direct access to any portion of the image quickly and conveniently.

431

Back in the "olden days" digital imaging was limited mostly to graphics professionals and computer "power users." Then, as now, working with high-quality images required large digital files to remain in active memory. This made imaging a slow and awkward process on most computers. Today, new users are faced with a confusing array of resolution and formatting decisions. The results are too often unpredictable and disappointing.

Products that use FlashPix will make digital imaging a faster and easier experience. Pictures can burst on-screen, change quickly when tweaked, move quickly through on-line services and look impressive when printed. The FlashPix architecture enables the use of high-quality images that people can manipulate like they manage the low-resolution image files typical on the World Wide Web today.

Development plans and summary

Most experts agree that FlashPix has excellent potential. It now has major support from some big companies. For example, plans are underway to build FlashPix into Netscape Navigator and Microsoft's Internet Explorer. Other companies expressing an interest in FlashPix include AccuSoft, Apple, Broderbund Software, Canon, Corel, Fuji Photo Film Co. Ltd., (one of Kodak's key competitors in the conventional film market), IBM, Intel, Macromedia, MetaTools, Object Design, PictureWorks and Storm Primax. These companies are expected to develop FlashPix-based digital cameras, scanners, software and printers throughout 1997.

Notably missing from this list (at least currently) is Adobe Systems, makers of Photoshop. It's interesting that they're missing, because Adobe is one company with the power to promote mainstream acceptance. They may, however, use a plug-in to take advantage of FlashPix in future projects.

Kodak

Kodak is developing products that capture and save FlashPix images and services that take advantage of the new format. The company said it will build FlashPix format support into its digital imaging products over time. This includes products that will take advantage of the new Advanced Photo System photographic format announced in 1996.

Hewlett-Packard (HP)

Hewlett-Packard (HP) announced in October 1996 that it was adding FlashPix to several new products. These include new Internet server software called *Imaging for the Internet*, a digital camera and a photo-quality printer. Imaging for the Internet will include a server module, a Navigator plug-in and Internet ActiveX controls. By combining these products you'll have a complete imaging solution for home or office.

HP believes their color inkjet printers will be an integral part of the FlashPix technology. This new printer will print high-quality hard copies of images for the same price as developing a photo. According to HP, the printouts should be indistinguishable from photographs. All three products are scheduled to ship in late '97.

Live Picture, Inc.

FlashPix also uses Live Picture's IVUE technology, which stores edits to an image separately from the basic data, greatly reducing storage and processing requirements. You can save edits independently of the original image file and link them to it, allowing on-line remote editing and multiple uses of the same data.

Live Picture, Inc., plans to integrate FlashPix technology into their full line of professional imaging products. This includes LivePix that we talk about in Chapter 11.

Microsoft Corp.

Microsoft released Picture It! as the first commercially available application to use the FlashPix format. See Chapter 14 for a complete description of PictureIt!.

Summary

Overall the FlashPix format will have a major impact on every application that does or can use digital images; and it will be as revolutionary for images as word processing was for text.

Appendix C

Glossary

Appendix C

Glossary

24-bit color

24-bit color images (also called true color and photo realistic color) are composed of three 8-bit color channels. Each color channel, similar to an 8-bit grayscale image, contains up to 256 colors. The red, green and blue channels provide up to 16.7 million colors w hen combined.

8-bit image

A digital image that can include as many as 256 possible colors. In this kind of image, 8 bits are allocated for the storage of each pixel, allowing 2 to the power of 8 (or 256) colors to be represented.

A/D converter

Acronym for Analog to digital converter. An electronic device that converts an analog signal, such as that generated by a CCD, into digital data that your PC can understand.

Additive primaries

Another name for Red, Green, and Blue. Called additive because when all three are combined they create pure white.

Aliasing

See Jaggies.

Aperature

The aperature of the camera controls how much light is passed on to the film or digital array while the shutter is open. The less the number, the more light. The aperature also controls other optical factors, such as depth of field and sharpness. All these cameras have preprogrammed exposure modes, so direct control of aperature isn't possible.

Bitmap image

An image with 1 bit of color information per pixel. The only colors displayed in a bitmapped image are black and white.

Bit depth

The amount of information that each pixel (or dot) carries with it. Only one bit is available for black and white. There are 8 bits of data stored on each pixel for 256 colors/grays. Raising the bit depth also increases the file size. It does, however, provide more colors and better color gradations. Typical bit depths are 1 (for line art), 8 (for grayscale) and 24 (for color images).

Brightness

One of three dimensions of color (others are hue and saturation). The intensity of light reflected from a print, transmitted by a transparency or emitted by a pixel independent of its hue and saturation.

CCD

Acronym for Charge-Coupled Device. A light sensitive electronic device that emits an electrical signal proportional to the amount of light striking it. Used in scanners and digital cameras.

Color depth

Refers to the amount of memory (and therefore number of simultaneously displayable colors) available to store color information for each pixel.

Channel

Analogous to a plate in the printing process, a channel is the foundation of a computer image. Some image types have only one channel, while others have several, with up to 16 channels.

CMS

Color Management System. A comprehensive hardware/software solution of maintaining color fidelity of an image from scanner to monitor to printer.

CMYK

Cyan, Magenta, Yellow, Black. The subtractive primary colors, also known as process colors, used in color printing. See subtractive primaries

Color cast

The effect of one color dominating the overall look of an image. Often caused by improper exposure, wrong film type, or unusual lighting conditions when shooting the original image. Also caused, when scanning, by the sometimes unpredictable interaction between an image and a scanner.

Color correction

The changing of the colors of pixels in an image, including adjusting brightness, contrast, mid-level grays, hue, and saturation to make certain they accurately represent the work shown.

Color separation

An image that has been converted or "separated" from RGB into the four process colors. See CMYK.

Compression

Algorithms used to create smaller file sizes of stored images. There are two kinds of compression: Lossless and Lossy.

Continuous-tone image

An image containing gradient tones from black to white.

Contrast

The difference in brightness between the lightest and darkest tones in an image. Also, a steep region in a tone curve.

Crop

To permanently discard unwanted information in the perimeter area of an image.

Degauss

Magnetic interference caused by a change in the position of a monitor in relation to the earth's magnetic field or the presence of an artificial magnetic field can cause discoloration. To correct this, all color monitors automatically degauss at power-on and some also have a manual degaussing button. This allows the monitor to compensate for the change in the magnetic field by realigning the electron guns. In some low cost monitors without degauss buttons it is necessary to leave the power turned off for at least 20 minutes in order to get maximum degaussing.

Dot pitch

The distance between a phosphor dot of one phosphor triad to its closest diagonal neighbor of the same color on a monitor. Expressed in mm - i.e. .28 dot pitch means .28 mm between triads. A smaller value indicates that the phosphor dots are more closely spaced, and that the resulting image displayed will be crisper.

Density

The measure of light blocking (in the case of transparencies) or absorption (in the case of prints), expressed logarithmically. Typical slides have a density of 3.0 while typical prints have a density of 2.0.

Descreening

The technique of eliminating Moiré patterns when scanning.

Dithering

A technique of using patterns of dots or pixels to create the effect of an intermediate tonal value.

Dot gain

The effect of ink spread and absorption into paper during printing resulting in darker tones, especially midtones

439

DPI (Dots Per Inch)

Refers to the number of physical dots associated with a file. A measure of the output resolution produced by laser printers or imagesetters. Generally, the higher the DPI, the better the resolution. Higher DPI also increases file size. As a general rule, the DPI should be about twice the size of the LPI of the printer. Many printers output at 300 DPI and the line screen default is 60. So, don't scan your image higher than 150 DPI. Too many extra dots will cause your image to become muddy. See also LPI.

Driver

A small software module that contains specific information needed by an application to control or "drive" a peripheral such as a monitor, scanner, or printer.

Digital camera

A camera that directly captures a digital image without the use of film.

Drum scanner

A high-quality image-capture device. The image to be captured is wrapped around a drum that spins very fast while a light source scans across it to capture a digital version of the image.

Dynamic range

The color depth (or possible pixel values) for a digital image. The number of possible colors or shades of gray that can be included in a particular image. 8-bit images can represent as many as 256 colors; 24-bit images can represent approximately 16 million colors.

EPS

Encapsulated PostScript. An image-storage format that extends the PostScript page-description language to include images.

Film speed

The higher the ISO number the faster the film. The faster the film the quicker it can record the image, which means larger depth of field or being able to freeze movement. ISO 80 is 1/3rd stop slower than ISO 100, so with these digital cameras, the speed difference isn't radical.

Focal Length

Simply put, the focal length of a lens allows you to classify it as a wide angle, normal, or telephoto lens. The normal size for a 35-mm camera is 42-mm, this is the size of the negative from corner. Lenses longer than this are telephotos, lenses shorter are wide angles. The standard normal lens for a 35-mm camera is 50mm. The digital cameras here all have approximately normal to slightly telephoto lenses. For comparison, the focal length of a Kodak Disposable

camera is 35-mm, or about where true wide angle lenses start. Panoramic 35-mm cameras producing those 3 1/2 x 10" prints have a 28mm lens (and are made by cropping out the middle of the negative) Many popular point and shoot cameras have 35-mm lenses.

Frame grabber

A device that captures and digitizes a single frame of a video sequence. Typical resolution is 640 x 480 samples.

Full-screen image

A digital image that covers the entire screen of a workstation.

Flatbed scanner

A popular type of desktop scanner so called because of its glass platen, or "bed", upon which originals are placed to be scanned. A flatbed scanner resembles a photocopier in both appearance and operation

Grayscale image

A continuous tone image of up to 256 levels or gray, with 8 bits of color data per pixel.

Gamma correction

The measure of contrast that results in lightening or darkening the midtone regions of an image. Also, the amount midtones need to be adjusted on a monitor.

GIF

Graphic Image File format. A widely supported image-storage format promoted by CompuServe that gained early widespread use on on-line services and the Internet.

Gray scale

The range of shades of gray in an image. The gray scales of scanners and terminals are determined by the number of grays, or steps between black and white, that they can recognize and reproduce. See also Dynamic Range

Halftone

A technique of converting a continuous-tone (grayscale) image into variable sized spots representing the individual tones of the image.

In older newsprint you could see small dots of varying sizes creating the illusion of gray scale. Comic books use larger screen dots. You can select different screen sizes and shapes (even lines) for various effects on your image.

Photo or Gray Scale or Continuous Tone all have similar meanings. This type of scan can (if selected) create the highest number of colors (16 million) or grays (256). Select this option when scanning color (& b/w) photos, watercolor and color illustrations. This format also generates the largest file sizes.

441

Highlight

The lightest part of an image. The tonal value in an image above which all tones are rendered pure white.

Histogram

A graphic representation of the number of samples corresponding to each tone in an image. See tone curve

Hue

The main differentiating attribute of a color. The wavelength of light which represents a color.

Image capture

Employing a device (such as a scanner) to create a digital representation of an image. This digital representation can then be stored and manipulated on a computer.

Image Manipulation

Making digital changes to an image using image processing.

Interpolation

The technique of estimating the tonal value that lies between two known tone samples. Used for enlarging an existing image. Also used when capturing an image during the scanning process to achieve higher than optical resolution.

Image resolution

The amount of data stored in an image file, measured in pixels per inch (ppi).

Inverting

Creating a negative of an image.

Image processing

The alteration or manipulation of images that have been scanned or captured by a digital recording device. Can be used to modify or improve the image by changing its size, color, contrast, and brightness, or to compare and analyze images for characteristics that the human eye could not perceive unaided. This ability to perceive minute variations in color, shape, and relationship has opened up many applications for image processing.

Inverting

Creating a negative of an image.

Lossless compression

Process that reduces the storage space needed for an image file without loss of data. If a digital image that has undergone lossless compression is decompressed, it will be identical to the digital image before it was compressed. Document images (i.e., in black and white, with a great deal of white space) undergoing lossless compression can often be reduced to one-

tenth their original size; continuous-tone images under lossless compression can seldom be reduced to one-half or one-third their original size.

Lossy compression

A process that reduces the storage space needed for an image file. If a digital image that has undergone lossy compression is decompressed, it will differ from the image before it was compressed (though this difference may be difficult for the human eye to detect). The most effective lossy-compression algorithms work by discarding information that is not easily perceptible to the human eye.

Jaggies

The pixelated or stairstepped appearance of low-resolution computer-generated images.

LPI (Lines Per Inch)

This is similar to dpi but used in printer specifications. The LPI is how close lines are place on paper during printing. This is important when considering the output of your file. To many lines per dot will give a solorized effect when printing a gray scale image to the b/w printers.

Line art

Also called "1-bit" or "monochrome," Images comprised of only pure black and white data. Also a mode of capturing such images. If scanning Gray Scale or Halftone images this converts the entire image to black or white. Any level of gray will be converted to black or white. This is the choice you would select if you were scanning hand drawn b/w illustrations, fonts, and old wood cut type Illustration from archival sources.

Virtually all scanners can capture images in this mode. Some 1-bit scanners fake grayscales by "dithering" shaded images. Dithered images do not scale well.

Lossy

A technique of compressing an image by eliminating redundant or not necessary information

Luminance

Lightness. The highest of the individual RGB values plus the lowest of the individual RGB values, divided by two; a component of a Hue-Saturation-Lightness image.

LZW

Lempel-Ziv-Welch. A popular, lossless image compression algorithm.

443

Midtone

Tonal value of dot, located approximately halfway between the highlight value and the shadow value.

Moiré pattern

An undesirable pattern in color printing, resulting from incorrect screen angles of overprinting halftones. Moiré patterns can be minimized with the use of proper screen angles. Also created when previously halftoned images are scanned.

Noise

Extraneous or random marks picked up when scanning that do not correspond to the original. Noise usually comes from the electronic components of a scanner.

OCR

Optical Character Recognition. Software that uses pattern recognition to distinguish character shapes in a bitmapped image. Typically used with scanners.

Optical resolution

The true number of discrete samples per inch that a scanner can distinguish in an image.

PhotoCD

A popular storage method for digital images. In the basic Kodak PhotoCD configuration, five different levels of image quality are stored for each image in an Imagepac.

Platen

The glass scanning region on a flatbed scanner.

Prescan

A quick, low resolution preview scan of an image to be scanned.

Primary color

A base color used to create other colors. Examples are Red, Magenta, Green, Yellow, Blue, and Cyan. Also loosely used to describe any highly saturated color.

Process color

The CMY primary colors (plus black) used in printing to produce the widest spectrum of printable colors. See also color separation.

Resample

To change the resolution of an image. Resampling down discards pixel information in an image; resampling up adds pixel information through interpolation.

Resolution

The number of pixels per inch in an image, or the number of dots per inch used by an output device.

RGB

Red Green Blue. An additive system for representing the color spectrum using combinations of red, green, and blue. Used in video display devices.

Screen frequency

The density of dots on the halftone screen, commonly measured in lines per inch (lpi). Also known an screen ruling.

Scanner

A device for capturing a digital image.

Slide scanner

A scanner with a slot to insert 35-mm slides; usually capable of scanning only 35-mm transparent material.

Saturation

The amount of gray in a color. More gray in a color means lower saturation; less gray in a color means higher saturation.

Shadow

The darkest part of an image, represented in a halftone by the largest dots.

Shadow point

The samples in an image that will print the darkest tone possible of the intended output device. Tonal values below this will print pure black.

Sharpening

A technique of accentuating the contrast between all areas of tonal difference within an image.

Shutter Speed

The shutter speed controls how long the film or digital sensor is exposed to the light. The faster it is, the less susceptible the camera is to subject or camera movement (causing blur)

Single pass scanner

Red, green and blue image data is acquired in a single pass of the scanning head. Not necessarily better, but generally faster than 3-pass scanning.

Subtractive primaries

Another term for Cyan, Magenta, and Yellow. Called subtractive because when all three are combined they absorb all light (theoretically) and create black. See CMYK.

Three pass

Image data is acquired in three separate passes of the scanning head. Each pass uses a different-color lamp or filter to acquire red, green and blue portions of the image.

445

Threshold

The tonal value ‹ used when scanning line art or converting grayscale images to bitmapped ‹ above which is rendered white and below which is rendered black. Typically expressed in percentage of gray.

TIFF

Acronym for Tag Image File Format. A popular file format used for storing images. TIFF formats support a wide range of color models and bit depths and is considered an industry standard.

TWAIN

Unofficially "Technology Without An Interesting Name" — really! A "mostly" PC standard software interface enabling compatibility between scanning software and scanning hardware.

Any scanner that comes with a TWAIN driver can be used with all software that supports TWAIN (all leading PC programs now support this scanner-driver standard).

Tone curves

A linear graphic representation of the mapping of input tones to output tones. See histogram

Thumbnail

A small image (usually derived from a larger one). Browse images (often called "thumbnails") permit a user to view a dozen or more images on a single screen.

True-color Image

Generally refers to 24-bit (or better) images.

Unsharp masking

Also known as USM. A technique of accentuating the contrast at border areas of significant tonal difference within an image. With proper controls, USM will only sharpen areas of important detail. See sharpening

Zooming

Enlarging a portion of an image in order to see it more clearly or make it easier to alter. Opposite of zoom-out, which is useful for viewing the entire image when the full image is larger than the display space.

Appendix

D

The
Companion
CD-ROM

Appendix D

The Companion CD-ROM

The companion CD-ROM to *Easy Digital Photography* contains several programs for image enhancing, editing, cataloging and much more. These include 30-day 'trialware', software demonstrations and a variety of the best graphic shareware products in the industry. Many of this programs featured on the CD-ROM are fully functioning *shareware evaluation versions* of the best programs available today. Shareware benefits both the user and the author. By avoiding distribution, packaging, and advertising costs, prices of shareware remains low. Keep in mind, however, that shareware programs are copyrighted programs. Therefore, the authors ask for payment if you use their program(s). To ensure that the program authors continue writing programs and offering them as shareware, we urge you to support the shareware concept by registering the programs that you plan to use permanently.

Using The Companion CD-ROM

You must load the MENU.EXE program located in the root directory before you can use the companion CD-ROM. When the program is loaded, you will have various buttons to select your utilities. Insert the CD-ROM into your CD-ROM drive. We're assuming that the letter assigned to your CD-ROM drive is "D:". If this is not the case, simply substitute your CD-ROM drive letter instead of "D:"

Loading the MENU in Windows 3.x

Select the **File/Run...** command in the Windows Program Manager. This opens the Run dialog box. Type the following in the "Command Line:":

```
d:\menu.exe
```

and press (Enter).

The Run dialog box should now appear. Then press the (Enter) key or click the (OK) button. The main MENU program will start. This MENU program is used to install or test various shareware utilities.

Loading the MENU in Windows 95

Select the Start menu and then the **Run...** command. This opens the Run dialog box. Then type the following in the Run dialog box:

```
d:\menu.exe
```

and press (Enter).

The Run dialog box should appear. Then press the (Enter) key or click the (OK) button. The main MENU program will start. This MENU program is used to install or test various shareware utilities.

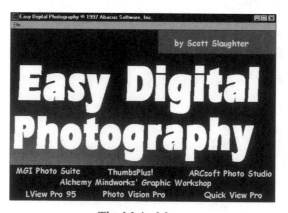

The Main Menu

450

Installing Adobe's Acrobat Reader

Adobe's Acrobat Reader is a utility allowing you to view PDF files. We have included the Abacus Catalog (CATALOG.PDF) on the companion CD-ROM. If you already have Acrobat Reader, skip the next steps. Follow these steps to install Acrobat Reader on your hard drive (requires approximately 2 Meg on space on your hard drive). Insert the CD-ROM in your drive and load Windows. Select the **File/Run...** command from the Windows Program Manager. Then type D:\ACROREAD.EXE and press the *e* key.

Simply follow the instructions and prompts which appear on your screen. Double click the Acrobat Reader icon to load it. After Acrobat Reader is loaded, select the **File/Open...** command and select CATALOG.PDF to view the latest catalog directly on your PC screen.

Programs Featured On The Companion CD-ROM

MGI's demonstration

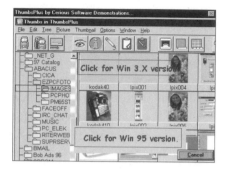

Thumbs+Plus!

Photo Studio

Graphic Workshop

Lview 95

Courtesy Inso Corp.

Photo Vision Pro

A Note About Shareware Software

Many of the programs included on the CD-ROM are fully functioning "shareware evaluation versions" of the best programs available today. Because shareware is copyrighted, the authors ask for payment if you use their program(s). You may try out the program for a limited time (typically 10 to 30

days) and then decide whether you want to keep it. If you continue to use it, you're requested to send the author a nominal fee. Shareware benefits both the user and the author as it allows prices to remain low by avoiding distribution, packaging, and advertising costs. The shareware concept allows small software companies and program authors to introduce the application programs they have developed to a wider audience. The programs can be freely distributed and tested for a specific time period before you have to register them. Registration involves paying registration fees, which make you a licensed user of the program. Check the documentation or the program itself for the amount of registration fee and the address where you send the registration form.

One final note: You'll find program instructions and notes on registration for the shareware programs in special text files located in the program directory of each program. Theseprograms are usually called READ.ME, README.TXTor README.DOC. As a rule, the TXT, WRI or DOC extensions are used for text files, which you can view and print with Windows 95 editors.

Index

456

459

Z

PC catalog

Order Toll Free 1-800-451-4319
Books and Software

**Includes CD-ROM
with Sample Programs**

Abacus

It's A Snap!

#1 BEST SELLER

MGI PhotoSuite is the easiest way to edit, capture, catalog and transform your photos!

Photo Lens Kit including fog, smoked glass, glamour, sepia, moonlight, tan & more!

You can choose from over 30 special effects

Add your own word balloons

Create your own flyers, posters and ads

Create photo sports cards

New simple interface

New easy-to-use activity guide

U.S. RETAIL WINDOWS MARKET UNIT SHARE

MGI Software
Adobe PhotoShop
Corel PhotoPaint 5&6
Micrografx Picture Publisher
U-Lead Photo Impact
Fractal Design Painter
Adobe Photo Deluxe

Source: PC Data Retail Report, Jan - June, 1996

MGI PhotoSuite™ is America's favorite PC photo software

Create your own photo greeting cards

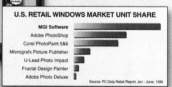

You can create magazine covers & calendars

Create winning business presentations

Kodak
DIGITAL PROCESSING

Get your Photos on a KODAK™ Picture Disk, FREE!

When you purchase MGI PhotoSuite, you receive a special offer from Kodak Digital Processing for a free transfer of your photos to disk.†

ONLY $49.95

Visit us on the World Wide Web at www.mgisoft.com

mgi® PhotoSuite™

Purchase any Casio Digital Camera and receive a FREE fanny pack!

Send UPC code from box and original sales receipt to:

Casio
Attn: Marketing Services
570 Mount Pleasant Ave.
Dover, NJ. 07801 (201) 361-5400

Please send my free pack to:

Name_____

Address_____

City_____ State_____

Zip Code_____

Offer expires December 31, 1997

Visit our Web Site at www.casio.com